THE IDAHO COWBOY

A PHOTOGRAPHIC PORTRAYAL

Photography by David R. Stoecklein

ISBN 0-922029-02-4

Publisher: Stoecklein Publishing
Photographer: David R. Stoecklein
Designer/Typographer: Typographics, Ketchum, ID
Color Separations/Printing: Sun Lithograph, Salt Lake City, UT

All photos in this book are available in original signed prints.
Please write or call:

David R. Stoecklein
P.O. Box 856
Ketchum, Idaho 83340
208-726-5191
800-727-5191

Front Cover: Barton Flat, Mackay
Left to right: Bill Sayer, Lester Hatch, Josh Goddard, Jack Goddard, Monte Funkhauser, Ross Goddard, Gerry Nelson, Vernon Roche and Steve Aslet

Back Cover: "Under the Three Sisters," Big Lost River Valley
Left to right: Jack Goddard, Gerry Nelson, Justin Williams, Monte Funkhauser, Josh Goddard, Ross Goddard, Vernon Roche, Bob Hadley, Bill Sayer, Steve Aslet and Lester Hatch

ACKNOWLEDGEMENTS

This book would not have happened if all the cowboys and cowgirls had not opened up their lives, their homes and their hearts to me, a total stranger. I feel my life has changed. I have had an opportunity to look into a very special world that very few get to see. I hope this book gives you a view of this very special world.

INTRODUCTION

Proud, wild and free. Rough and ready, full of mystique and legends. The life of today's cowboy is much the same as that of his nineteenth century counterpart, only modified by the modernization of society. Cowboys are as different in their day-to-day lives as the landscapes that surround them, but similar in their basic characteristic lifestyles. The modern ranch cowboy epitomizes the cowboy of our present day. These ranchers can be owners, foremen, or ranch hands, and in most cases, all of these rolled into one.

There is an old saying that cowboys live poor and die rich but cowboys know that isn't true; deep down they know that they live rich in the things that give meaning to life. A strong supportive family—his wife and kids—the very essence and center of his existence, a good friend, a good horse, a good dog and a good brand of whiskey. Cowboys only die poor in the fact that it ended too soon—he didn't get that fence fixed or that hay cut or that colt ridden—things he'd always intended to get around to.

The romance of a cowboy's life is only a notion held by those on the outside looking in. But the mystique of the cowboy lives on, reinforced by hard work, hard luck and hard times. Yet he endures these hardships in a stoic sort of way, almost as if it's an obligation or privilege to pass on the legacy to the next generation. There is a bonding of brotherhood between cowboys both to each other and to those who've experienced life the same way before them.

And so this book is a glimpse at that exclusive image of the Idaho Cowboy. They're still out there, they're just a little hard to see sometimes.

D E D I C A T I O N

I would like to dedicate this book to my mom. She took hundreds and hundreds, maybe even thousands and thousands of photos, covering every inch of our family room with beautiful black and white as well as color pictures of our family and friends.

I am sure that this wonderful life I live as a photographer is because of all the exposure I had to these photos and the encouragement I received from home.

Thanks Mom

Love,
David

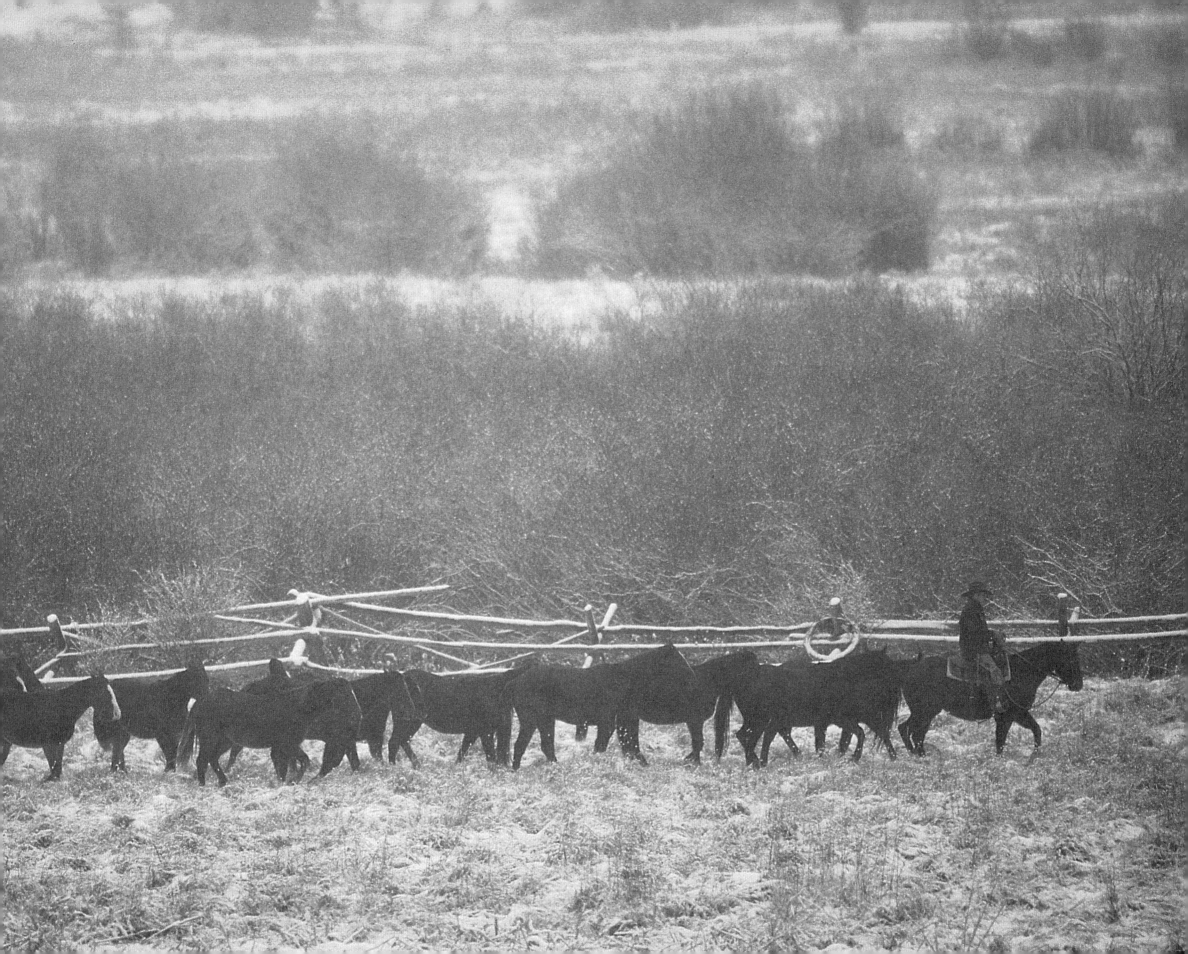

W I N T E R

Winter is the hard time for both the cowboys and their cattle because large ranches are located at higher elevations where snow accumulates more, comes earlier and remains later in the spring. After a strong, cold winter blizzard, the hay stacks, roads, gates and doorways have to be dug out before the routine feeding can be done, taking up most of a cowboy's day. Most feedings are done by tractors and hydraulics but there are still a few outfits that feed with a team of horses that pull a sleigh in heavy snow and then a wagon when the snow breaks and patches. The big team of work horses prance and pull against the driving lines as they're stepped into place to be hitched to the feed sleigh. Their hoofs make a rubbery, crunching sound as they back up to the singletrees and straddle each side of the hitch tongue. Leather, wood and iron snap and pop when the big horses jump and lean into their collars. Small white clouds form from steam off their hot, sweaty bodies and freeze to their hair tips, giving them a frosted appearance. Feeding with a team is slower but more soothing and satisfying. A team always starts and doesn't have fuel or oil to gel, wax up or glob.

Things are slow when it's cold. Movement of any kind seems an effort. Clothes are layered on thick and animals are haired up and stand humpbacked and gathered together against the cold. Their heads hang down, eyes closed, as they enjoy the morning sun's warm rays soaking into their thick furry hair. The cattle are in a state of waiting: waiting for morning, waiting to be fed, then waiting for night and waiting to calve.

Calving is the busiest and the most important aspect of the economic survival of a cattle operation. It's when the new dollars are made. The cows have to be watched closely because forty degrees below zero will freeze a calf to death in ten minutes. Sometimes a cow will calve during the warmer part of the day, but must be found and brought in, her calf sometimes across a saddle, to the calving barns in order to protect them from brutal temperatures.

Winter can be harsh, yes, but it can also be predictable. During this season, more than any other, routines are definite but cowboys take a break from their everyday chores. Cowboys flock together in their favorite local coffee shop. Coffee takes on a different taste in winter, one that may take an hour or so to sip on, rather than the usual twenty minutes. A good dose of market news and a little gossip helps pass the otherwise monotonous day. That famous cowboy romance spawns from these coffee shop encounters. This is when horses buck harder, yet are ridden with more grace and style, loops never miss a head and always pick up two heels. The girls get prettier and the conquests more gallant and grand. Time, coffee, cowboys and tales of heroics are the things legends are made of and winter brings out the best of all cowboy folklore. It's the time to reflect on years past and to contemplate on the days ahead.

BRING IN THE HERD
Sean Powers - Powers Ranch - Leadore

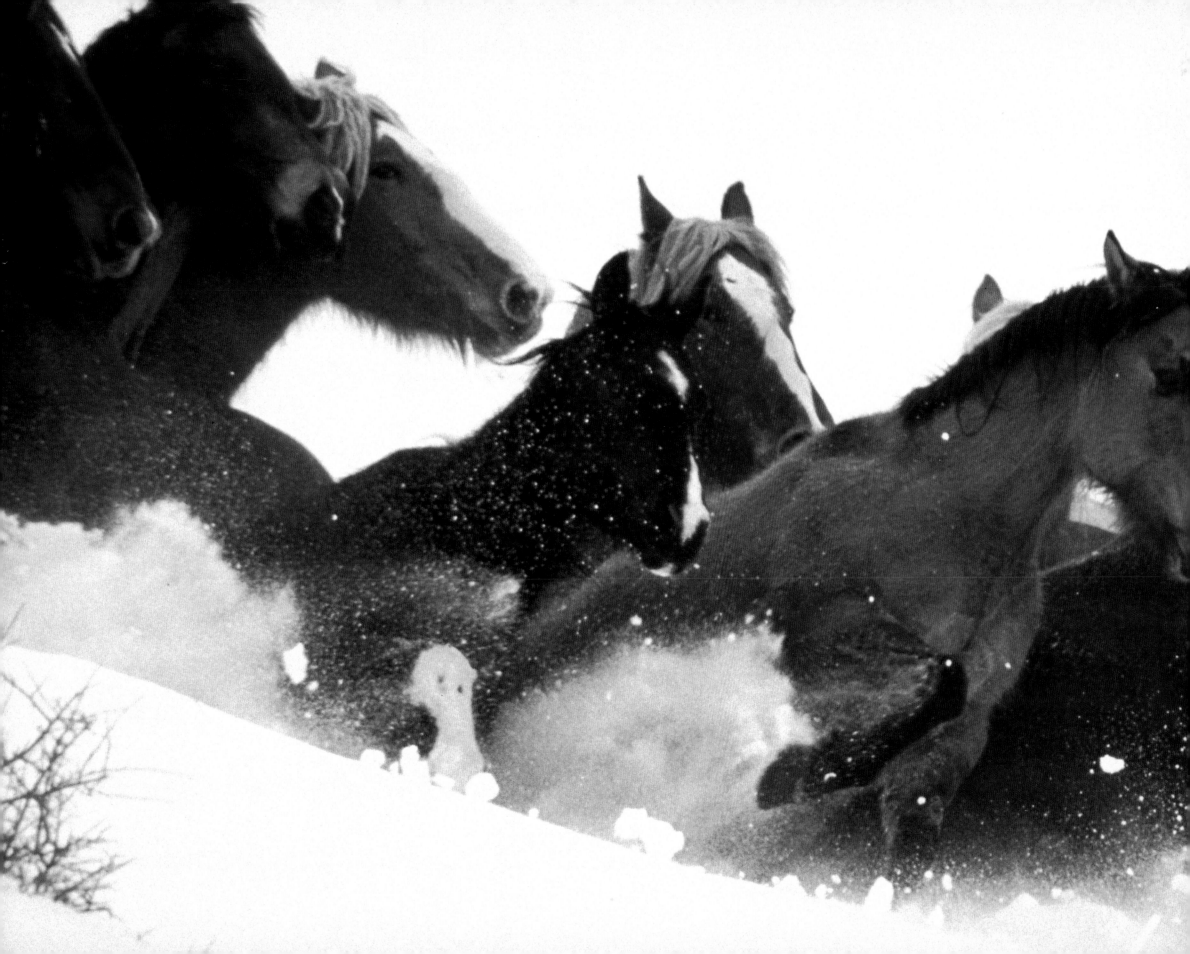

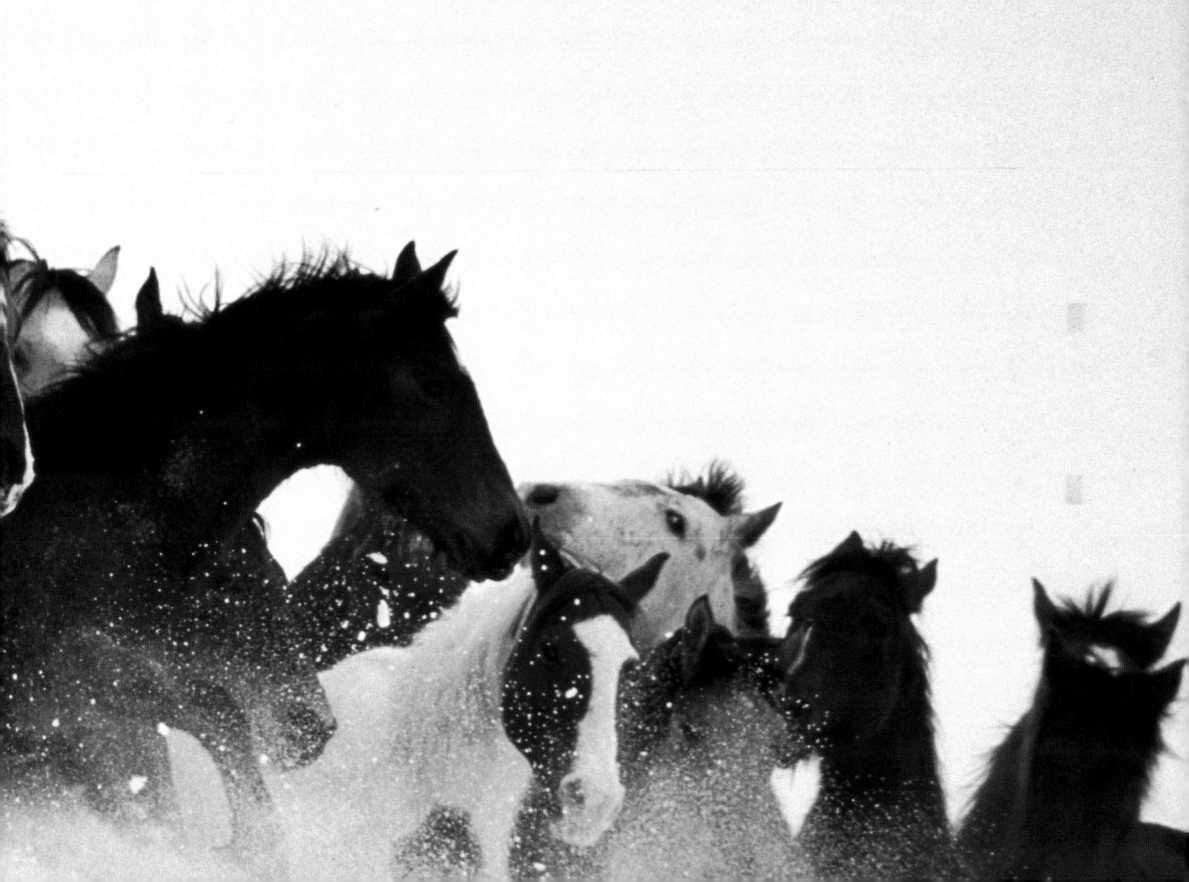

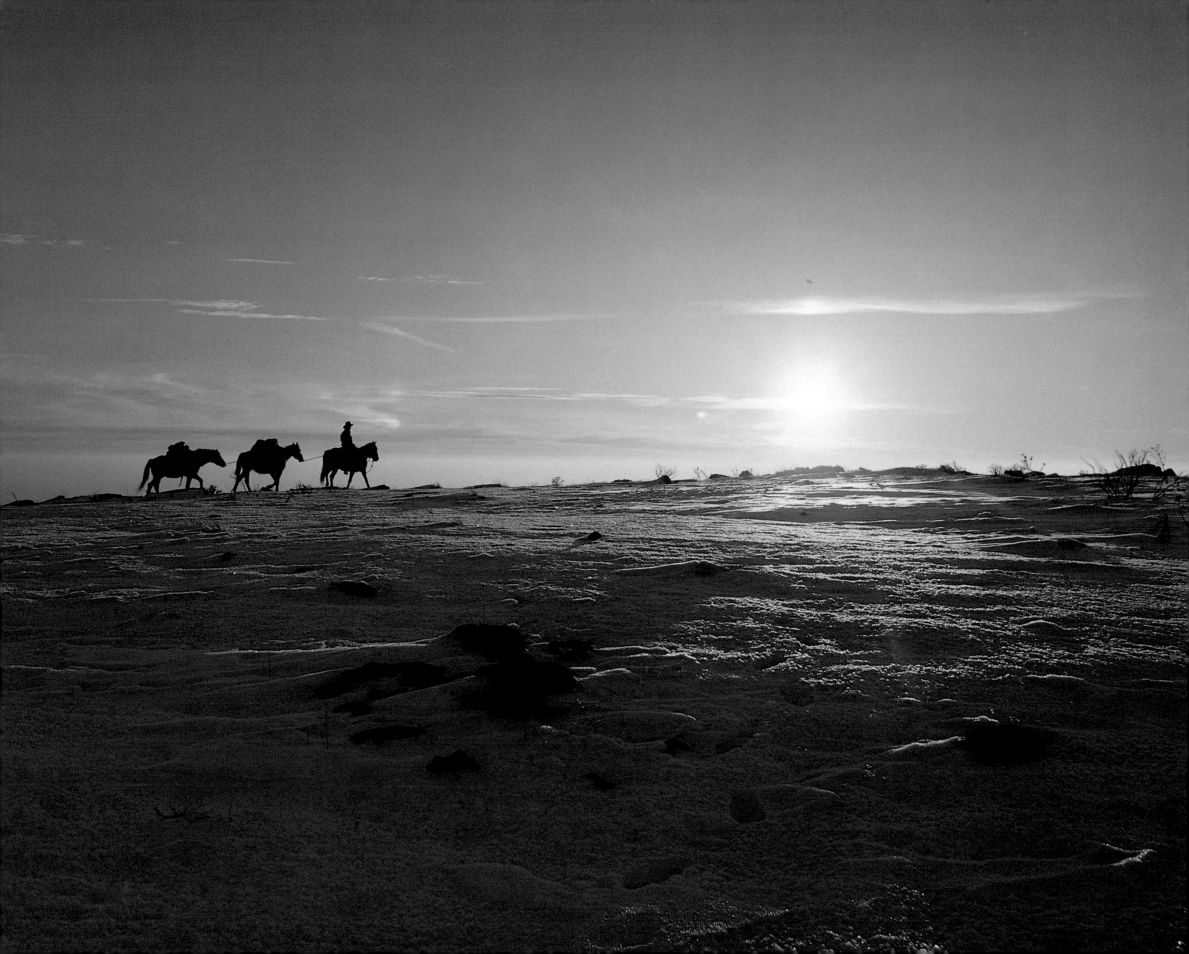

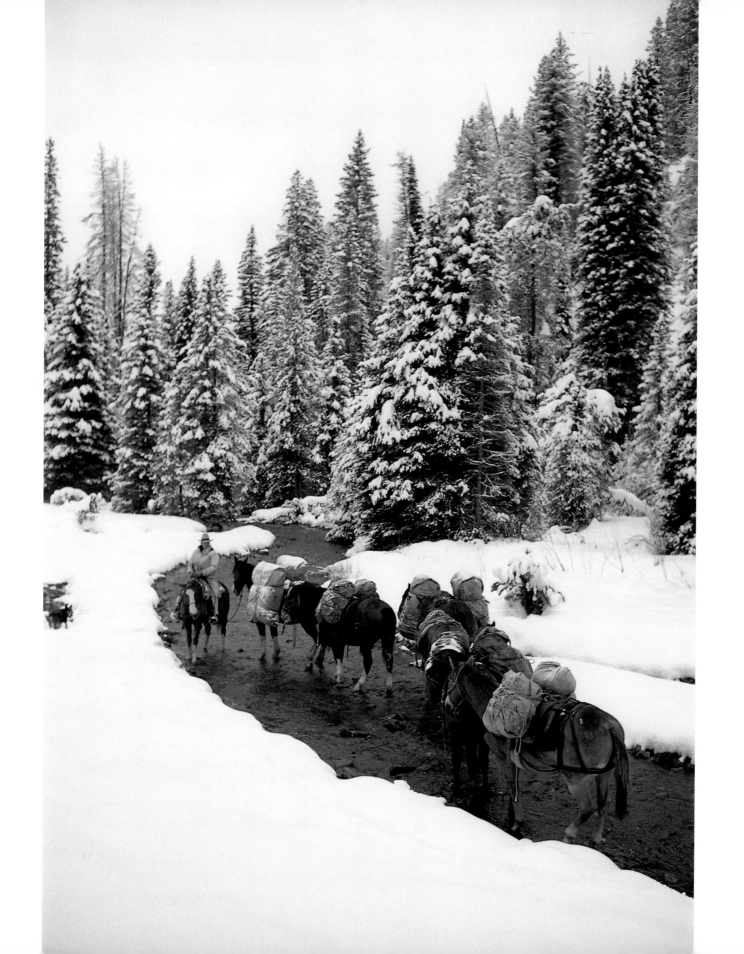

previous page: BUSTIN' OVER THE RIDGE
Hoggan Ranch - Medicine Lodge

left: DAY'S END
Jeff Bitton - Mountain Home

right: PACKIN' IN
Ray Seal - Big Smoky Creek

13

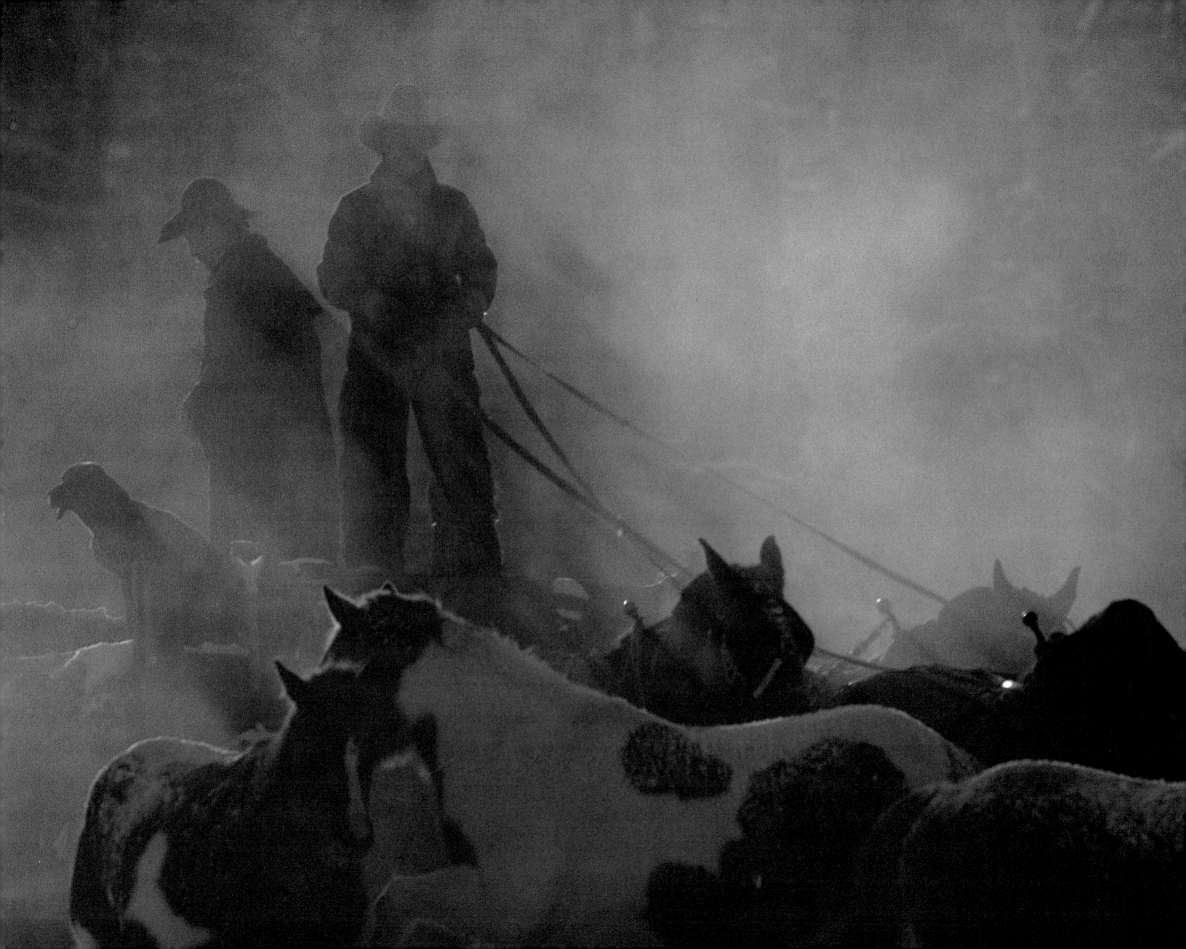

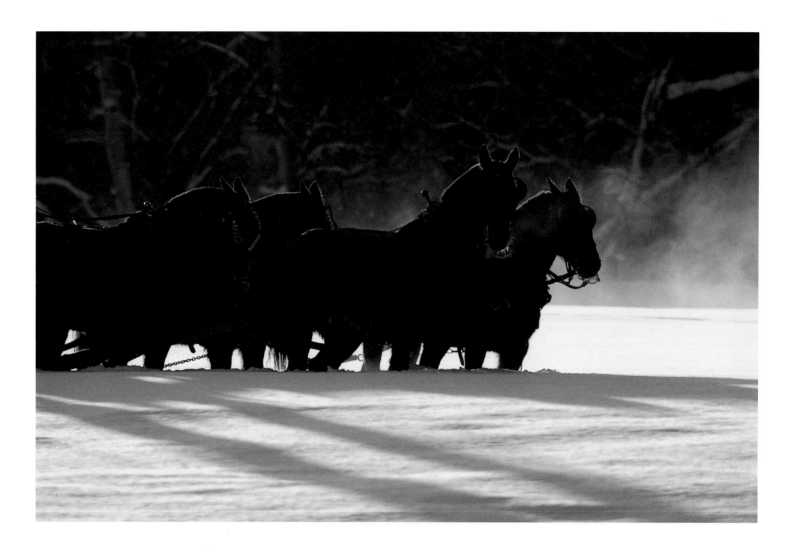

left: HOLDING THE LINES
Mike Angell and Hessy Baler · Pierced Heart Ranch · Driggs

above: WAITING TO LOAD
Feed Team · Pierced Heart Ranch · Driggs

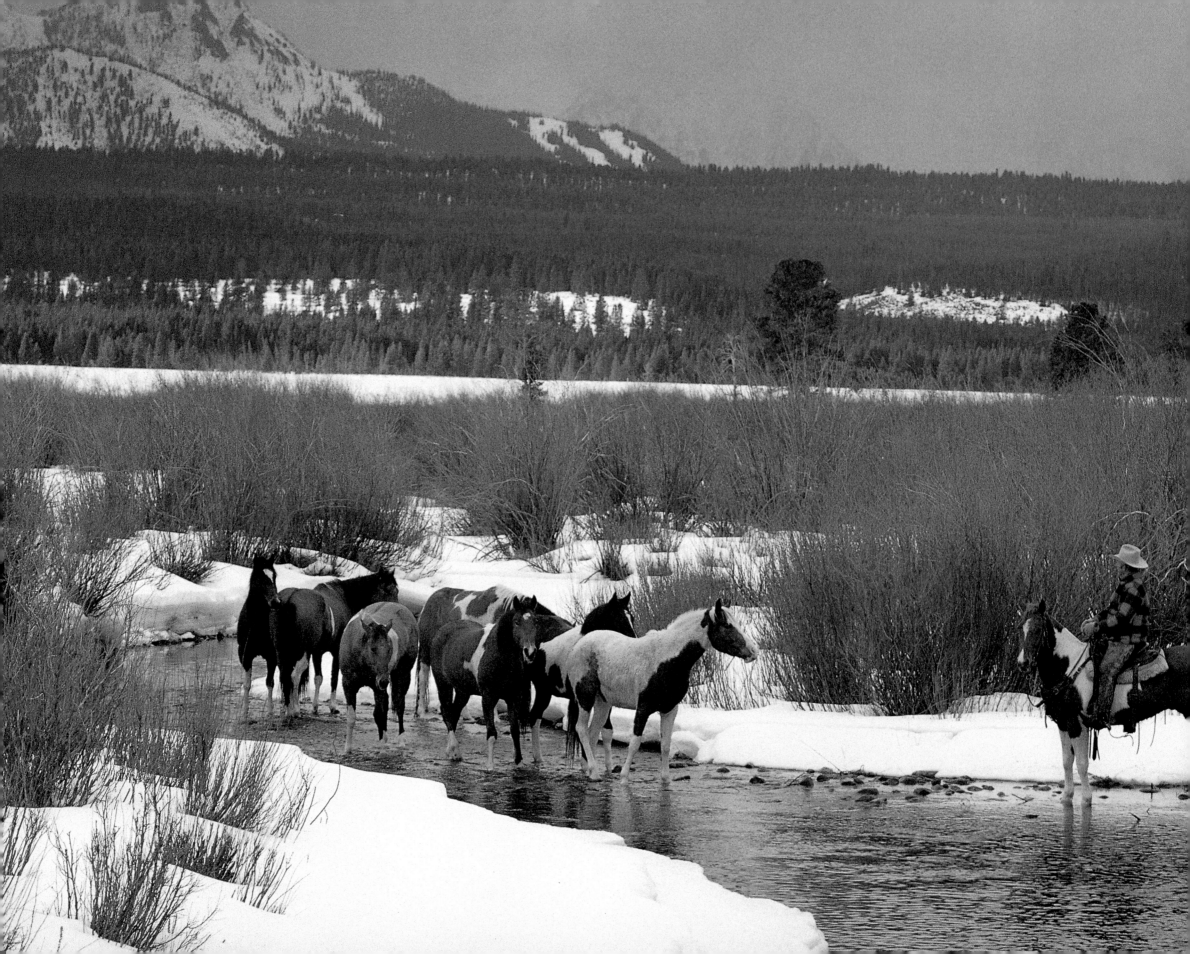

left: LAST RIDE OUT
Ray Seal - Stanley

above: JACK FENCE - MORNING AFTER FIRST SNOWFALL
Powers Ranch - Leadore

17

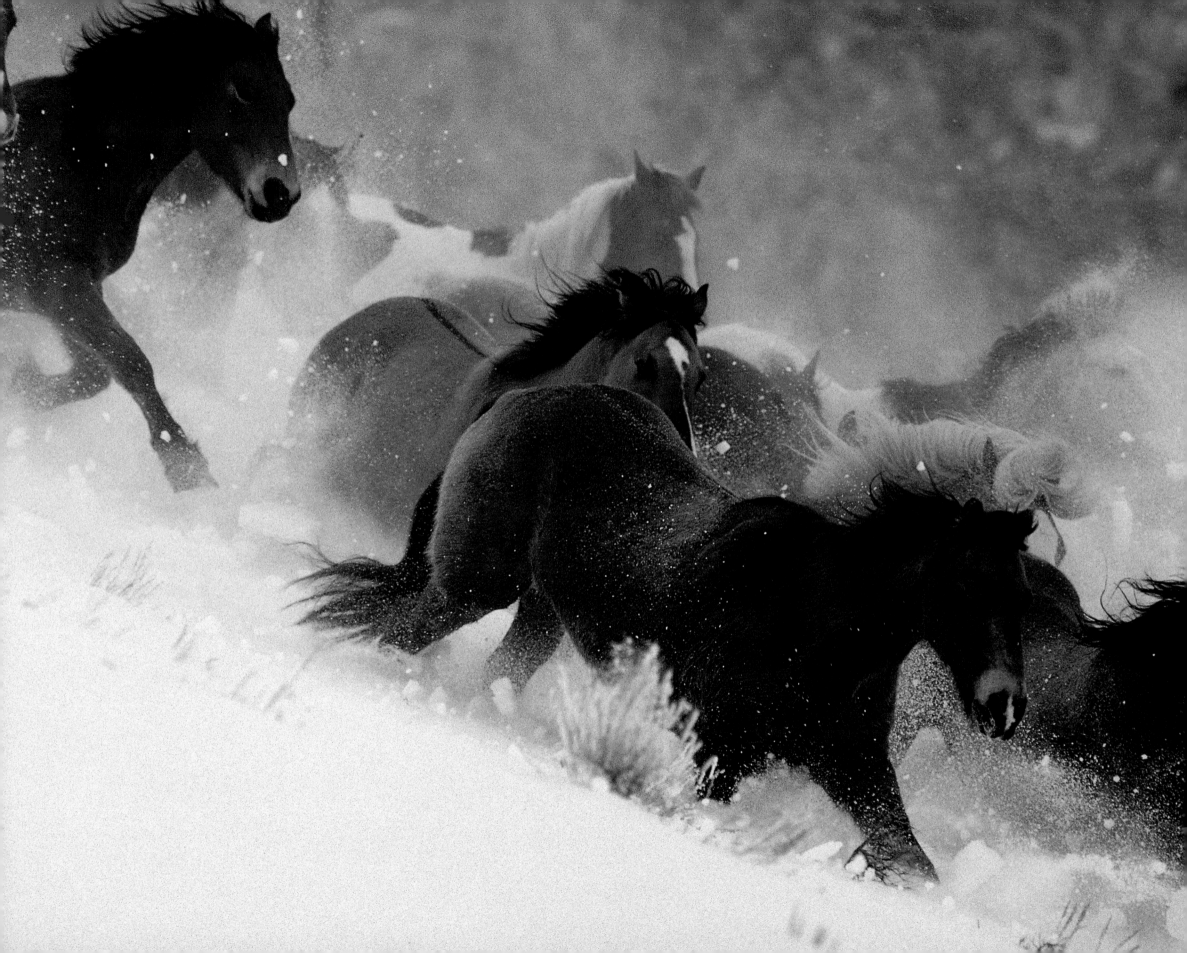

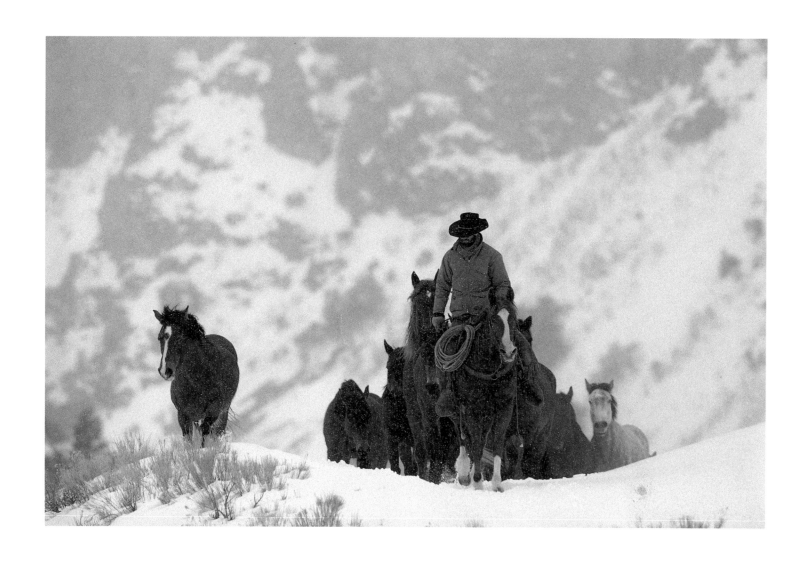

left: BREAKIN' CRUST
Hoggan String - Medicine Lodge

above: BRINGING 'EM HOME
Pat McGarry - Medicine Lodge

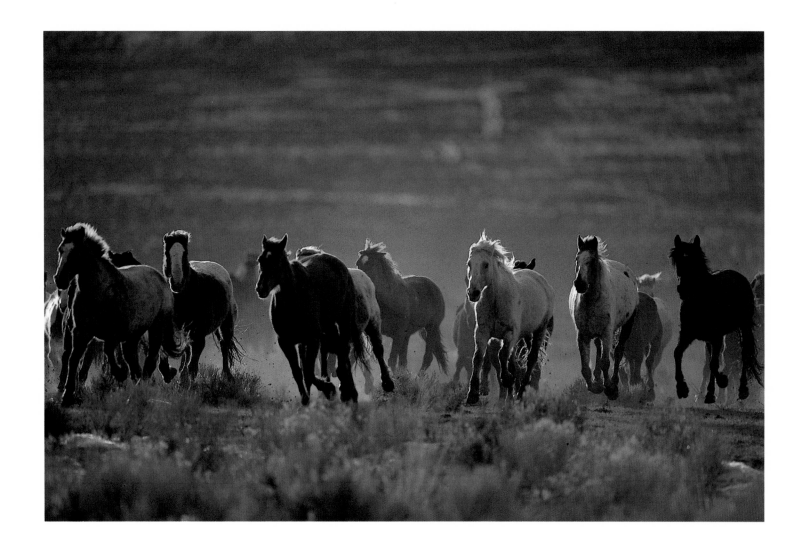

above: EVENING GATHER
Chilly Slough - Chilly

right: NAPPIN' BEHIND THE "TEE JAY"
Hoggan Ranch - Medicine Lodge

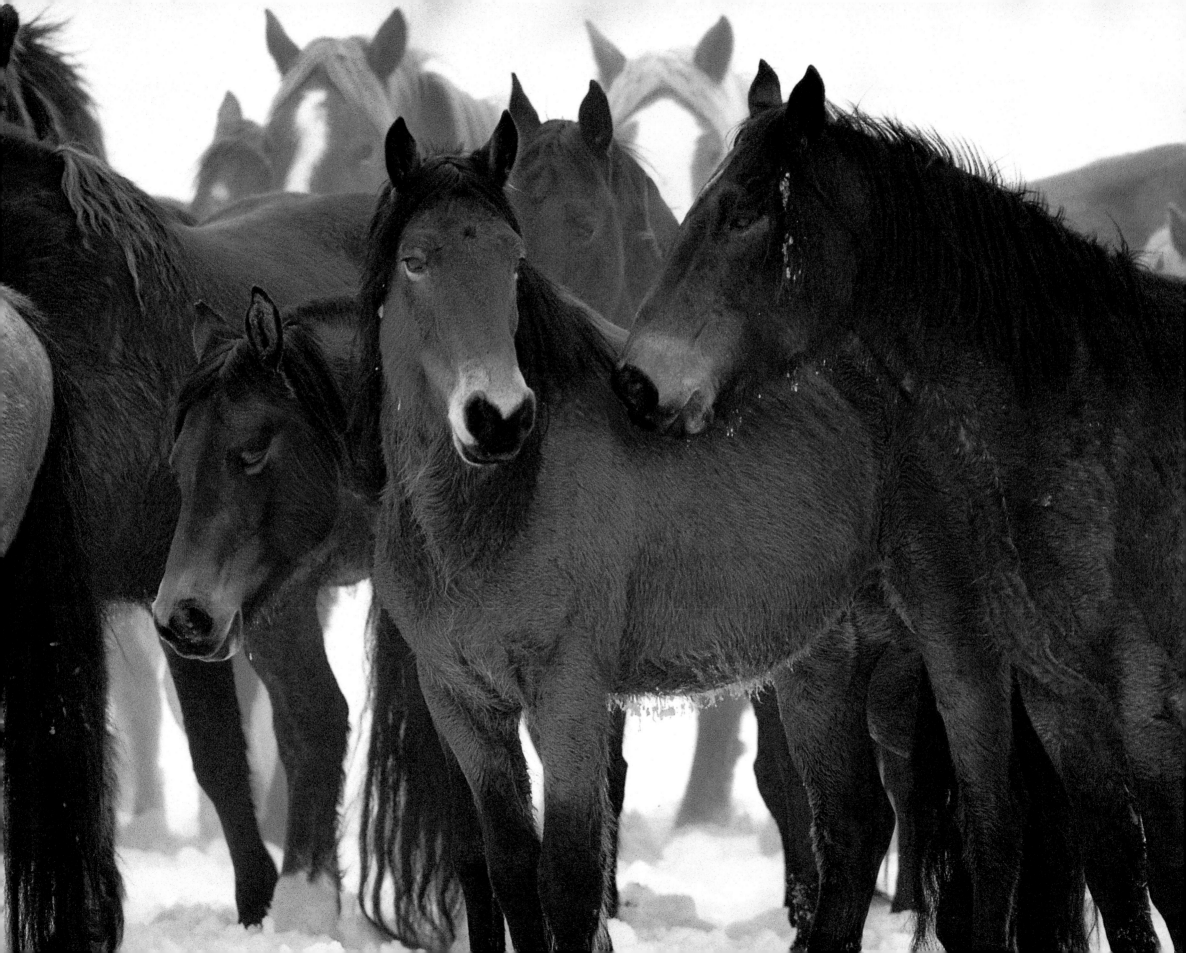

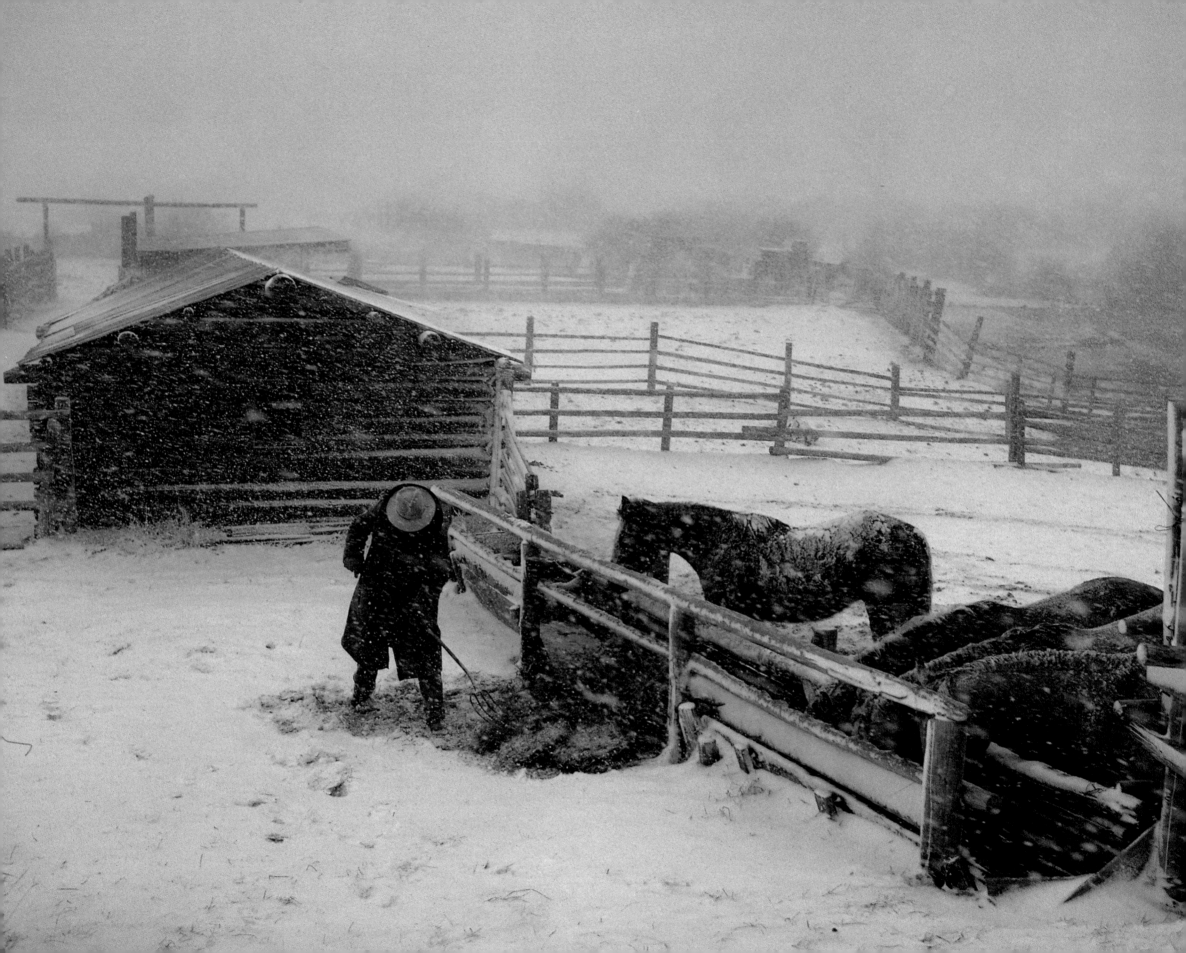

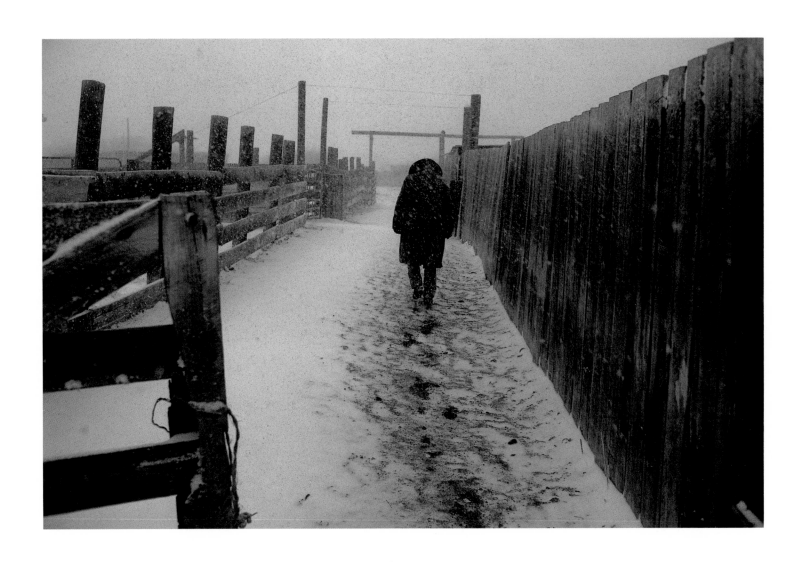

left: BLIZZARD FEEDING
Ross Goddard - Bar 13 Ranch - Mackay

above: HUNKERED UP
Ross Goddard - Mackay

23

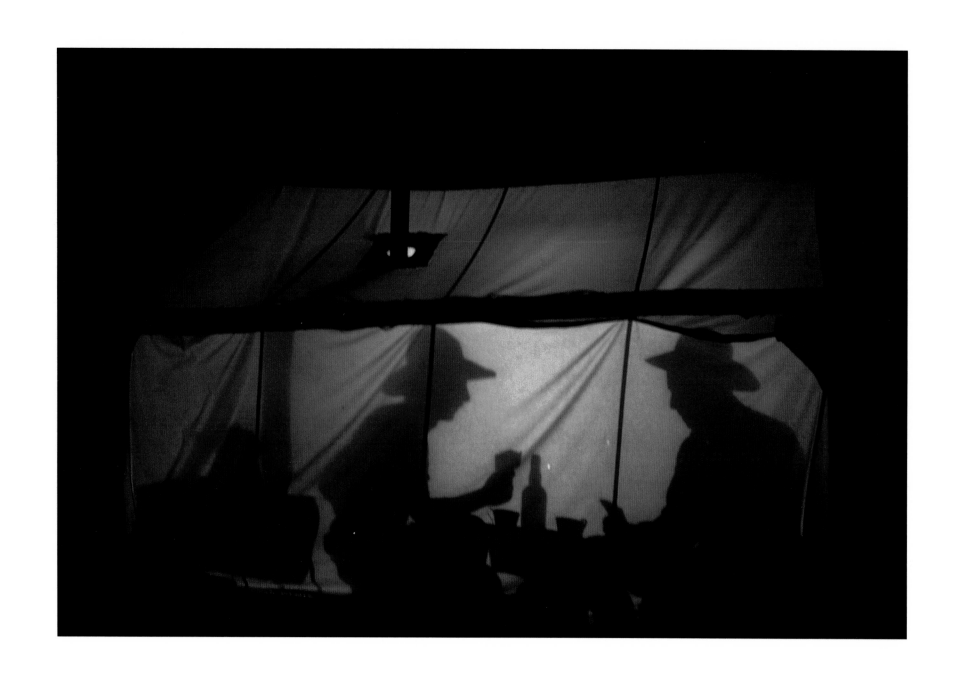

HOLDIN' A BLUFF
Mike and Ray Seal · Big Smoky Creek

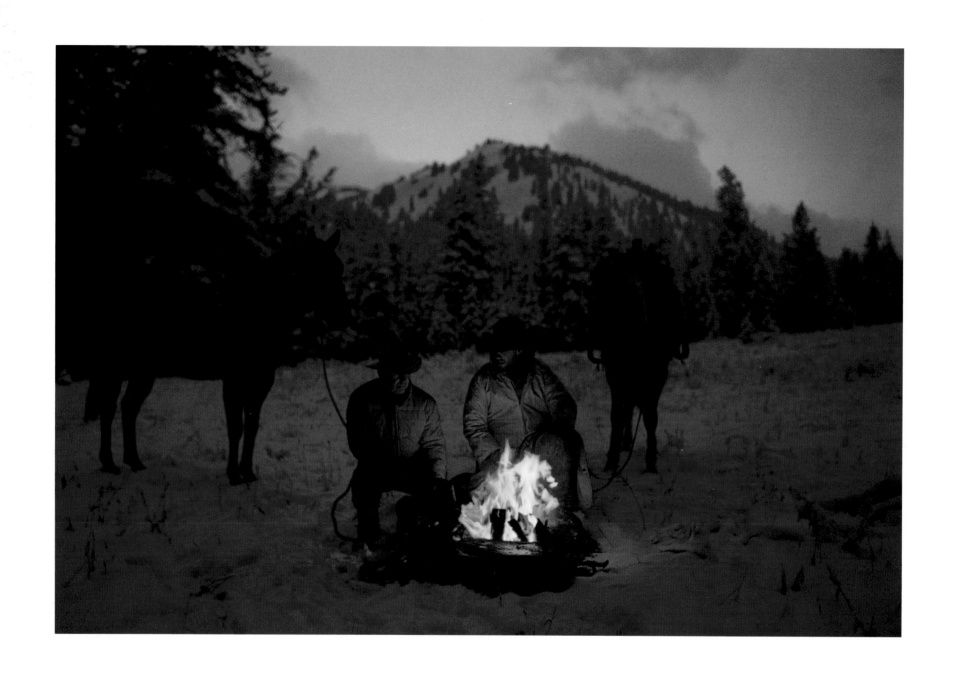

THAWIN' OUT
Mike and Ray Seal · Smoky Mountains

above: HEATER'S ON
Winter Blizzard - Bar 13 Ranch - Mackay

right: BEAVER SLIDE
Powers Ranch - Leadore

next page: CORRALED
Pat McGarry - Medicine Lodge

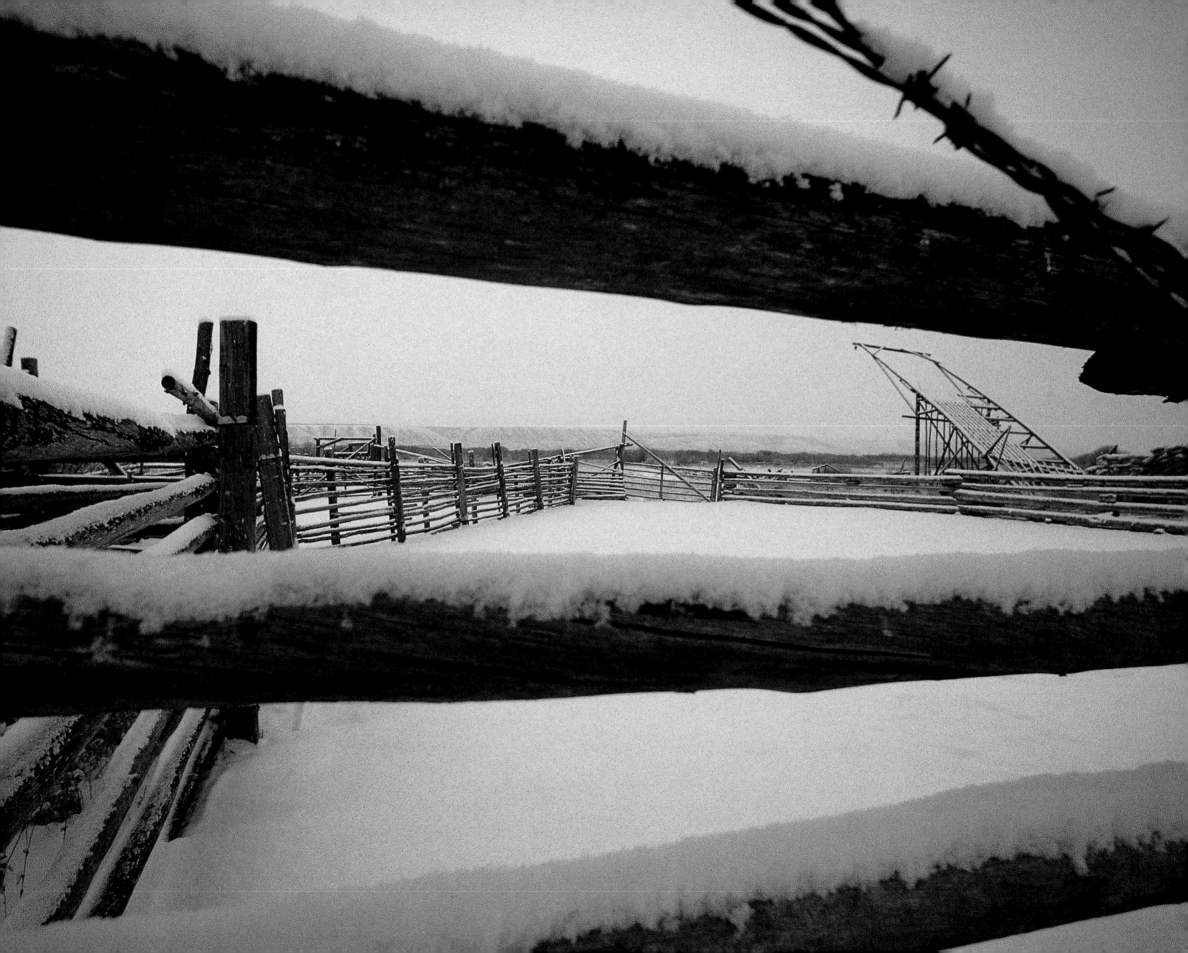

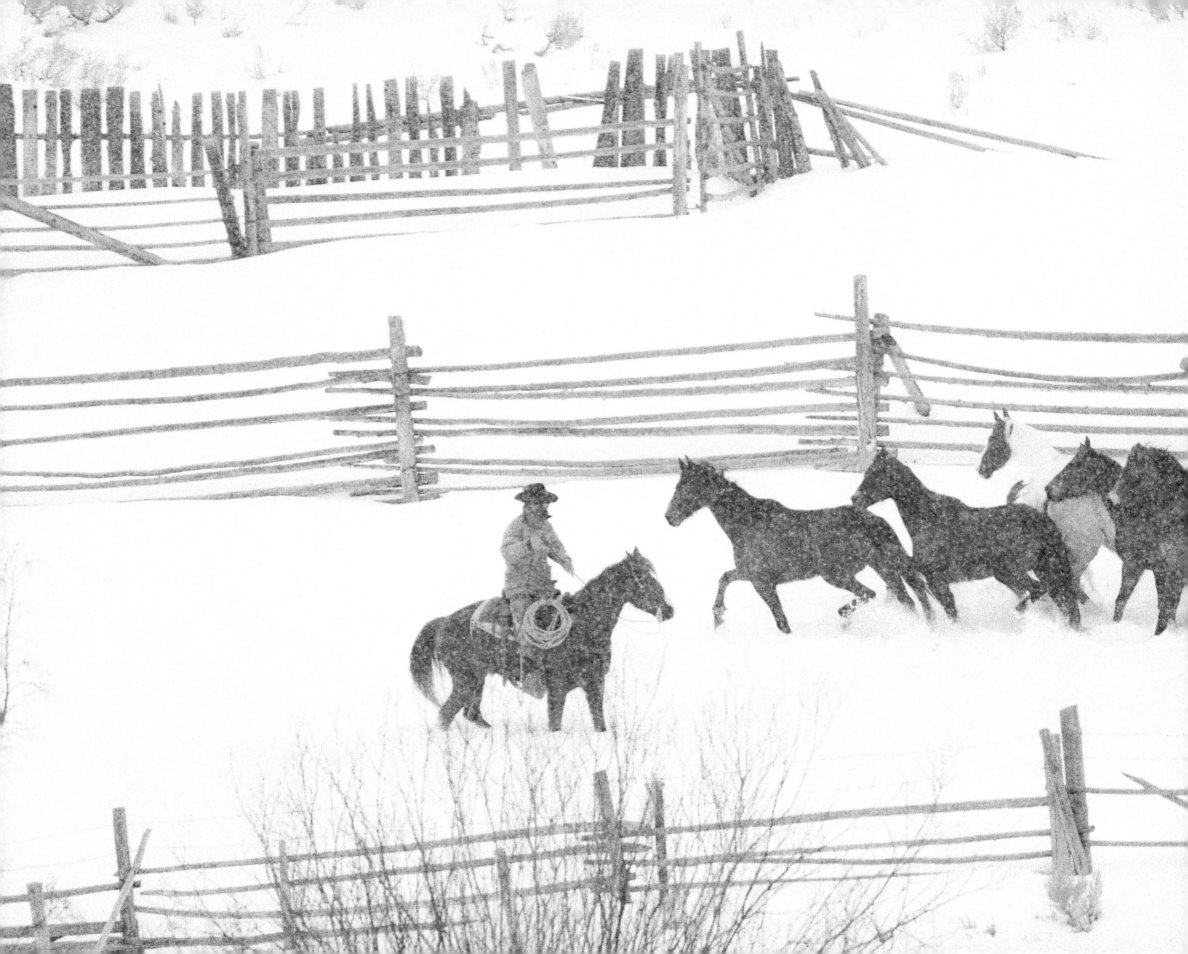

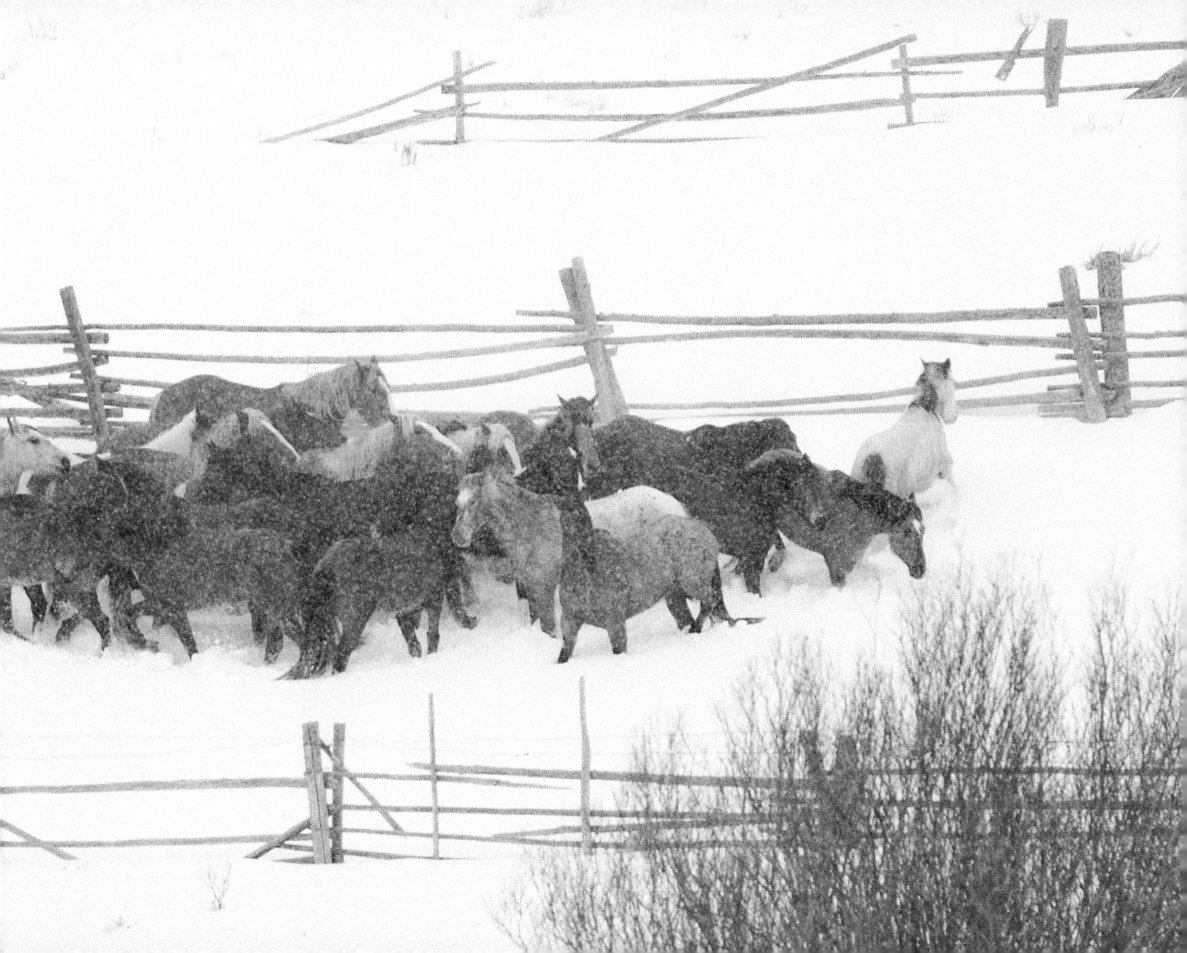

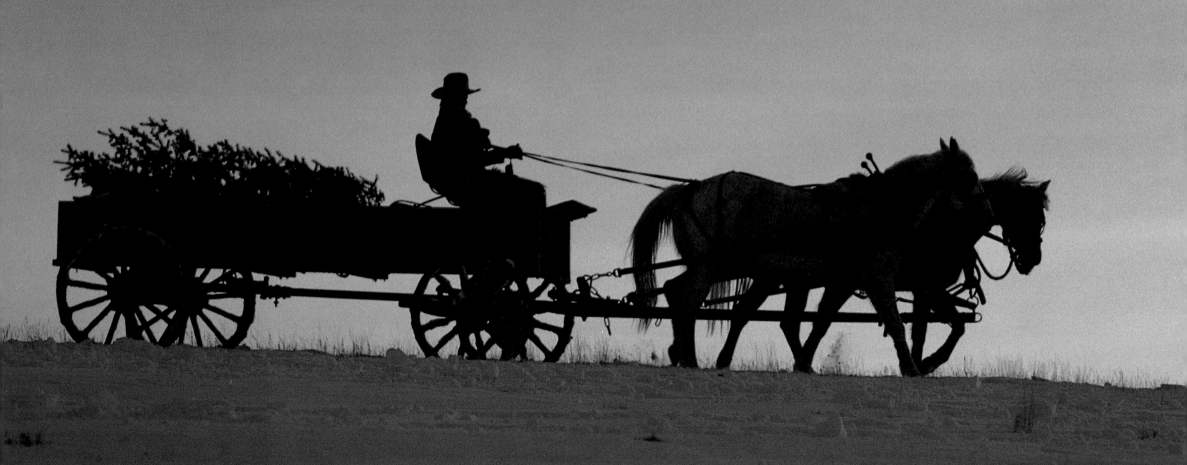

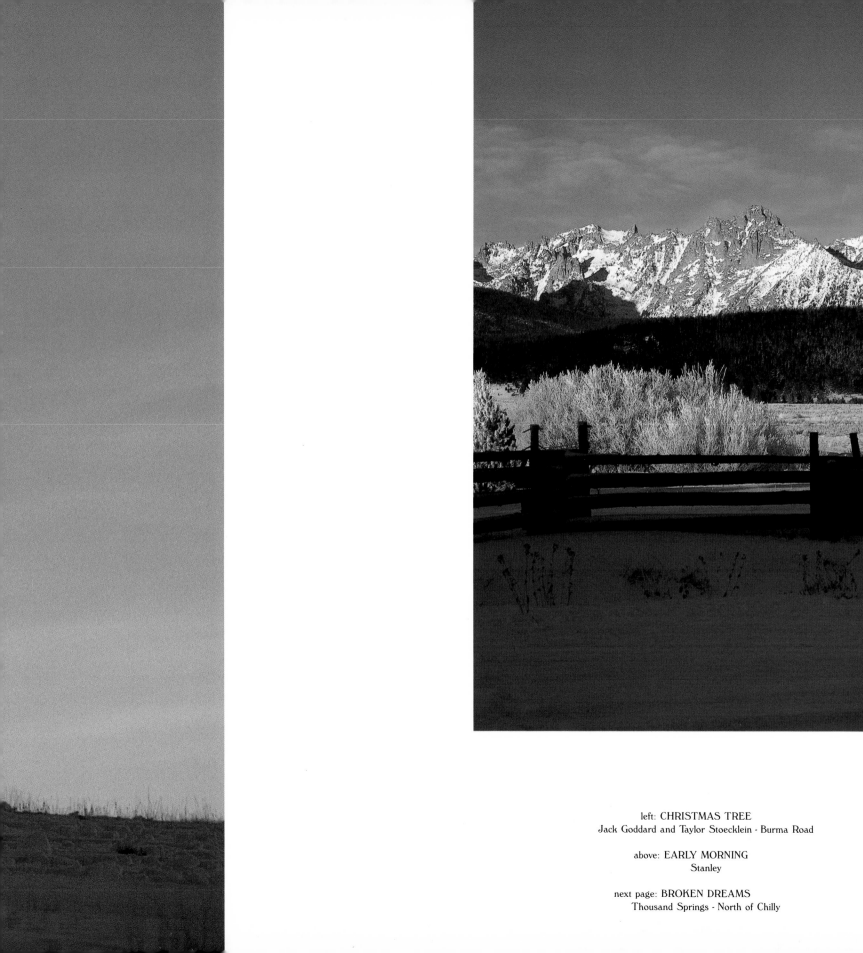

left: CHRISTMAS TREE
Jack Goddard and Taylor Stoecklein · Burma Road

above: EARLY MORNING
Stanley

next page: BROKEN DREAMS
Thousand Springs · North of Chilly

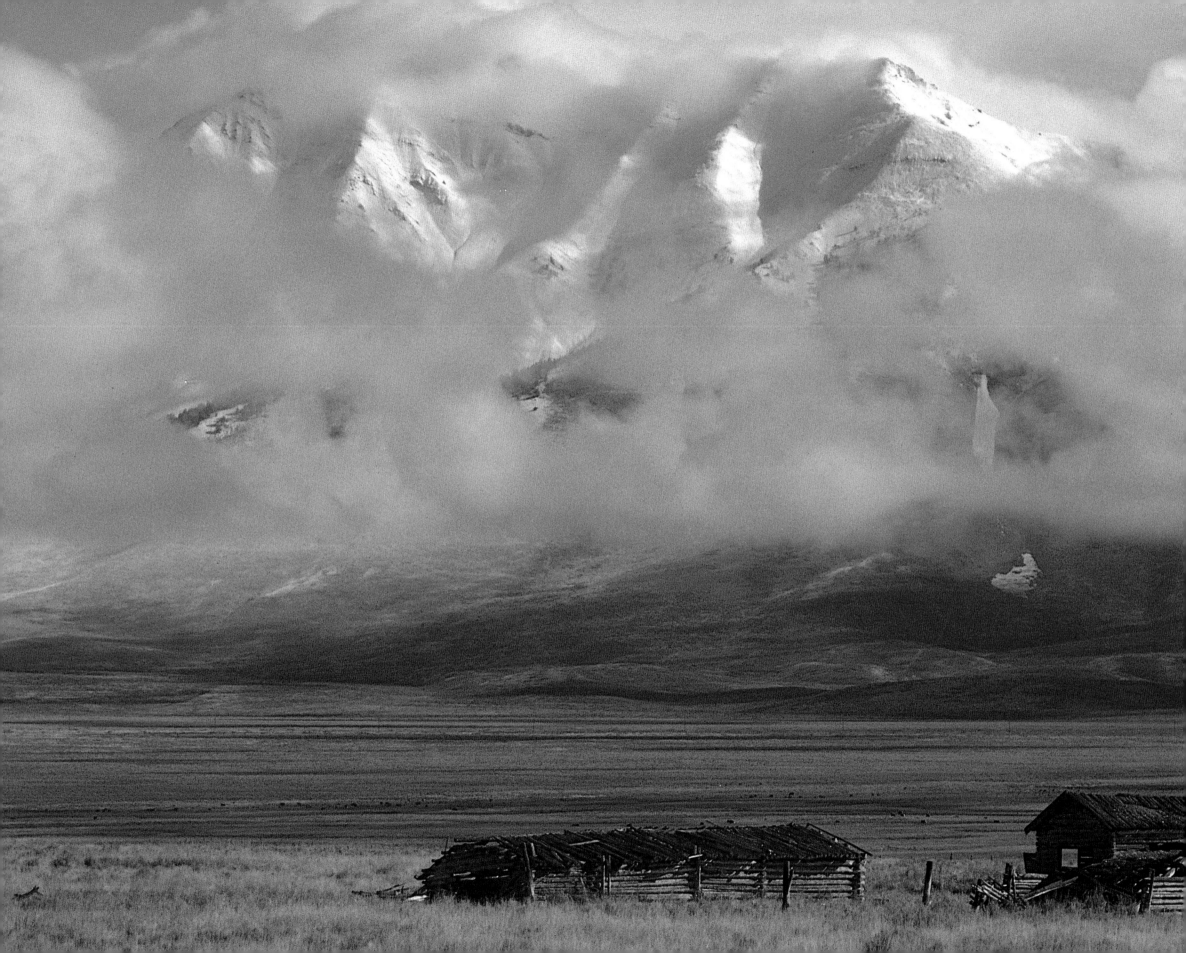

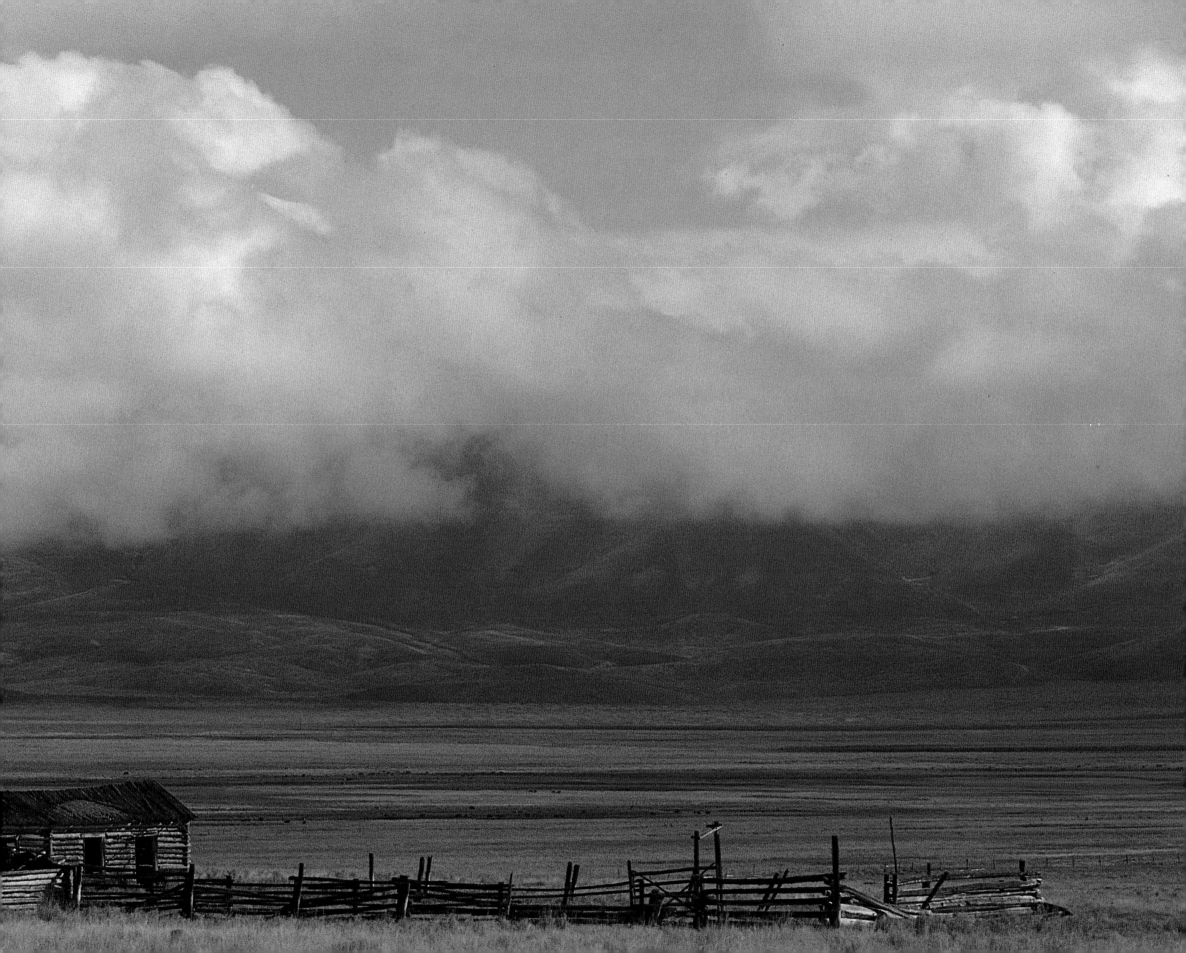

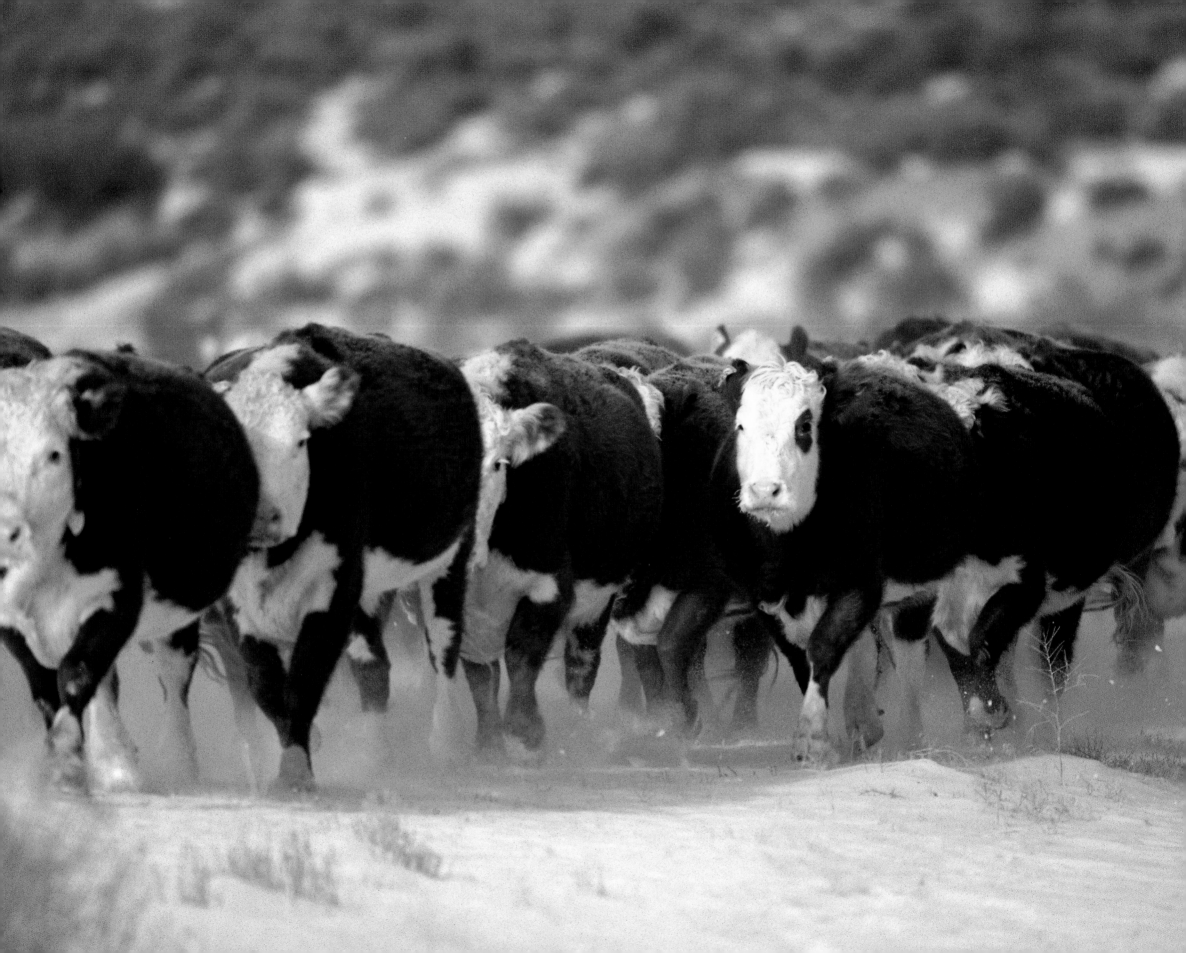

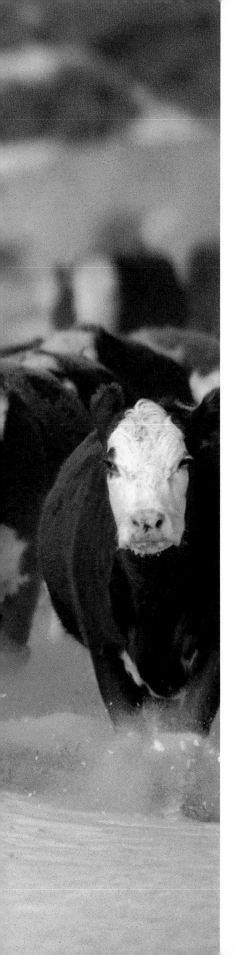

left: TRAILING HOME TO CALVE
Bar 13 Ranch - Mackay

above: MORNING WARMTH
No. R 235 - Bar 13 Ranch - Mackay

SHEDS ON TACK HOUSE
Bar 13 Ranch · Mackay

HOARFROST ON WIRE
Shoshone

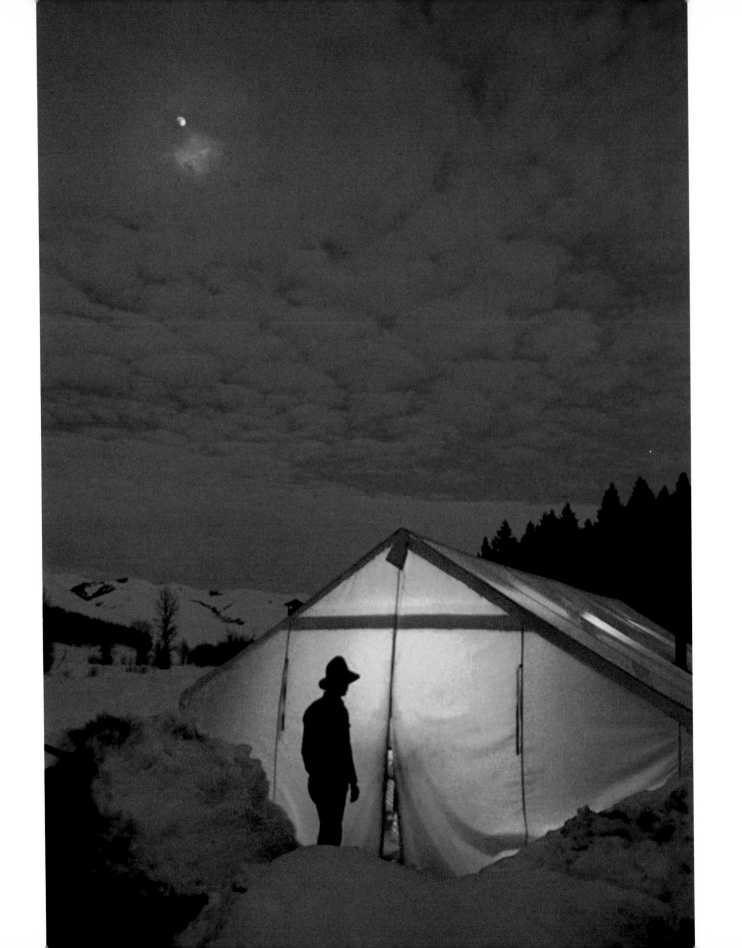

40

left: MOON GLOW
Dave Muscavage - Adams Gulch

right: END OF THE DAY
Sunset - Lost River Range

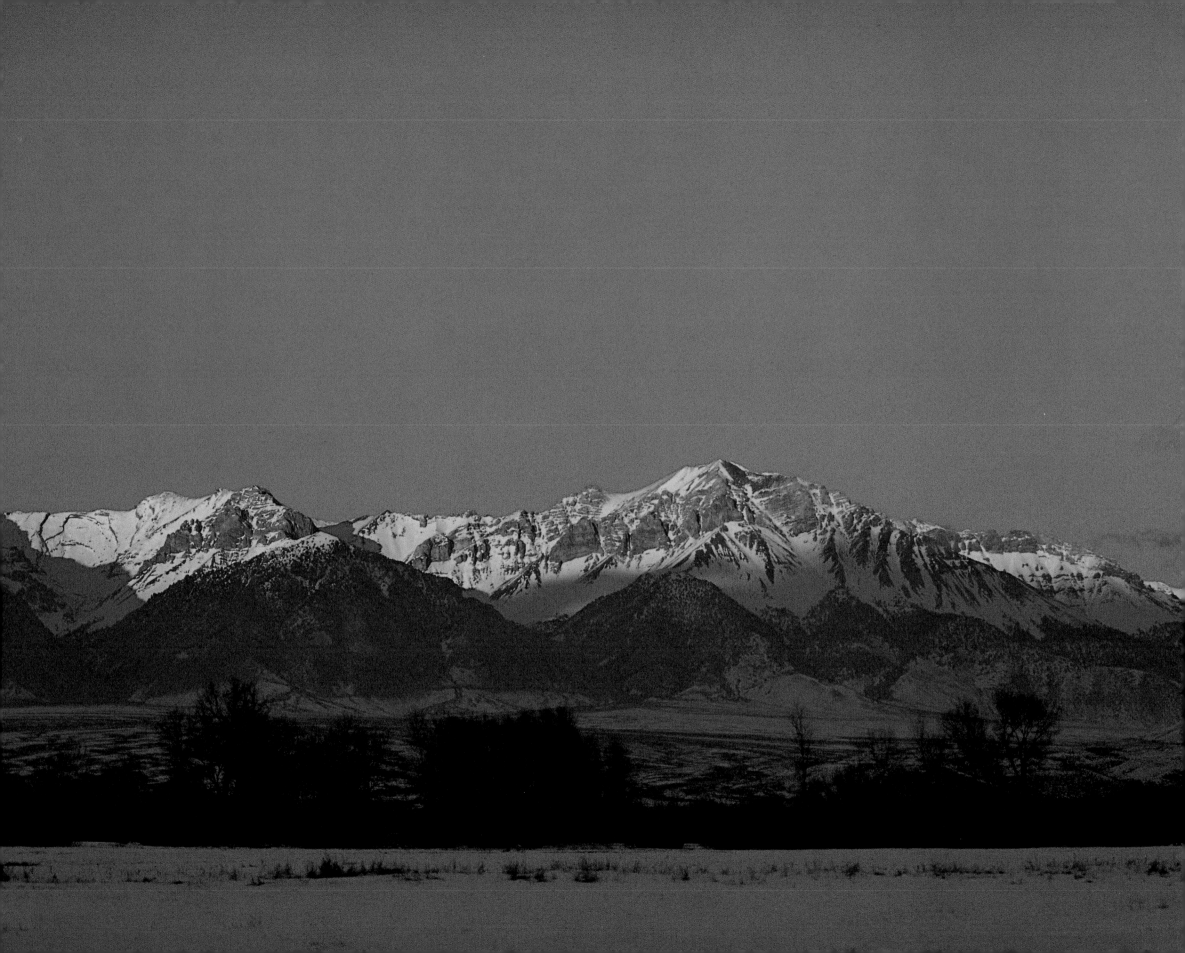

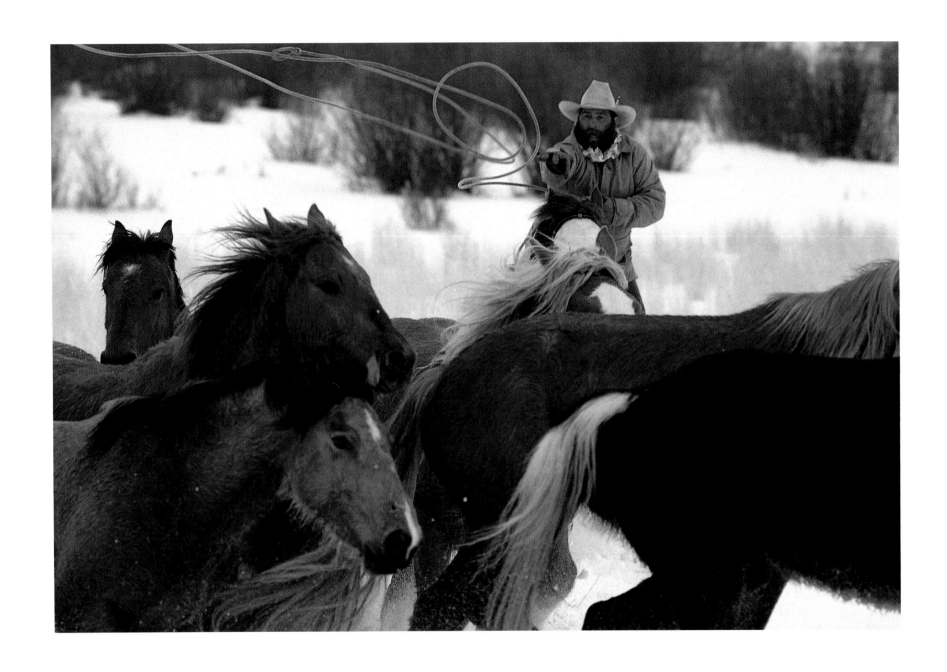

PERFECT LOOP
Jay Hoggan - Medicine Lodge

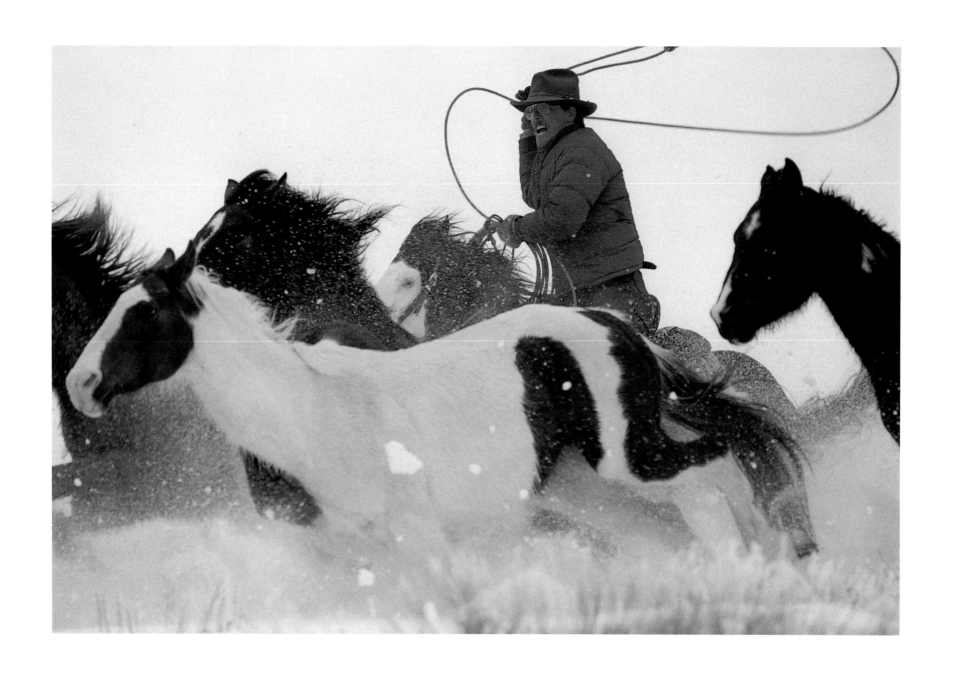

BEND 'EM BACK
Lynn Tomlinson - Dubois

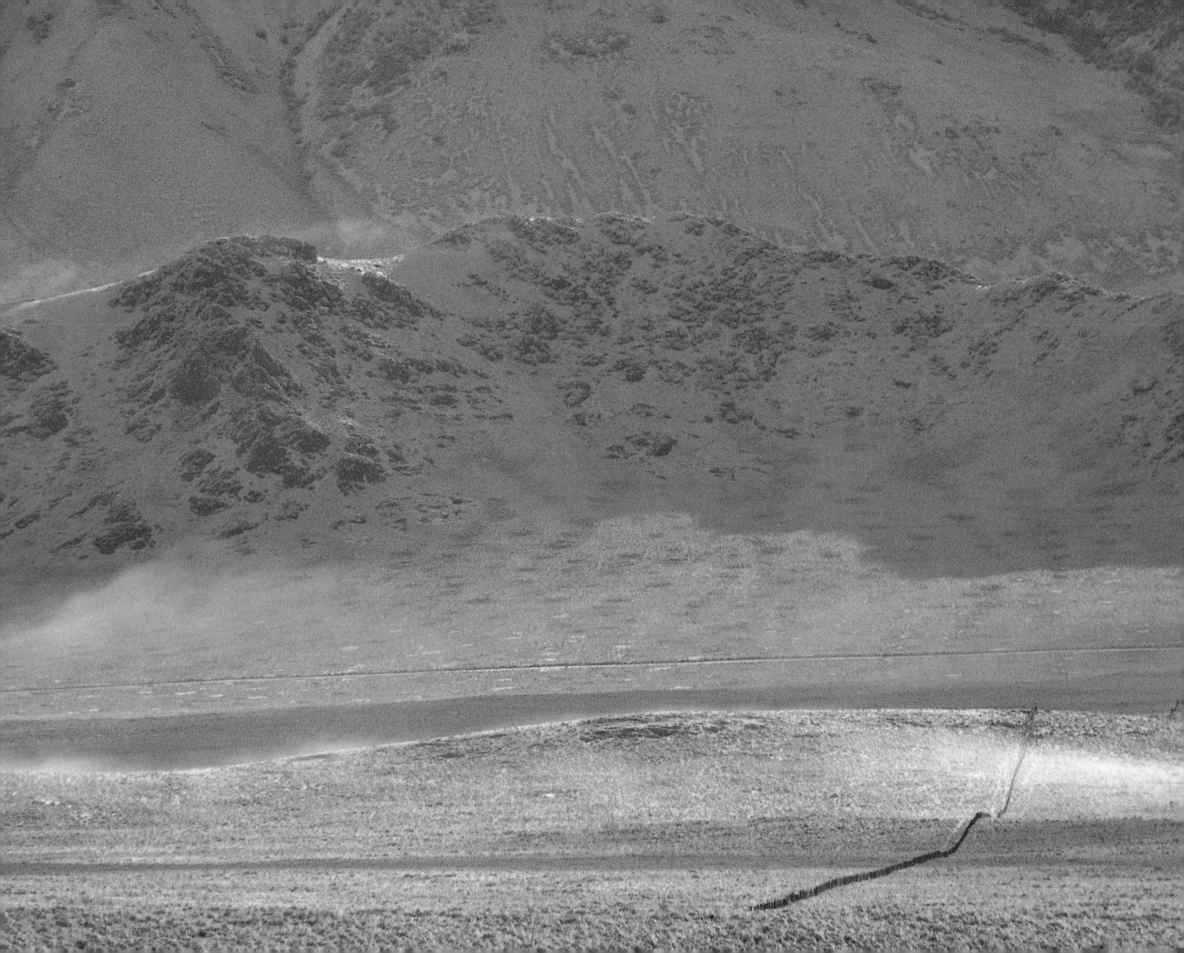

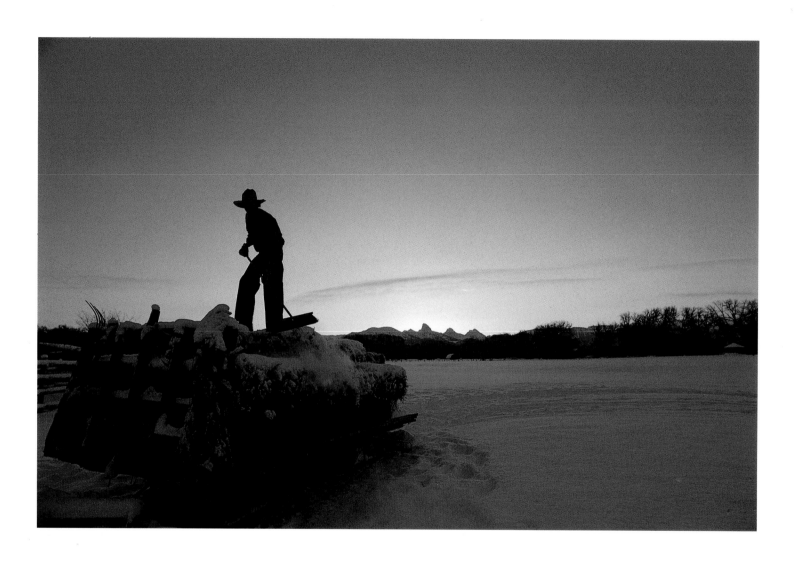

left: DIVISION FENCE
Chilly - Lost River Range

above: MORE SNOW LAST NIGHT
Martin Baler - Pierced Heart Ranch - Driggs

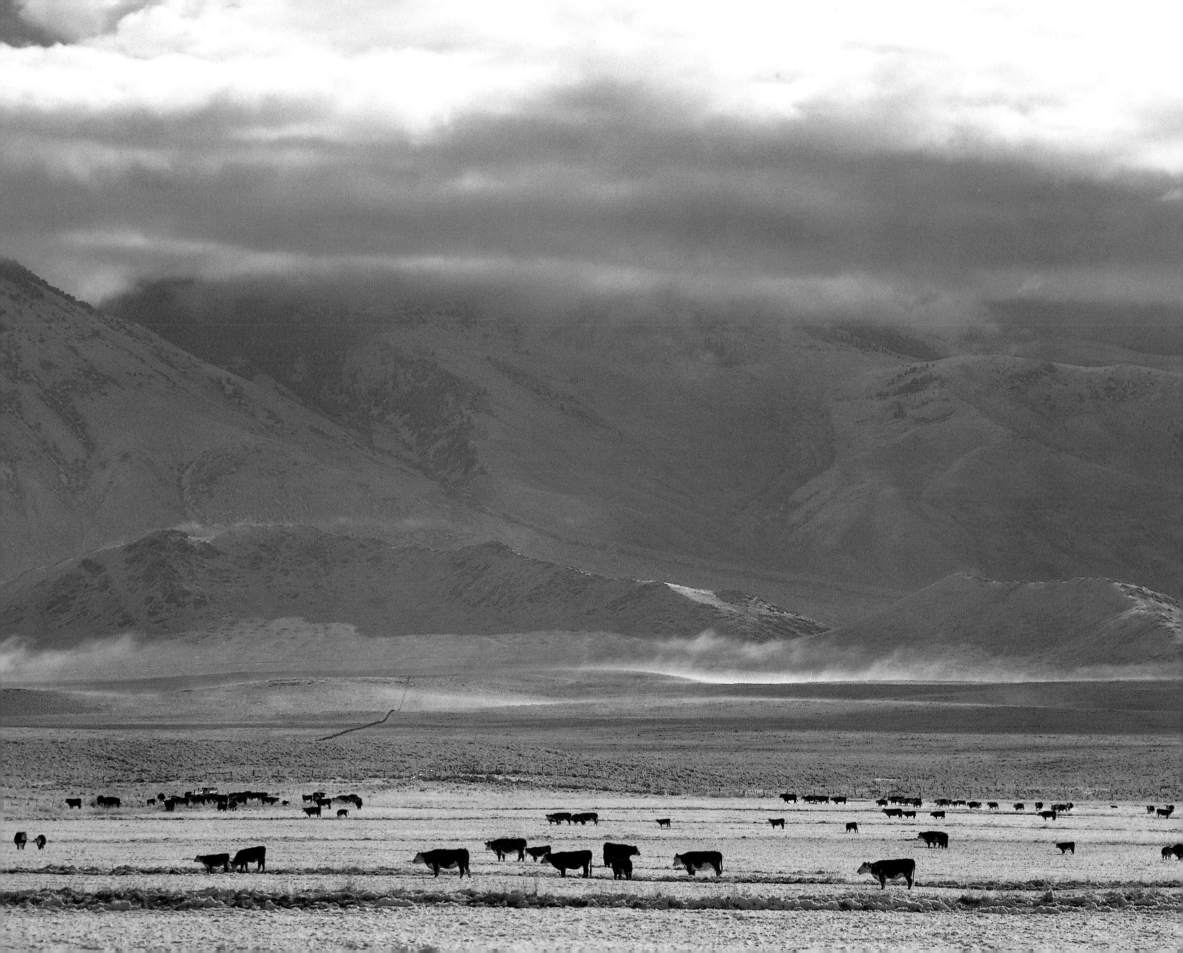

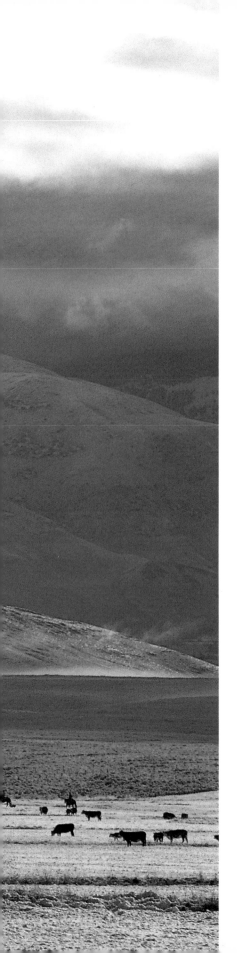

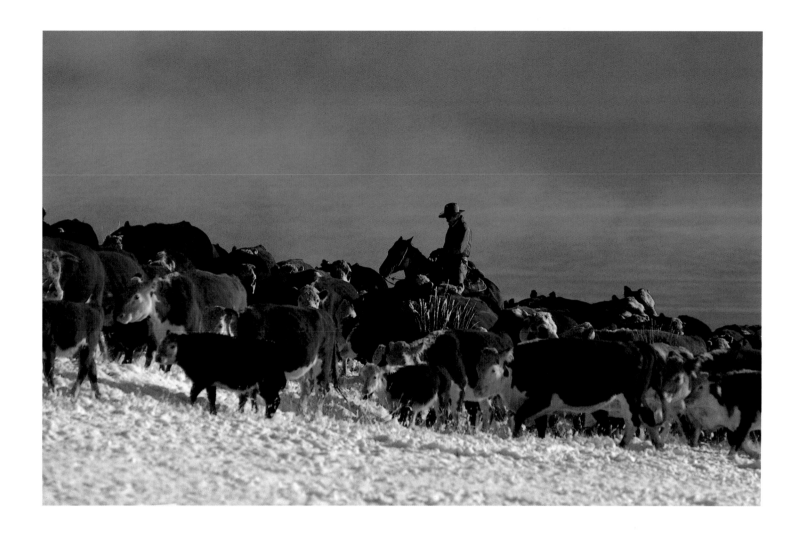

left: WINTER PASTURE
Coates Ranch - Dickie

above: TIME TO SHIP
Ross Goddard - Chilly Slough

47

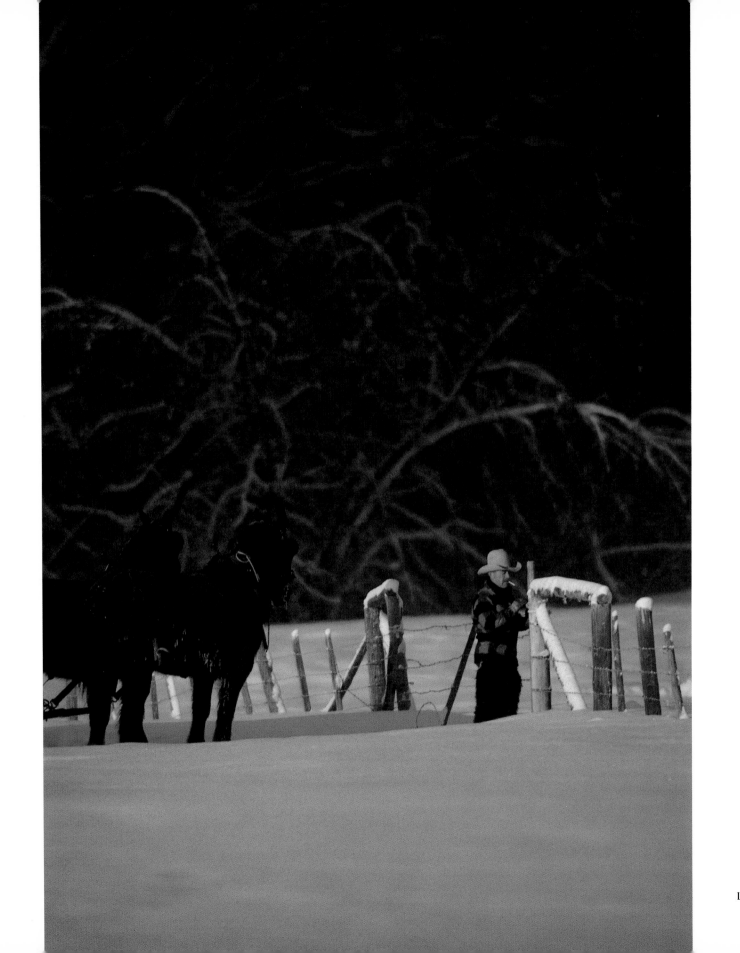

left: NEXT FEED GROUND
Mike Angell - Teton Basin

right: ALPENGLOW
Jack Goddard, Monte Funkhauser
Lehman Canyon Ranch - Lost River Range

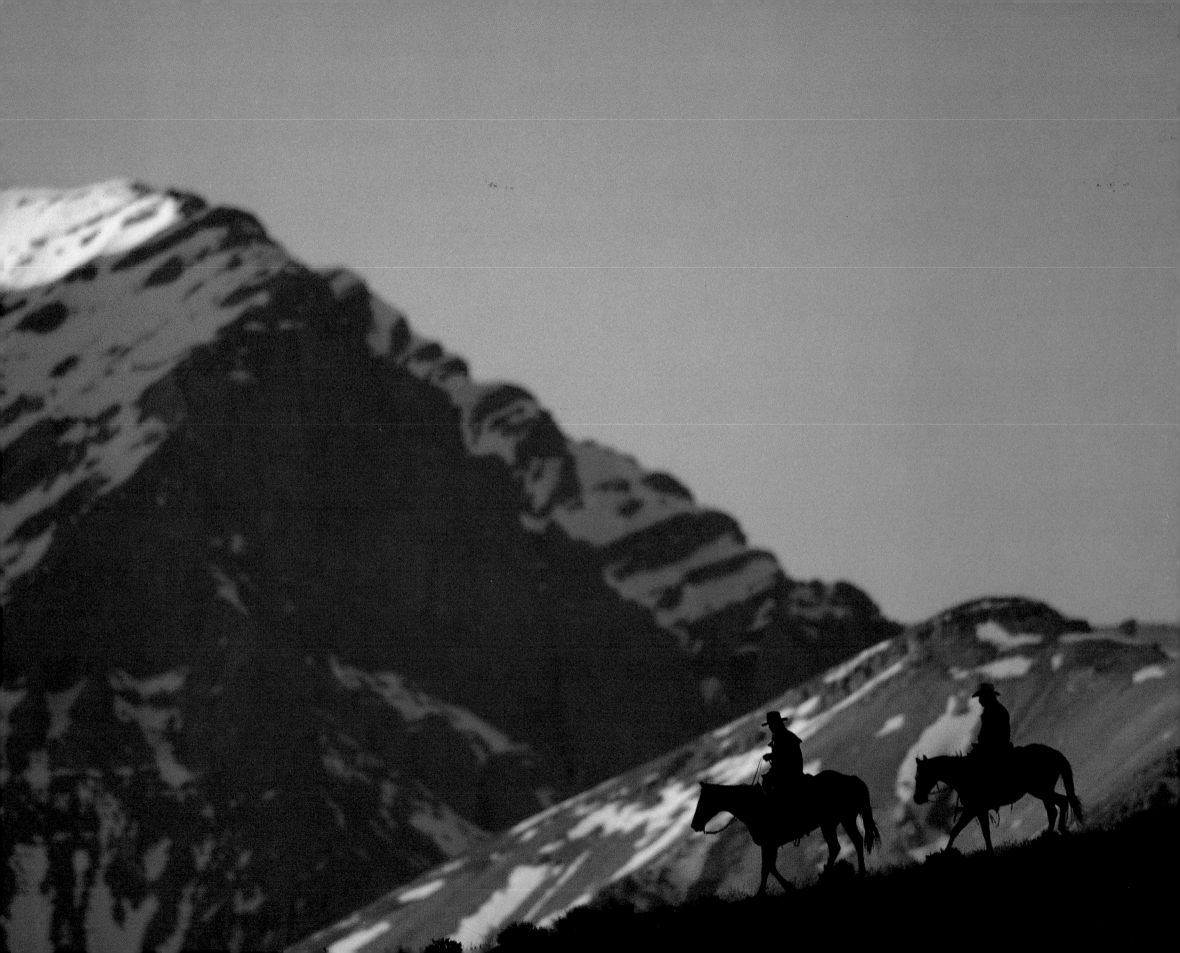

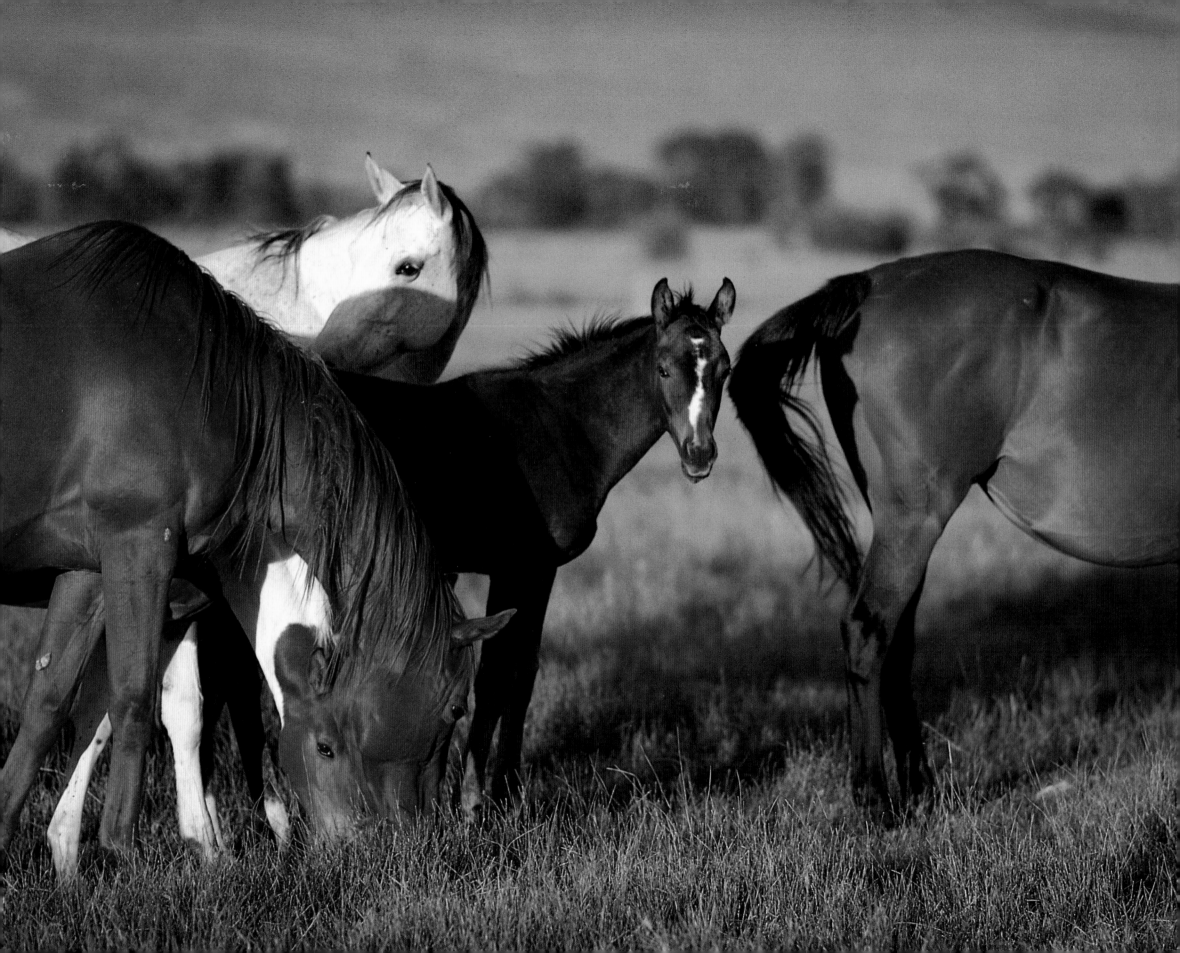

S P R I N G

When the snow begins to melt and the first new shoots of green grass begin to emerge, life on the ranch begins to soften as well. After a long winter of cold winds and blowing snow the migration of blackbirds and first sign of small willow buds are a welcome sight. The transition comes slowly at first, with a stubborn winter's reluctance to let go its hard hand: ice in the mornings that turn to puddles in the afternoons, patchy meadows, horses scratching and clawing for balance when turning a headstrong cow barreling for a patch of willows. Calving is winding down and the recently born calves have grown quickly, now needing to be branded and given their first vaccinations.

Brandings are usually a fun time looked forward to by the entire cowboy family. Many times it becomes a social gathering of neighbors who join other ranch cowboys and their families to brand their calf herd. Cowboys now get to show off their roping skills and brag on the fine bloodlines of their newest roping horse. The cowboy's wife gets to share the recipe for her newest favorite dish that everyone is raving about. The kids get to be kids, playing in packs of miniature buckaroos, mimicking their dads in only the way a child can who idolizes the "grown up cowboys." Life looks good now: a new crop of calves to sell in the fall, the hay is growing and optimism is blossoming like the new spring flowers.

After the branding it's time to turn out on the range. Nearly all the range in Idaho is on public lands. The early season and most of the spring is spent on the lower hills that are managed by the Bureau of Land Management (BLM). As spring passes on to the hot days of summer, the cattle are moved to the forest to graze high mountain canyons and Alpine meadows. These lands are administered by the U.S. Forest Service.

Spring is a time of new beginnings for a cowboy. New crops, new calves and colts, new activities. He loves the smell of smoke from the branding iron and the commotion and activity of turning cattle out on the range. He loves seeing the newborns, the new colors and the new attire. There's cattle to be worked, chores to be done, life to be enjoyed!

COLTS AND MARES
Bar Horseshoe Ranch · Barton Flat

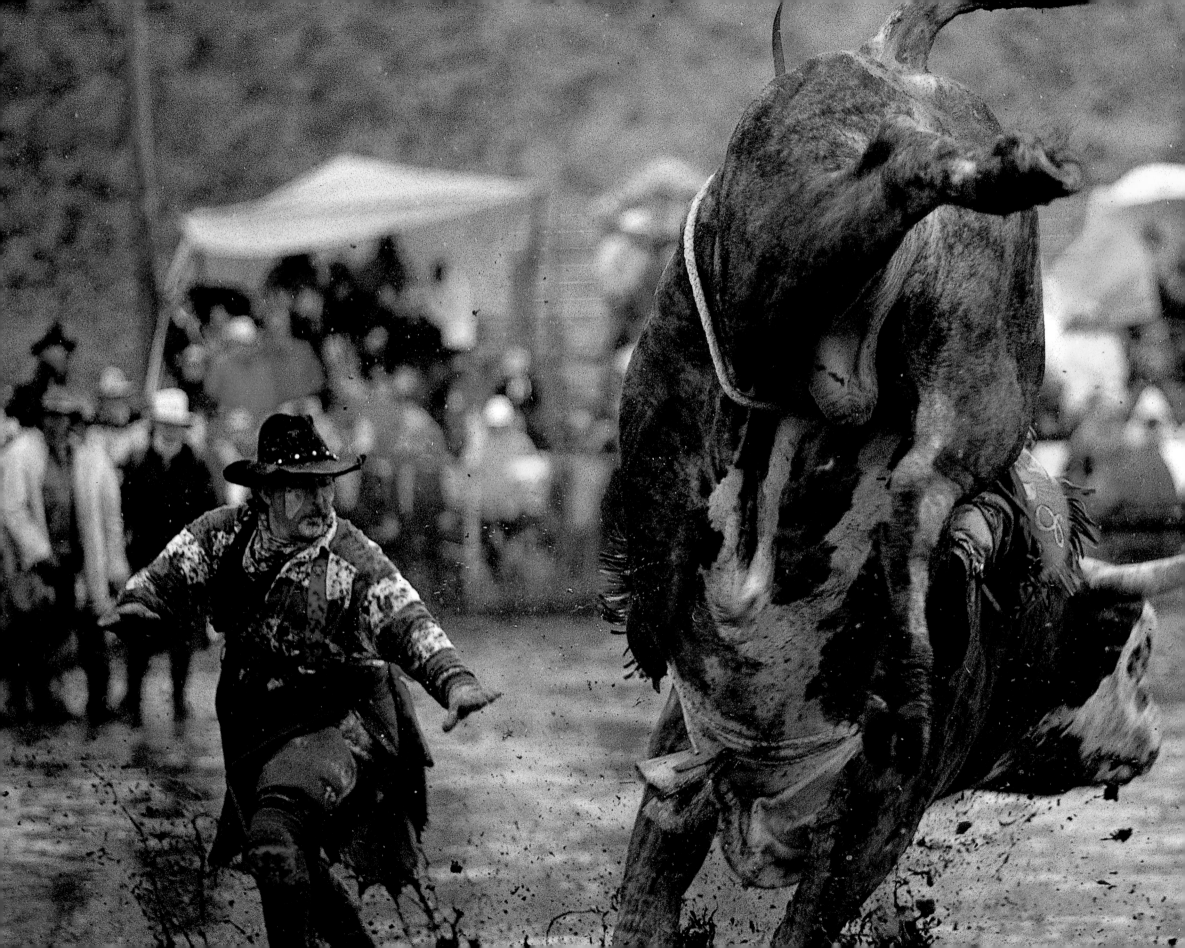

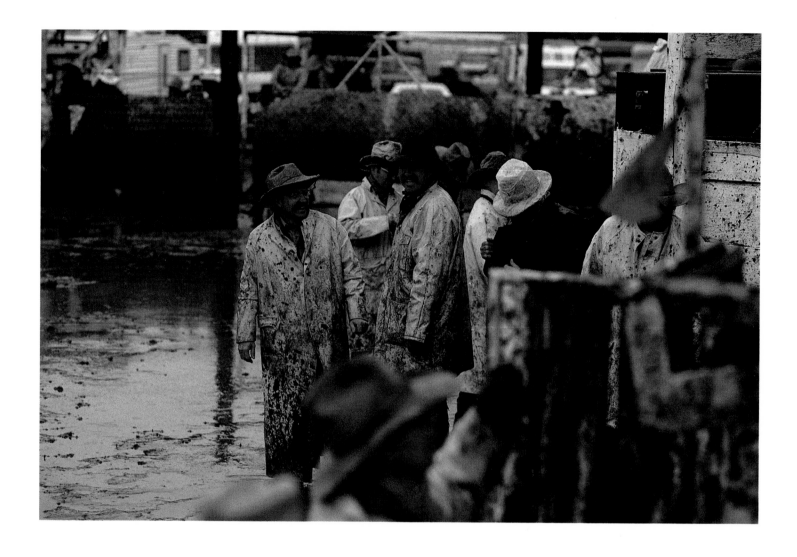

left: LOOSE FOOTING
Big Loop Rodeo · Jordan Valley

above: FORECAST: PARTLY CLOUDY, POSSIBLE SHOWERS
Big Loop Rodeo · Jordan Valley

above: SLICKERS AND MUD
Big Loop Rodeo - Jordan Valley

right: BIG LOOP RODEO
Martin Black and Randy Everett - Jordan Valley

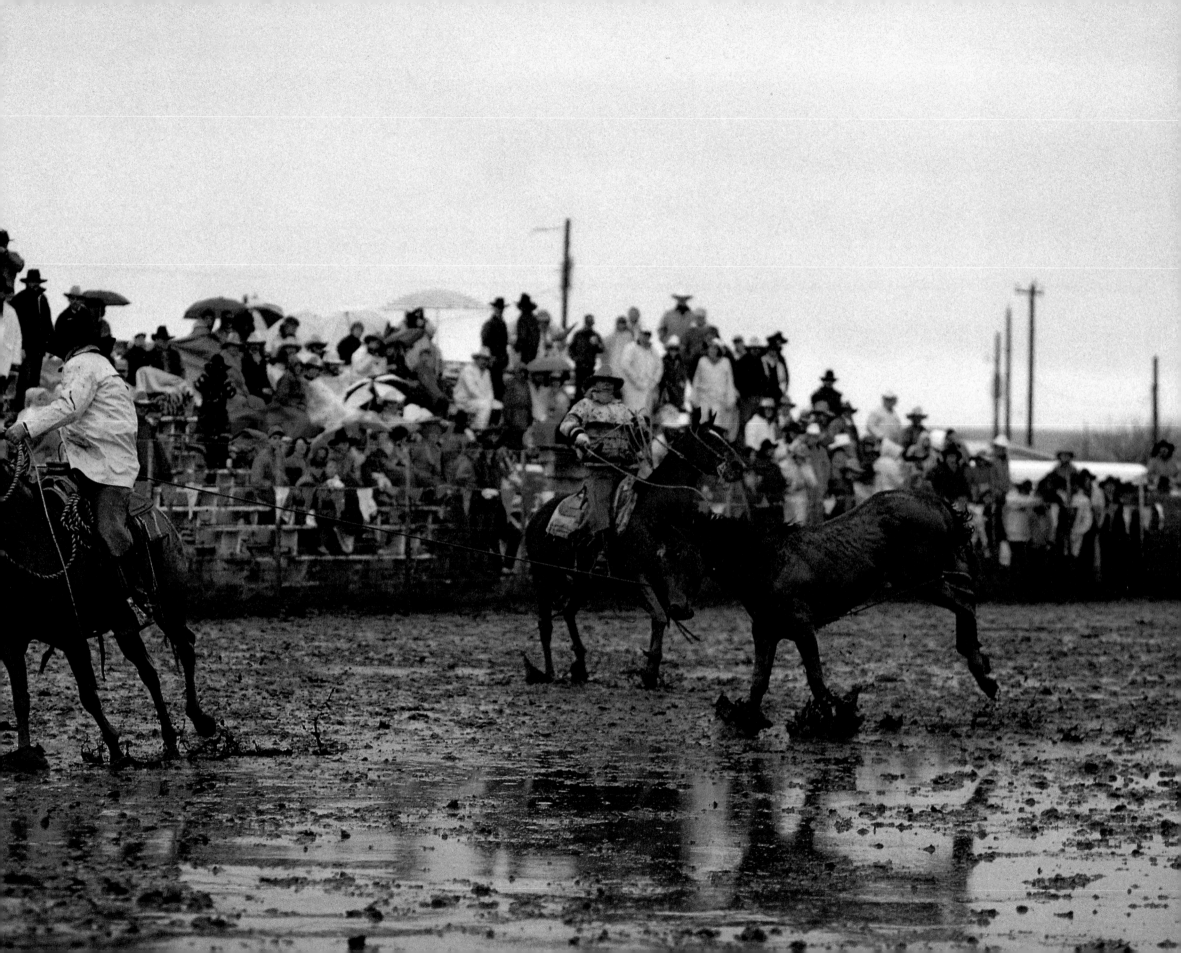

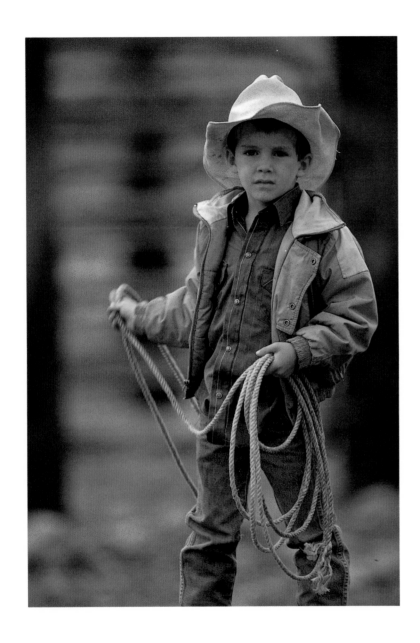

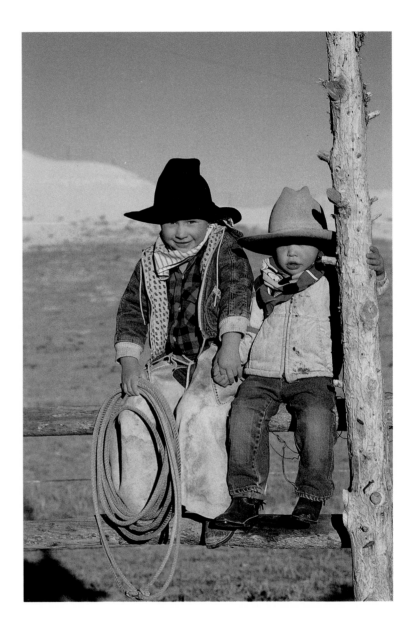

NEXT GENERATION
left: Jack Christensen right: J.R. and Jake Steiner

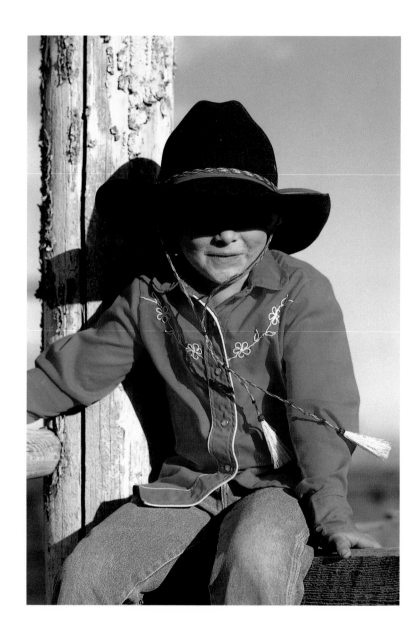
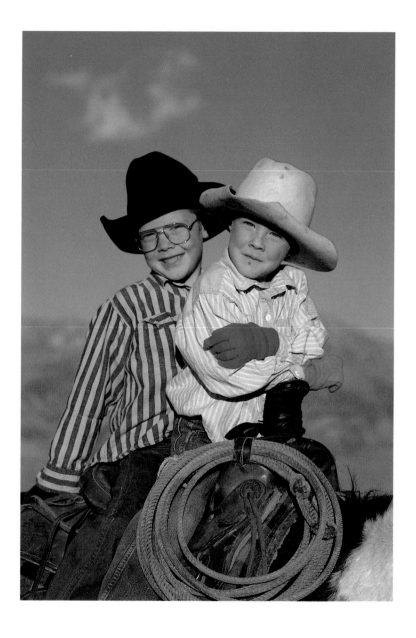

NEXT GENERATION
left: Spike Hoggan right: Garret and Geremy Nelson

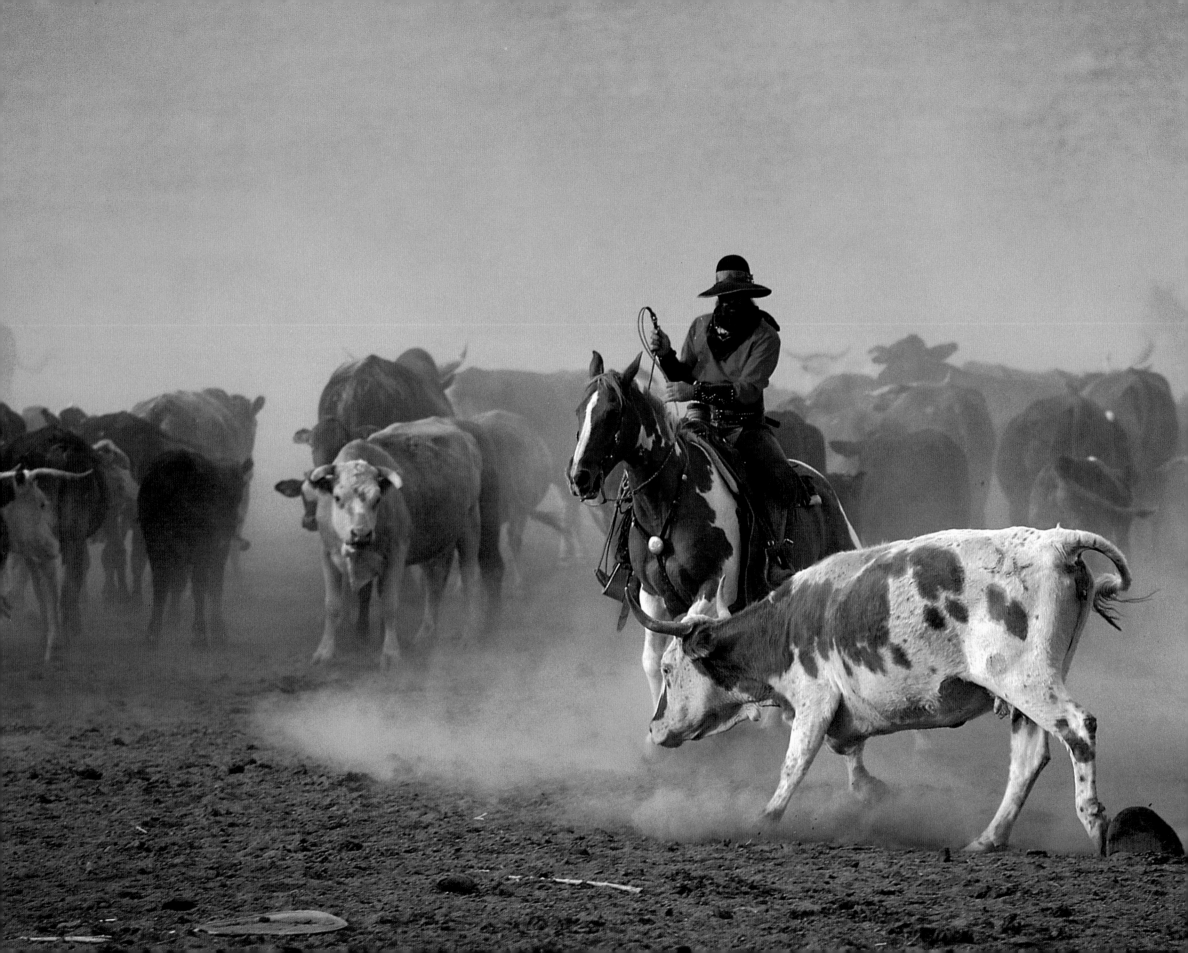

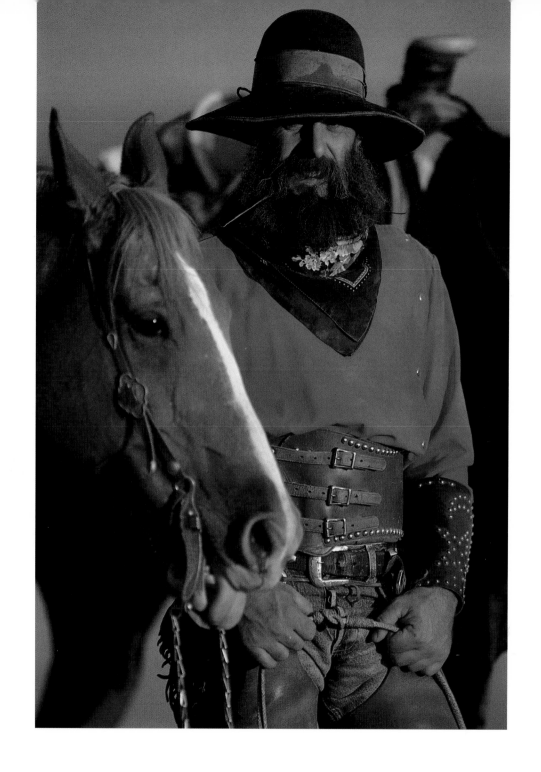

left: COWBOY CUTTER
Raymond Jayo - Payette

above: BUCKAROO
Raymond Jayo - Payette

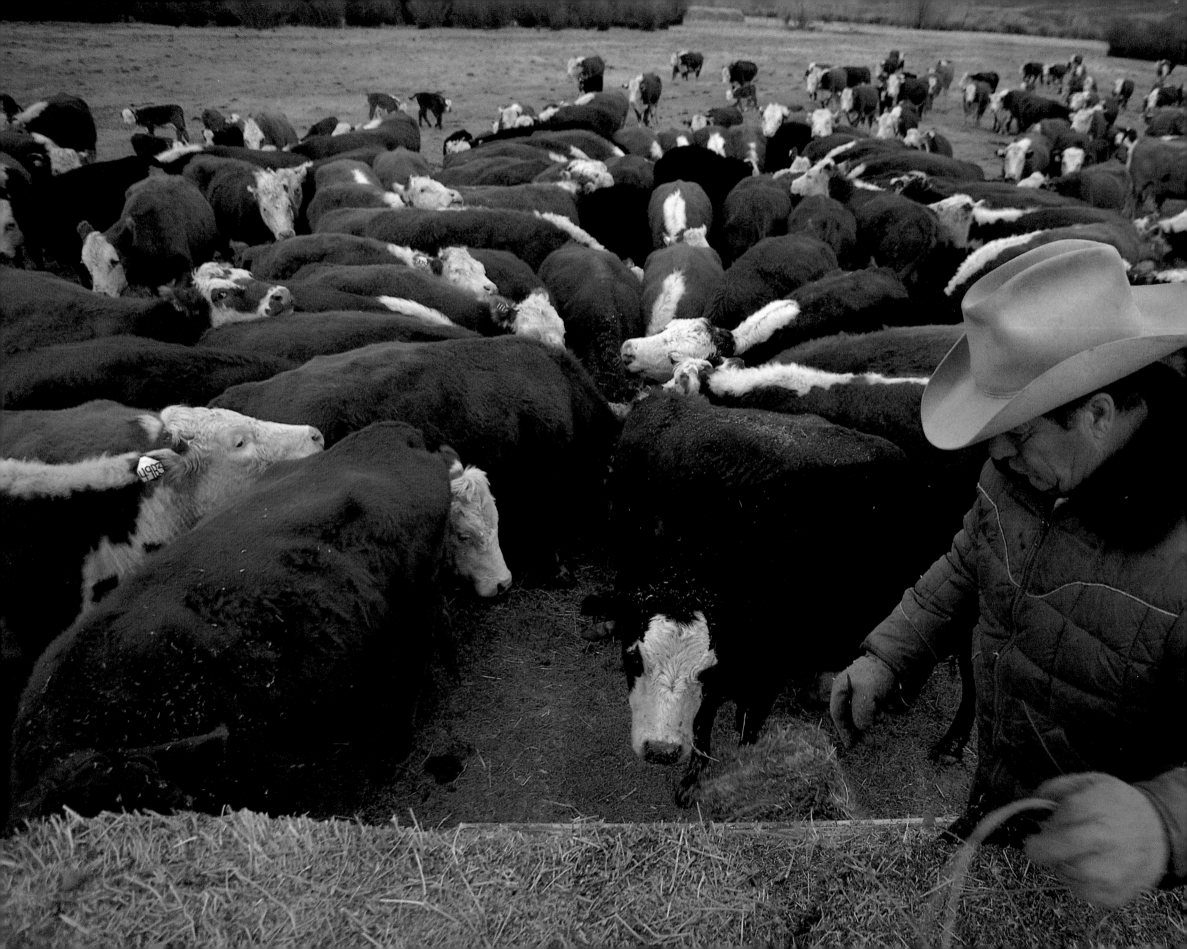

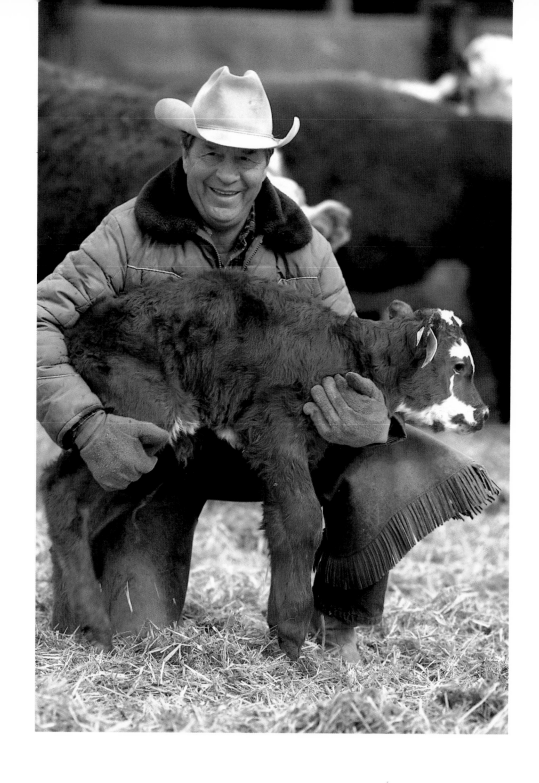

left: LUNCH LINE
Marv Goddard - Bar 13 Ranch - Mackay

above: DAY OLD
Marv Goddard

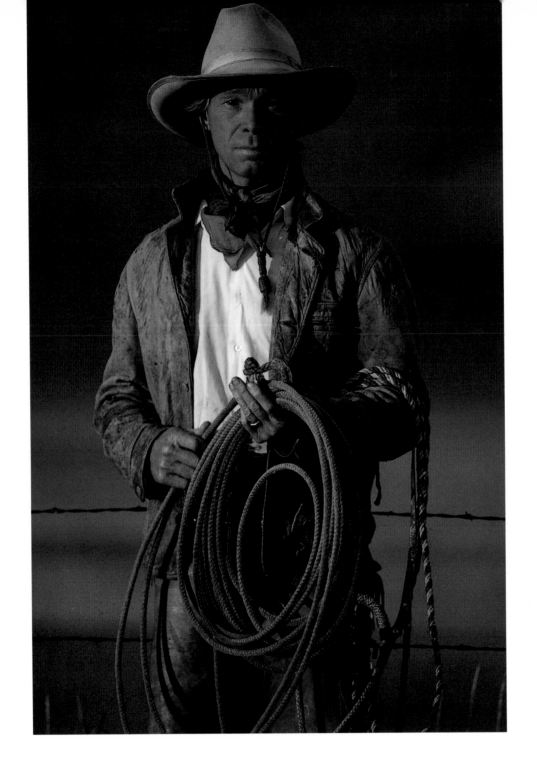

above: TACK AND WIRE
Bill Rousey - Bellevue

right: GRAIN STORAGE
Picabo

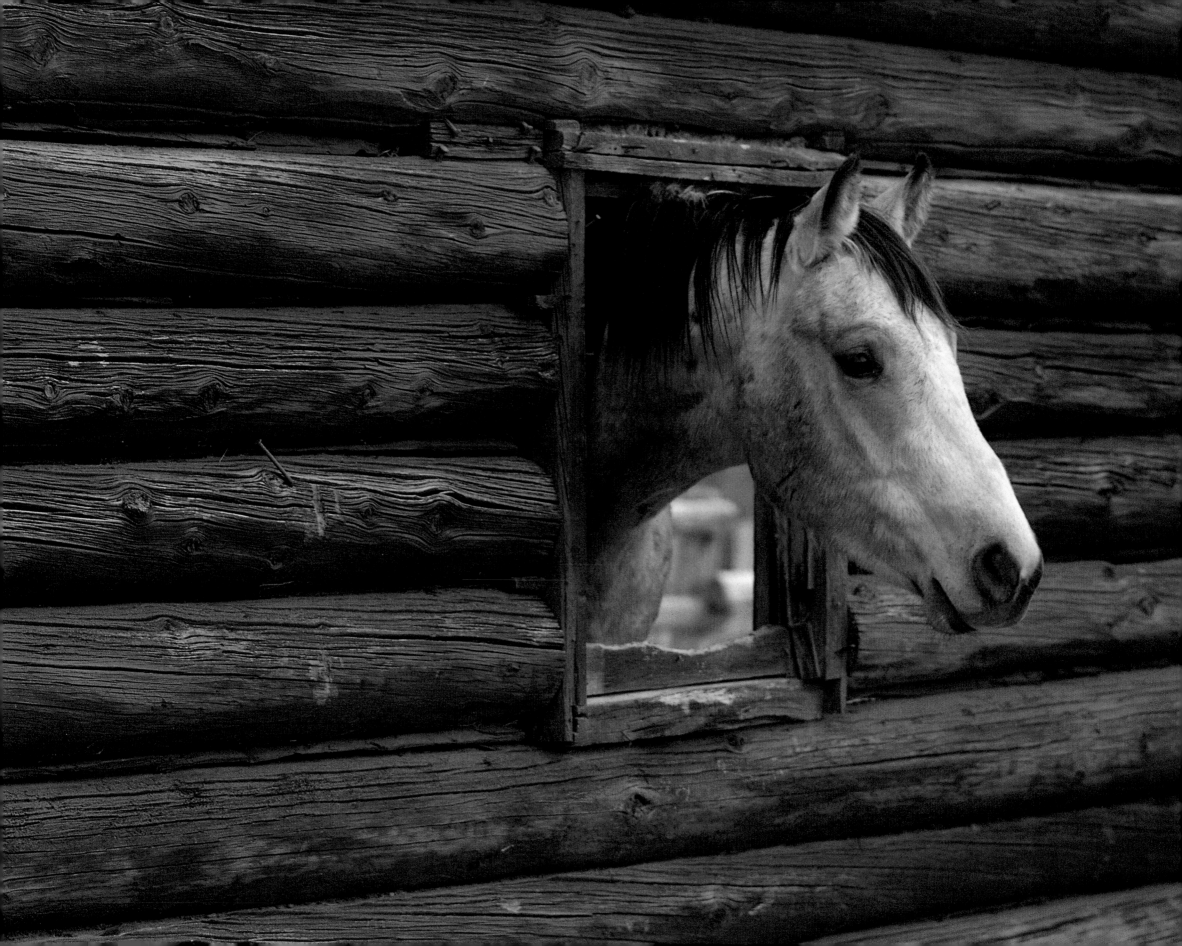

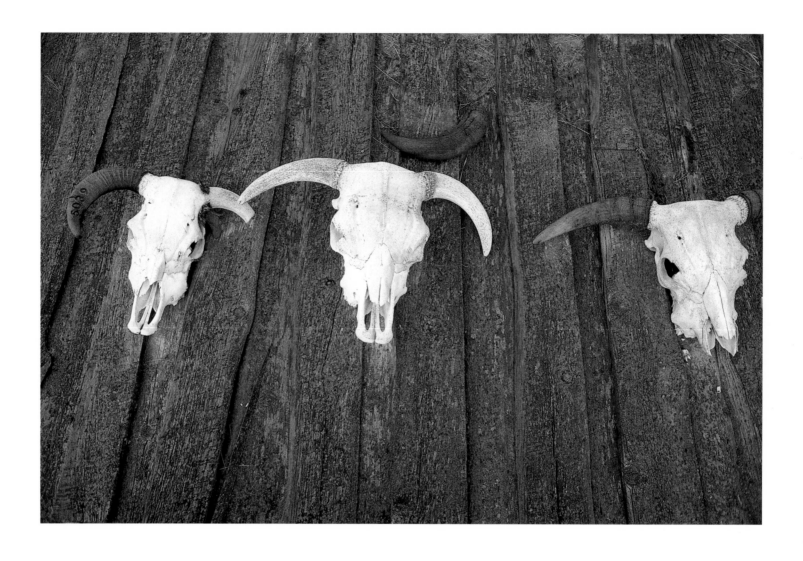

left: SUITABLE FOR FRAMING
Bucky · Bar 13 Ranch · Mackay

above: HORN BRAND NO. 5039
Bull Skulls · Bar 13 Ranch · Mackay

65

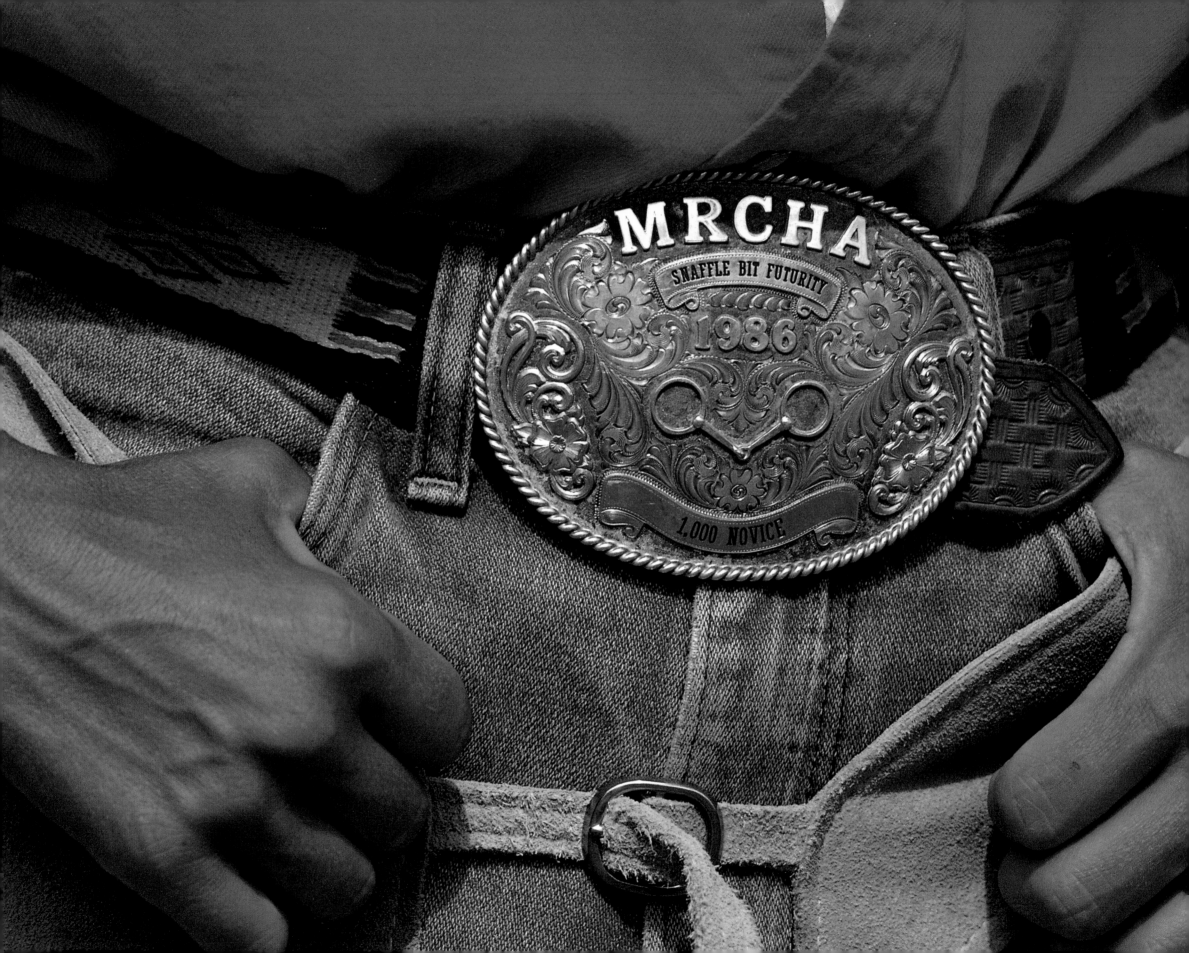

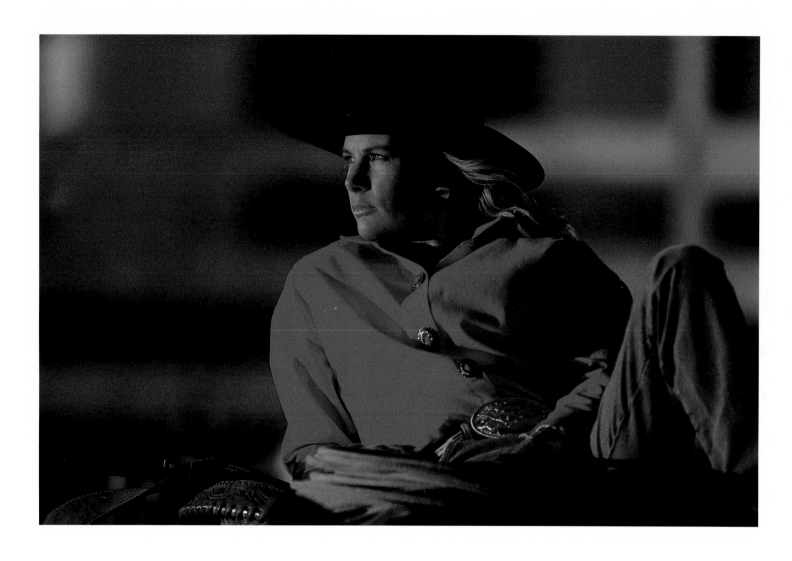

left: 1,000 NOVICE
Lynn Greenfield - Shoshone

above: RED BLOUSE
Lynn Greenfield - Preacher Creek Ranch - Shoshone

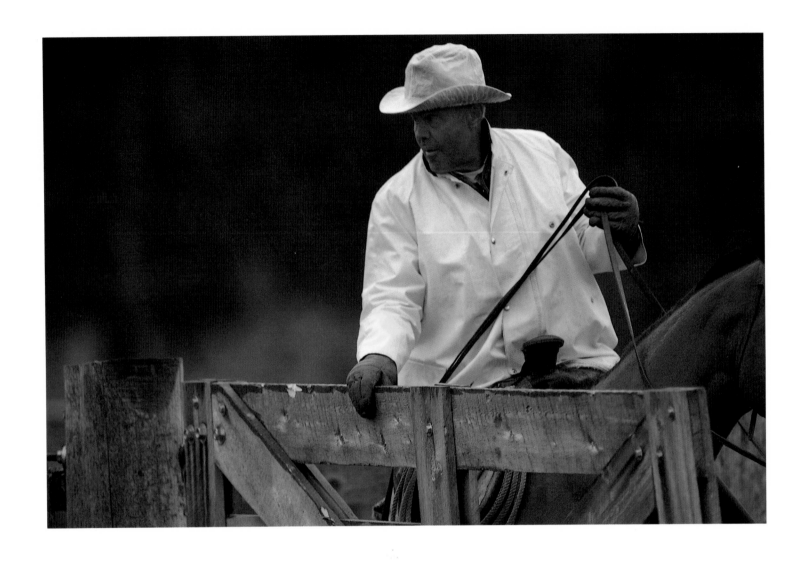

above: ONE MORE COUNT
Harold Drussel - Busterback Ranch - Shoshone

right: I'LL LEAD, THANK YOU
Oufitter String - Chilly Slough

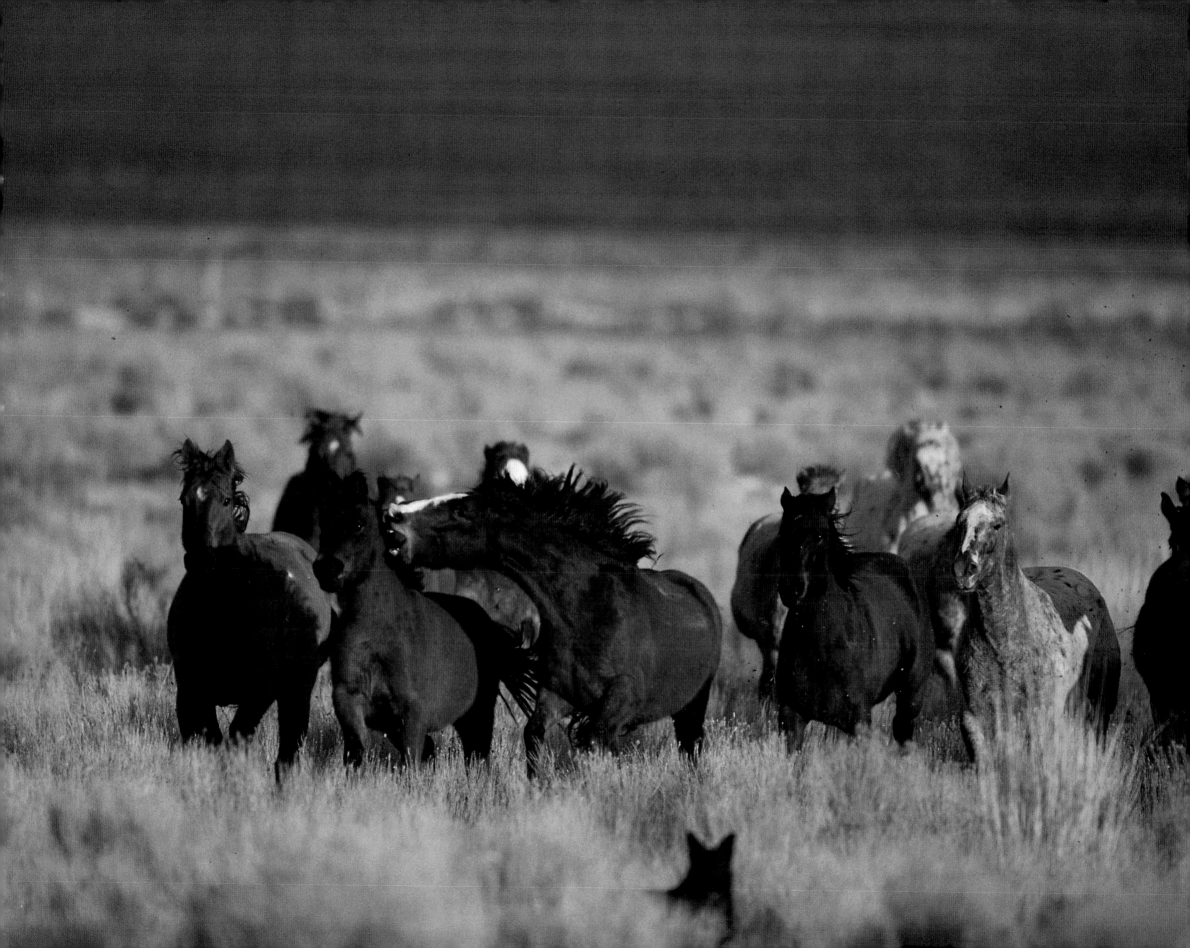

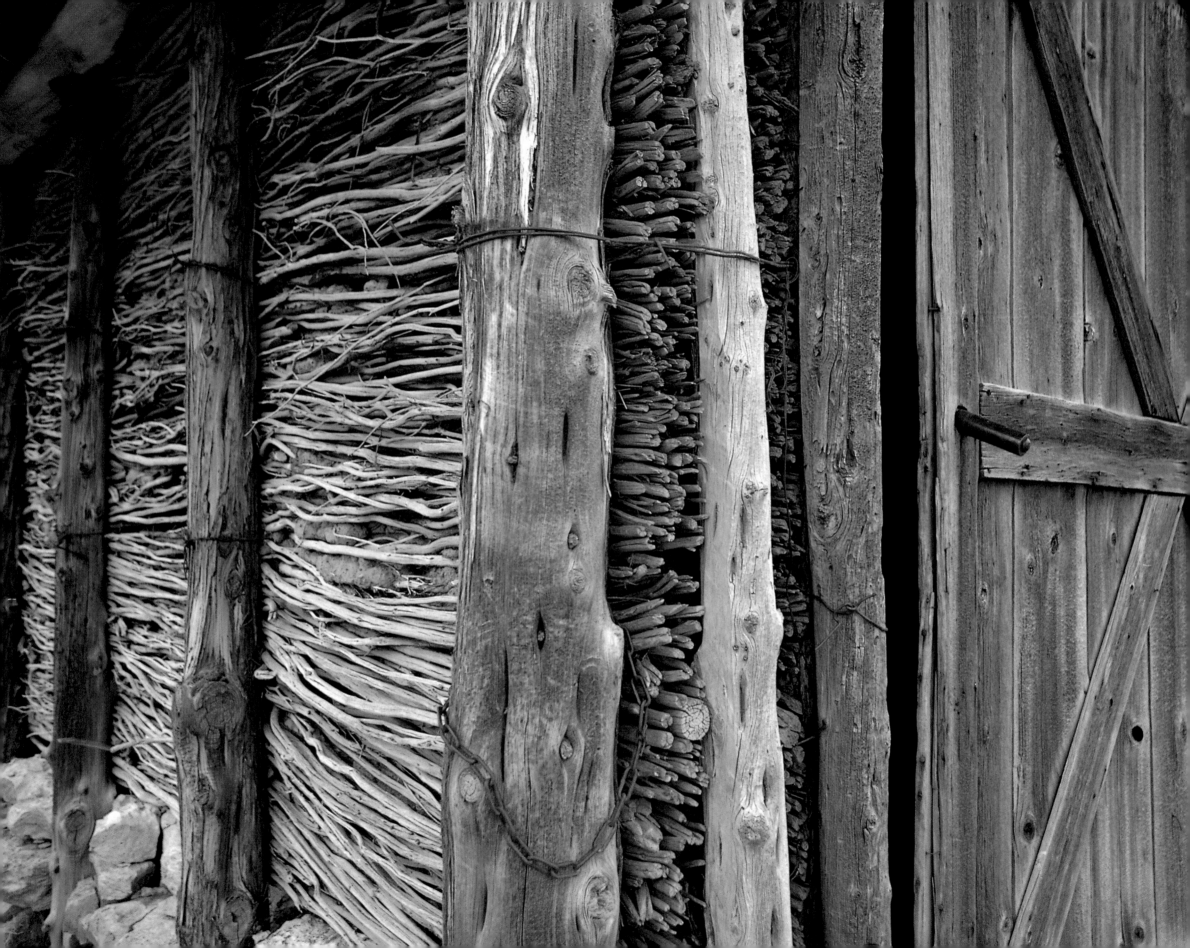

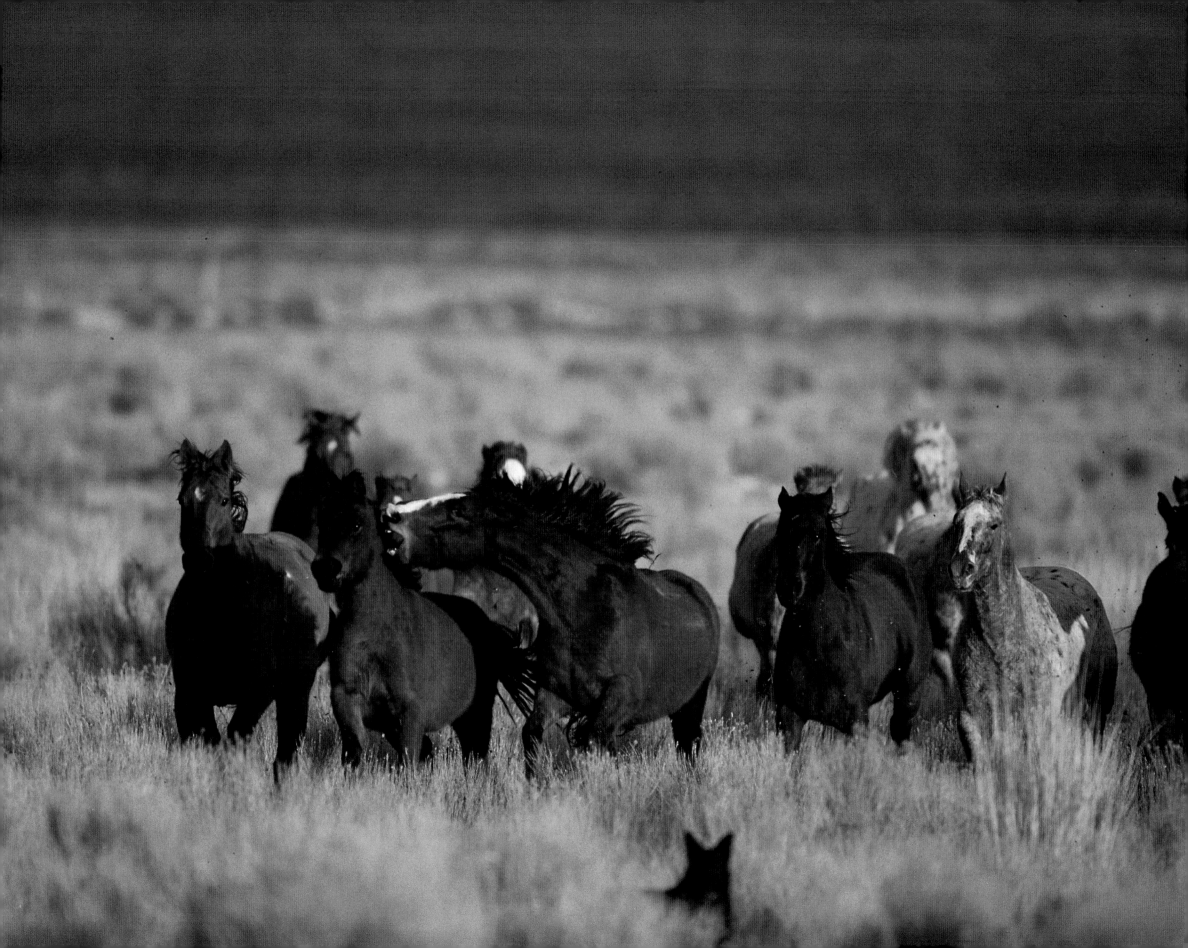

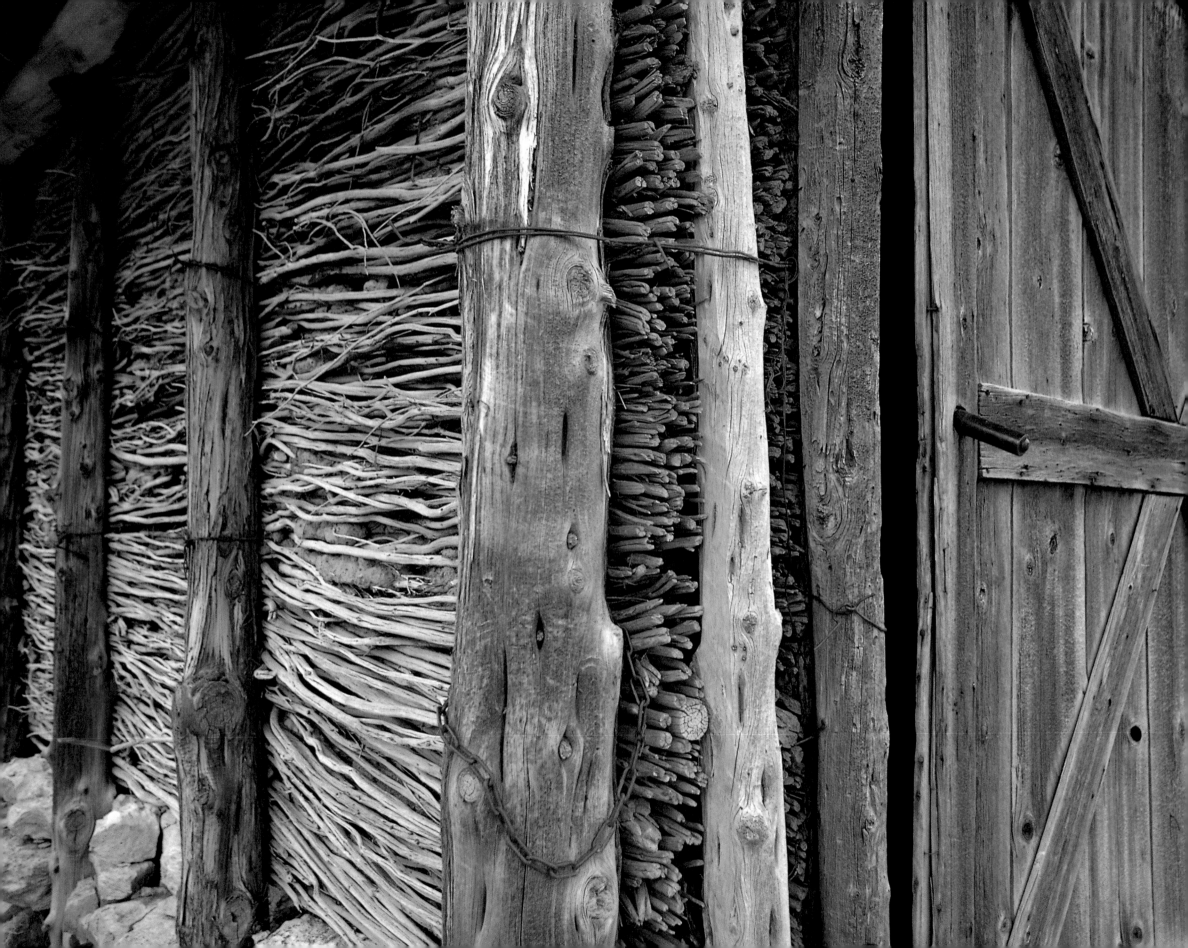

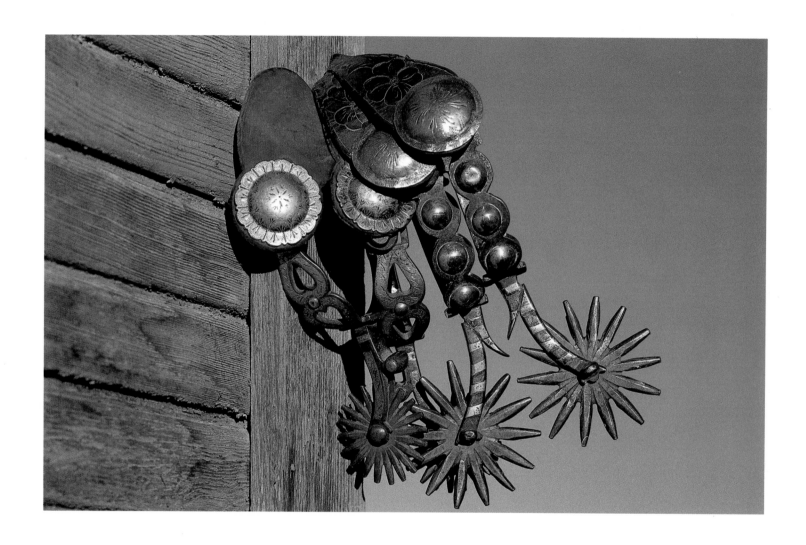

left: WILLOW BARN
Brace Ranch - Bruneau Desert

above: HANDMADE SPURS
By Frank Jayo - Oreana

71

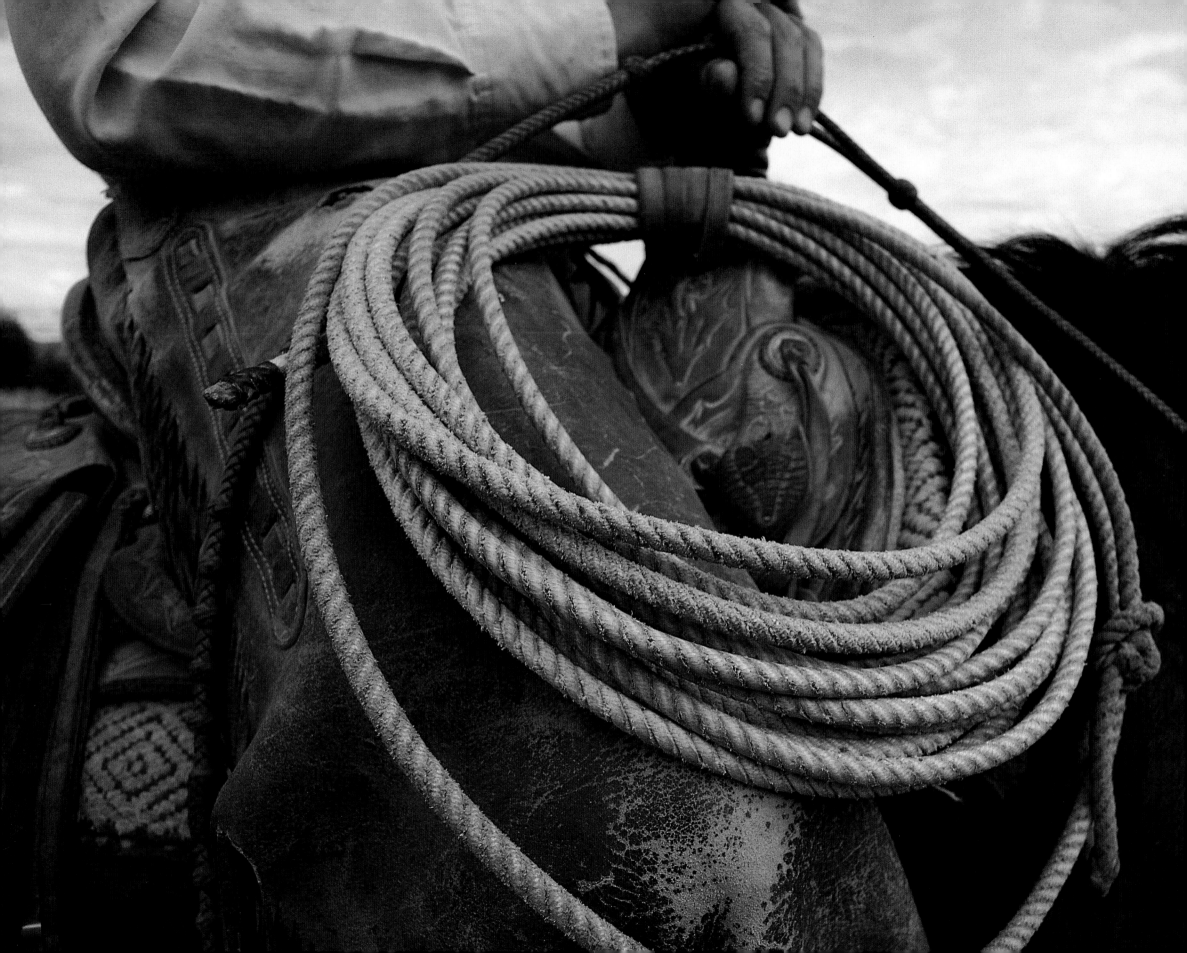

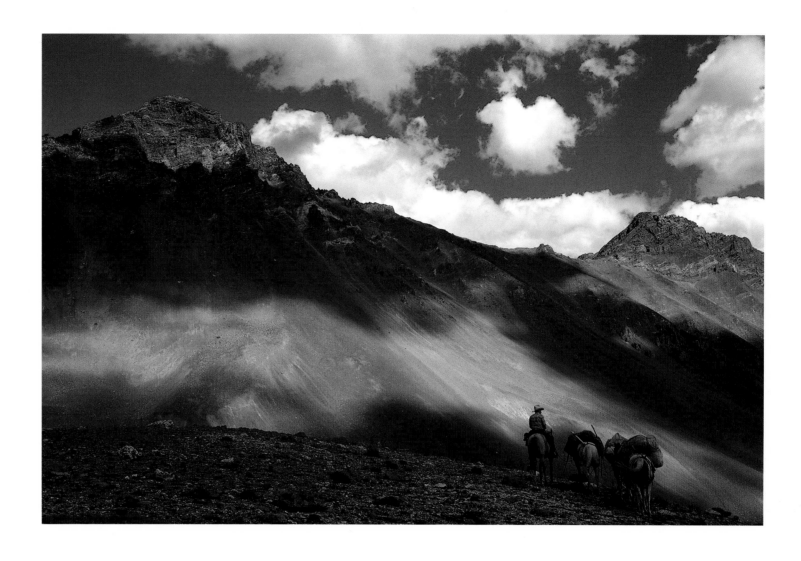

left: ENOUGH LOOP
Winecup Ranch - Idaho/Nevada Border

above: GOIN' THROUGH THE PASS
Darrell Leavitt - Leatherman Peak

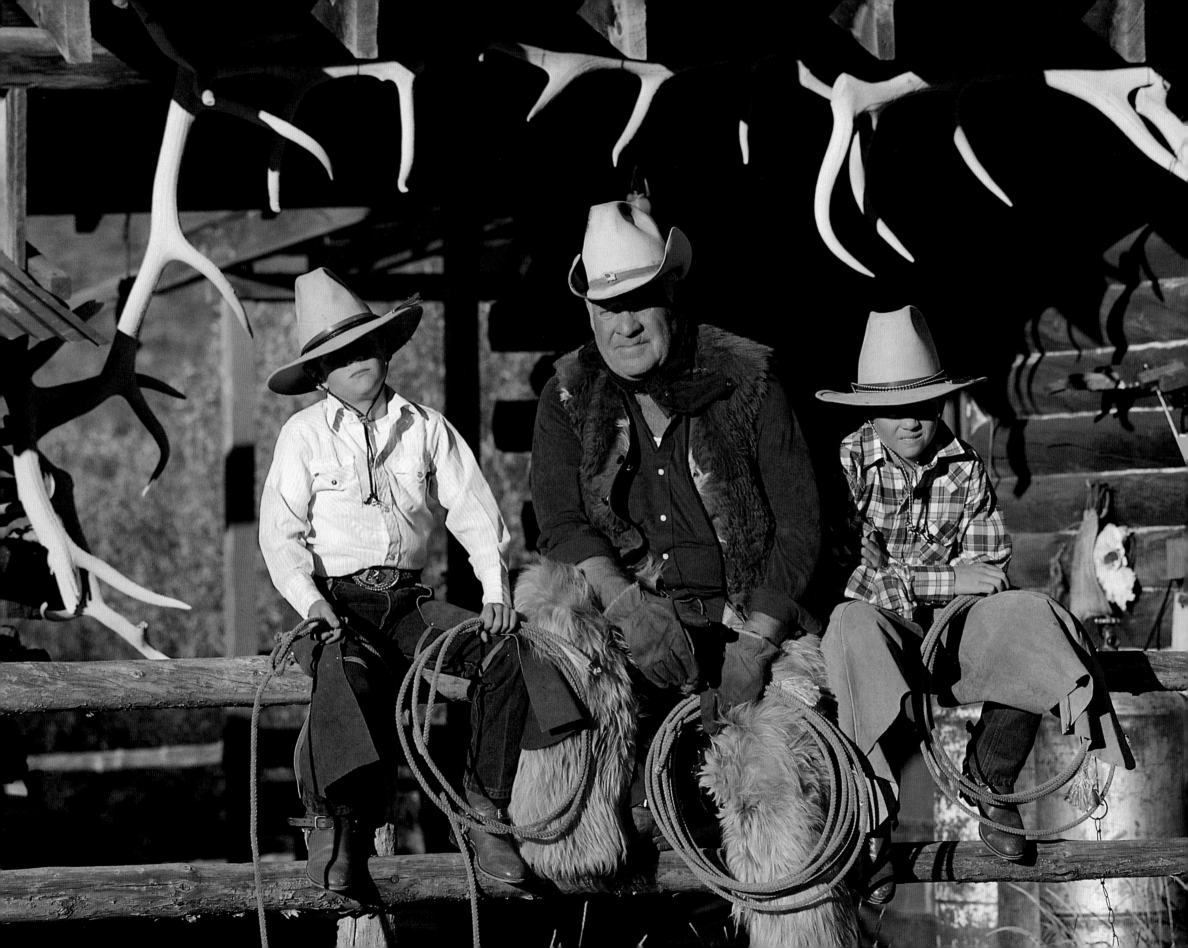

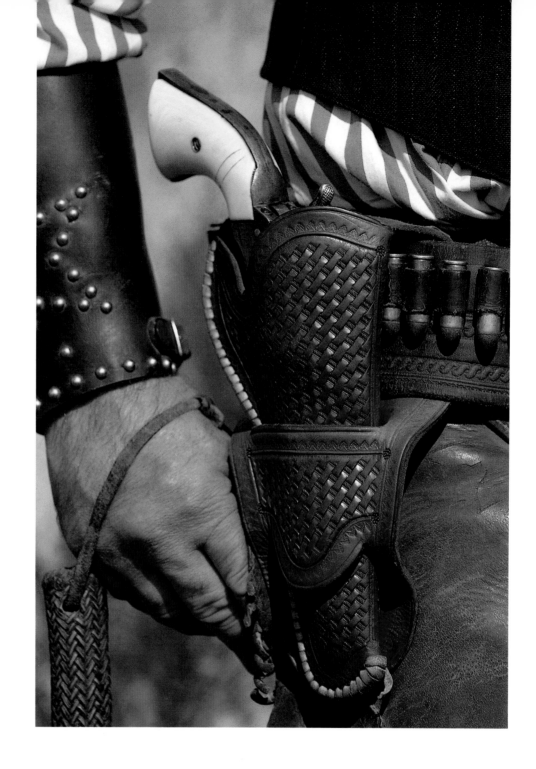

left: CHURNDASHER RANCH BOYS
Vic, Jake and Caleb Johnson - Copper Basin

above: SAME CALIBER AS BILLY THE KID
.42, Cuff and Quirt - Payette

next page: COMIN' IN FOR A DRINK
K-K Picabo Ranch - Spring Range in the Picabo Hills

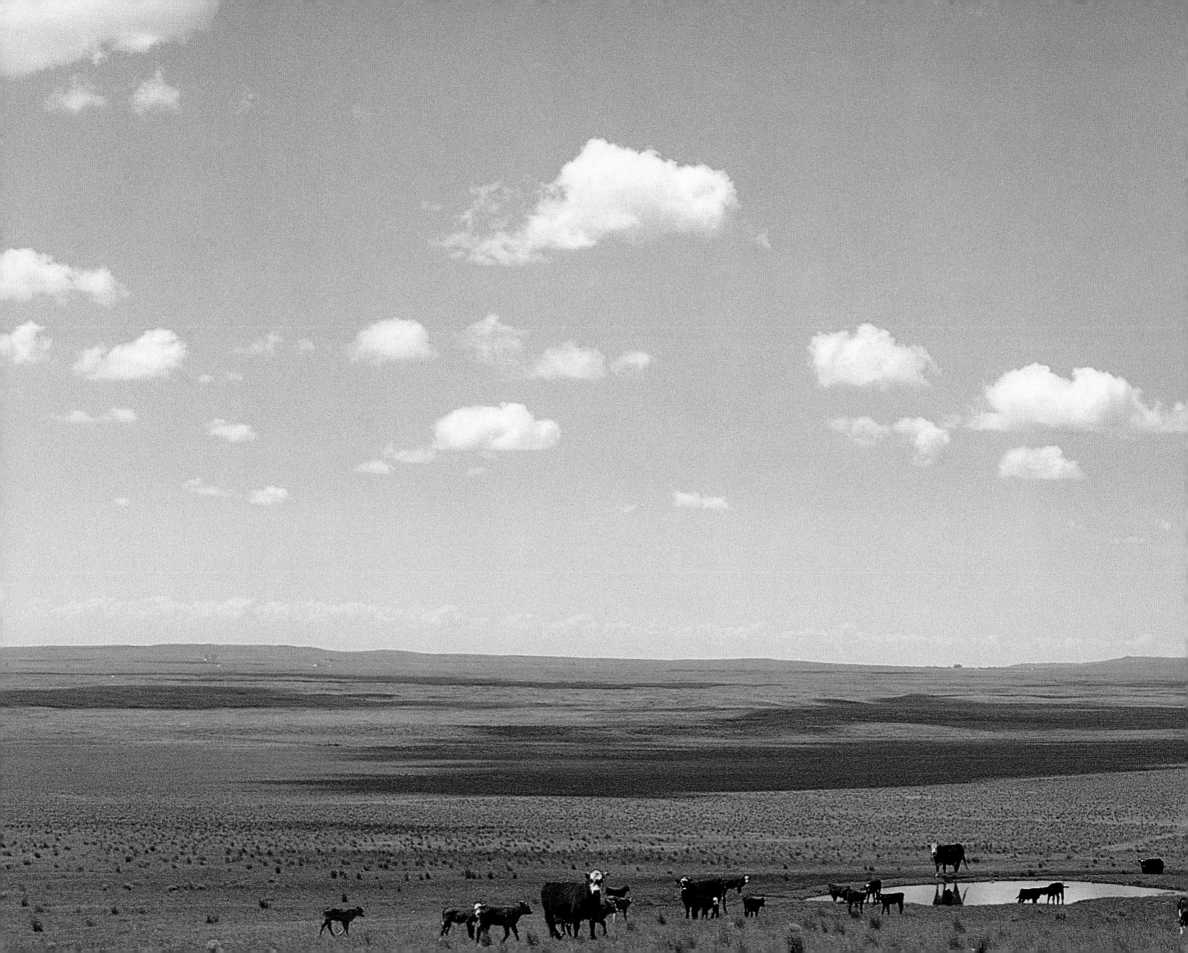

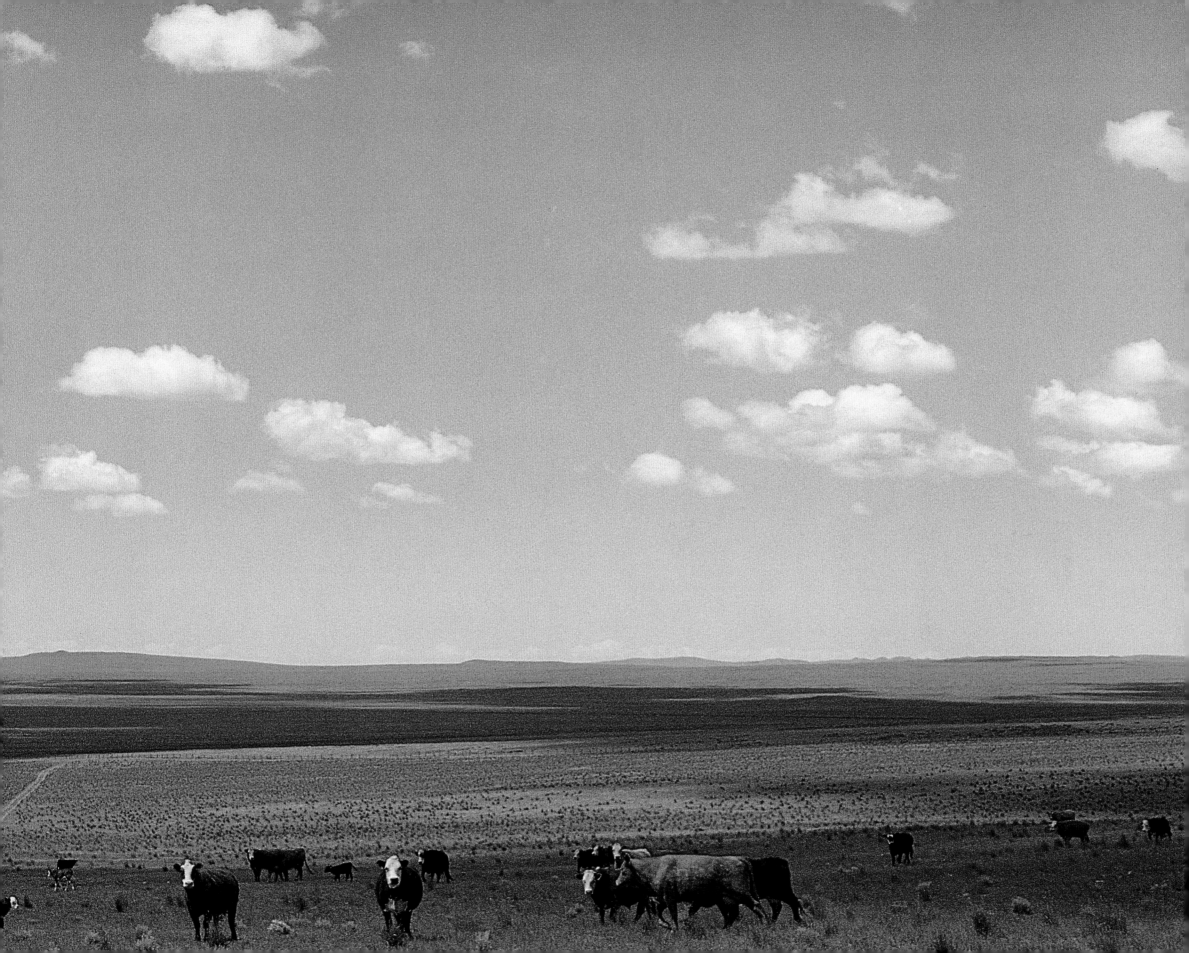

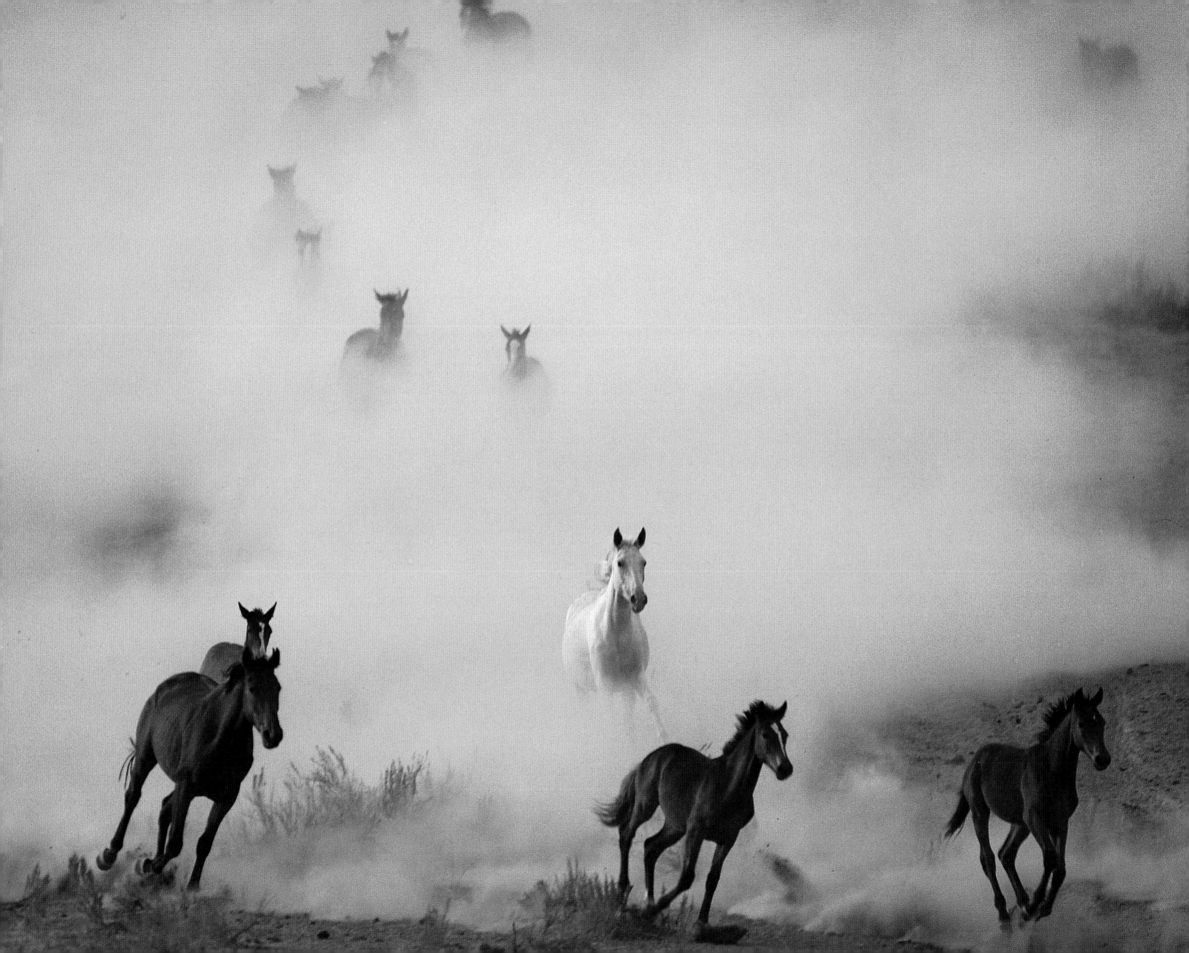

S U M M E R

The long hot days of summer provide new directions for the cowboy's efforts. Long trail drives to summer pasture are training grounds for newly broke colts and young excited pups wanting to work the trailing cattle similar to the older dogs. Loop after loop is thrown at the heels of the slow stragglers in preparation for upcoming rodeos and neighborhood ropings.

Summer is a time when cowboys spend many hours working with their horses. Long evenings give the cowboy time to fine-tune the green broke colts into good reining horses. Cattle are moved higher into forested meadows. The cool Alpine air is a refreshing change from the hot, dusty afternoons in the valley below. Cowboys can nearly always find some time, when moving cattle to the high country, to fish and camp at the high mountain lakes and streams.

Hay needs to be cut and put in the stack and stored so it can be fed to cattle during the upcoming winter. A cowboy hates turning his horse out to pasture for a few weeks, and instead of climbing into a saddle, climbing onto the seat of a tractor, hay baler or swather. Nothing can be more degrading to a "true" cowboy. His only consolation is looking forward to a rodeo.

Summer is showtime! Rodeos, ropings, cuttings, reinings—you name it—he'll do it. Cowboy sports have evolved around the elements of cowboy life—namely horses, cattle and ropes. Women and girls compete as hard as men and boys. Although the events are different, the competitive spirit and instilled will to win is in no way diminished between barrel racing or bull riding. Cowboys like to compete, to win, to be champion! They strive to gain the respect of their peers. Respect to a cowboy is the ultimate prize and takes precedence over buckles, trophies and checks. Cowboys learn the value of respect from the way they live. The unforgiving ways of Mother Nature are a good teacher. Cowboys respect women, family, friends and each other. They respect the value of well bred horses, cattle and dogs and the value received is a direct result of the degree of respect given. It's a value that society is gradually letting slip away and thus we look to these cowboy virtues as a way of life to envy, to look up to, to hope and dream for.

The images of cowboys in summer are dramatic. It's seen in the excitement of competition—the dramas which horse and rider so poignantly portray. We see it in clouds of dust kicked up by thundering hooves, twirling lassos and grimacing expressions that almost will the loop to settle. We see it in the satisfied smile on a face caked with dust, under a sweat-soaked hat. It's a very unusual way of having fun, but these are cowboys and this is summer!

RUNNIN' TO WATER
Merlin Rupp Ranch - Payette

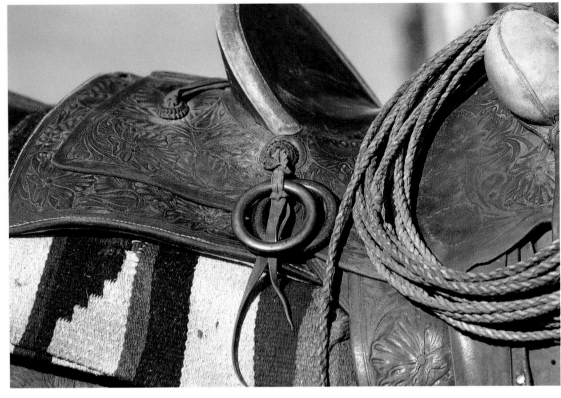

RUNNIN' IRONS

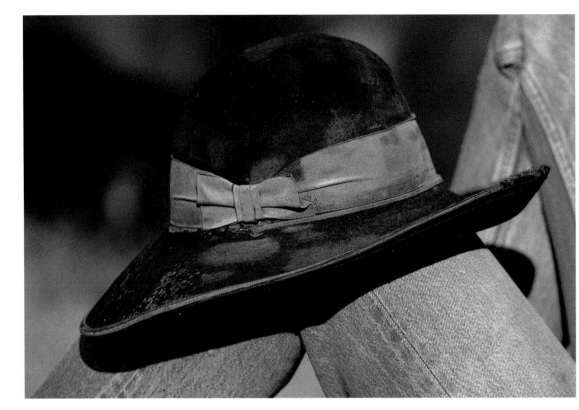

STETSON AT REST

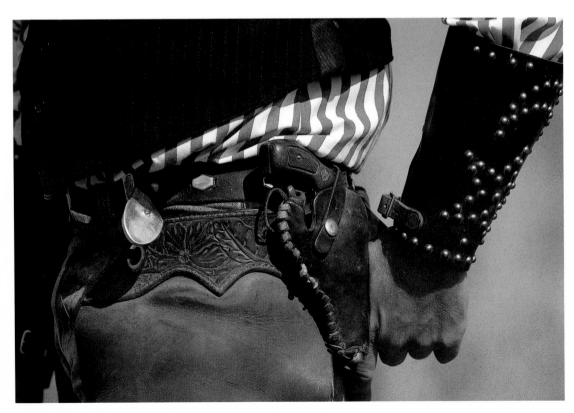

.38 CALIBER

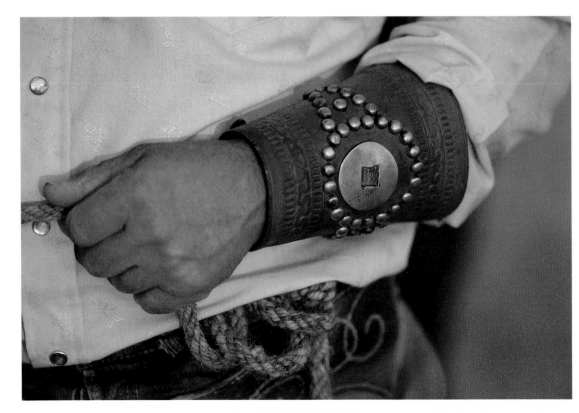

CUFF AND CONCHO

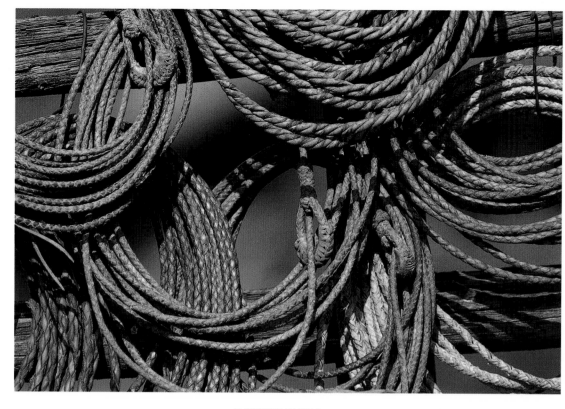

RAWHIDE RIATAS

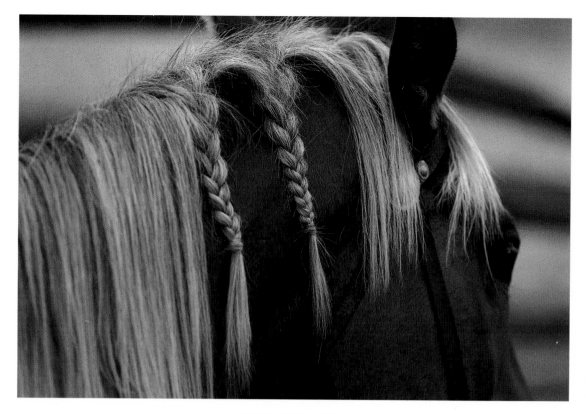

BUCKAROO BRAID

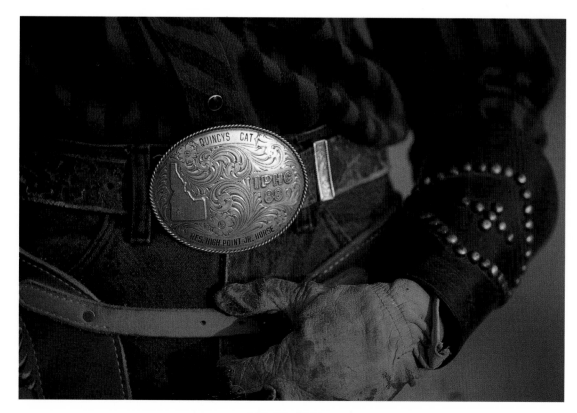

CAT AND CUFF

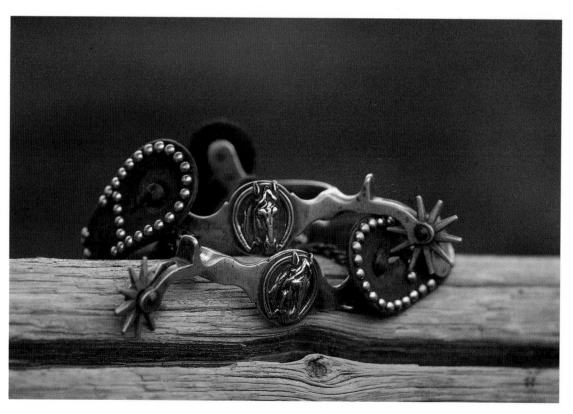

NORTH AND JUDD SPURS

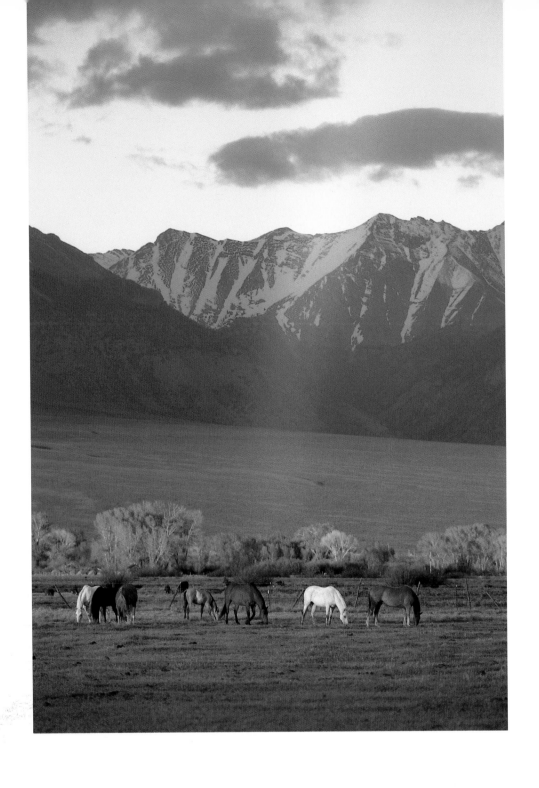

above: POT O'GOLD
Bar Horseshoe Ranch - Barton Flat

right: TURNIN' OUT
Jim Barton and J2 Brown - Camas Prairie

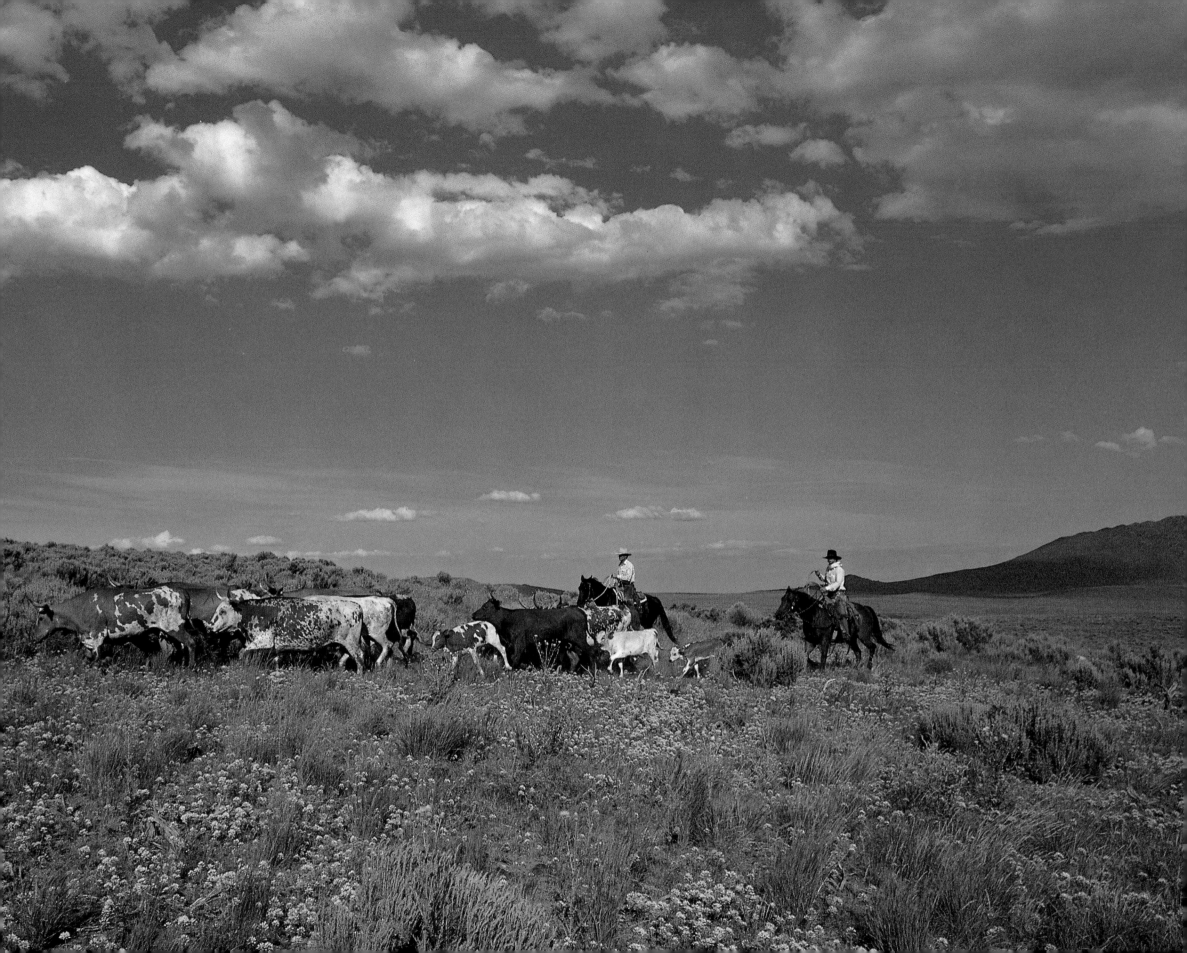

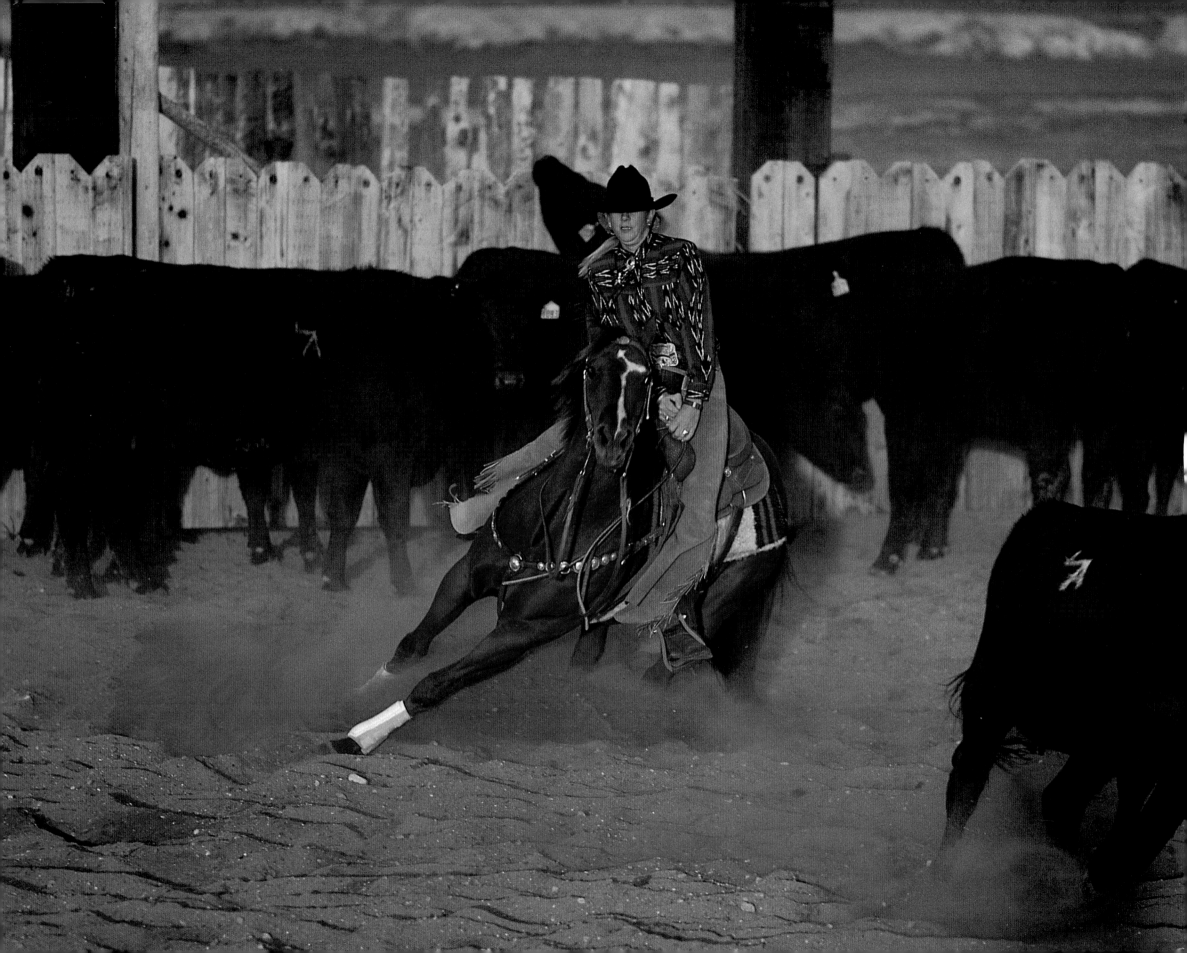

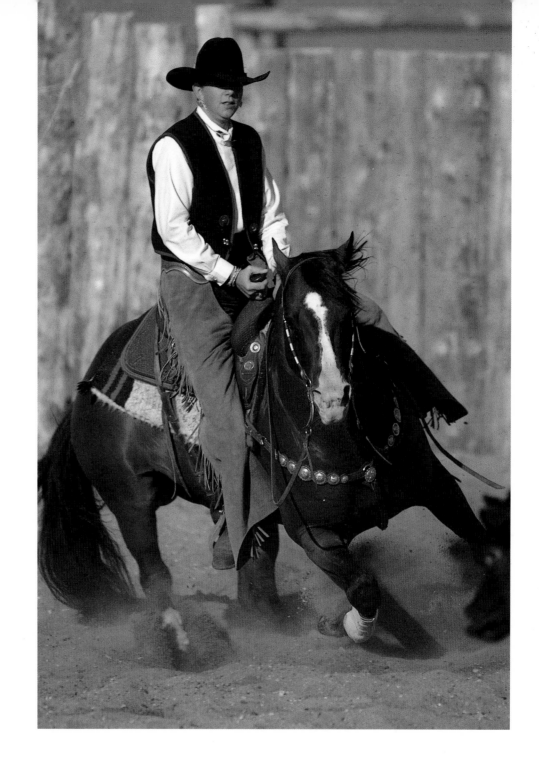

left: ANNE REYNOLDS
Cutting on Idaho Lynchin

above: ANNE REYNOLDS
Cutting on Sensitivio

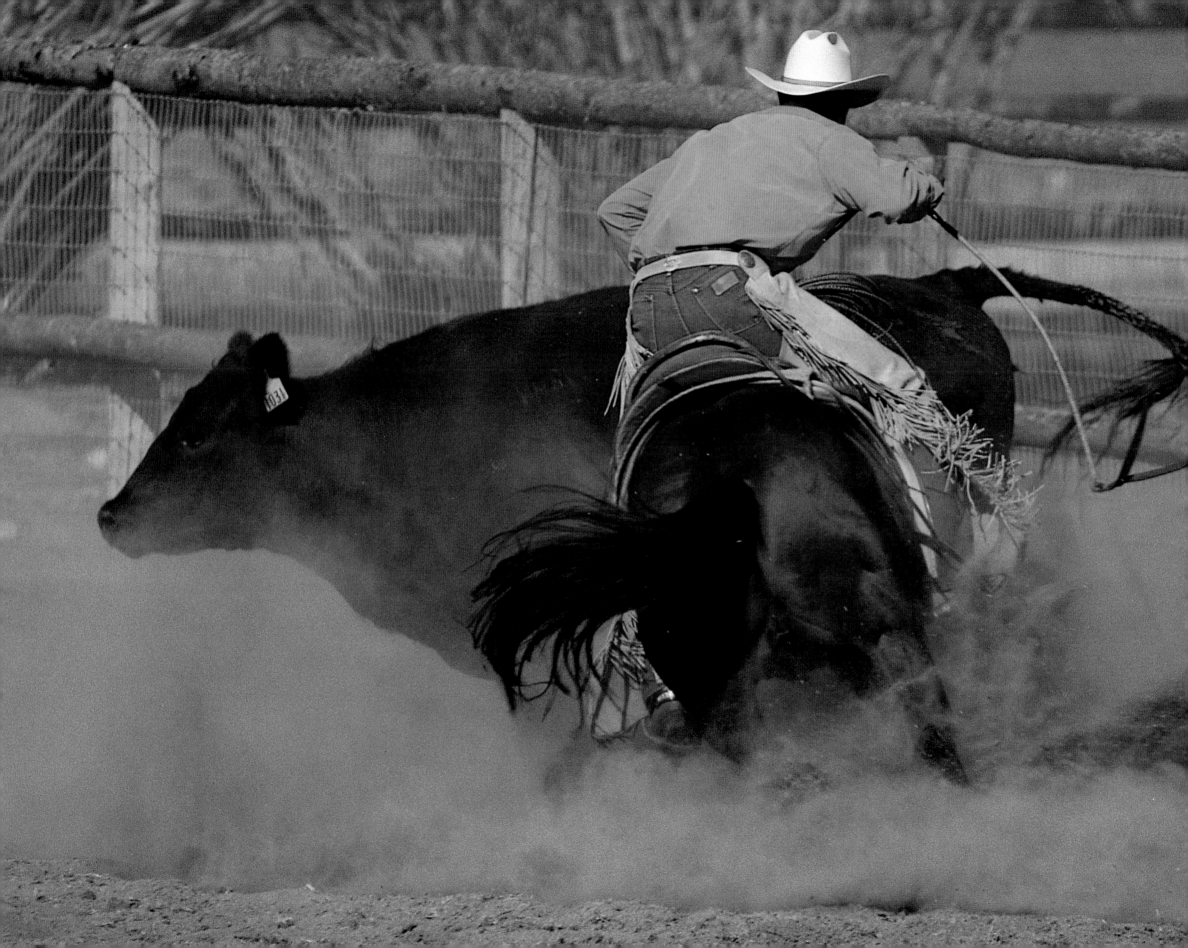

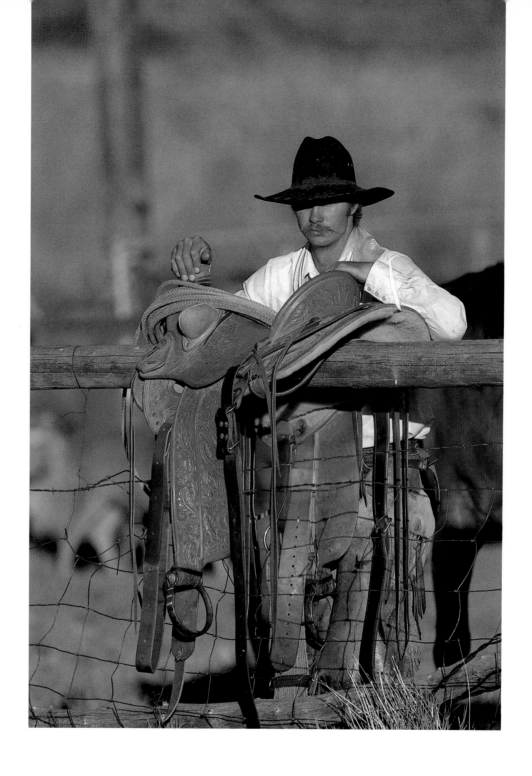

left: TURN THAT COW
Larry Christensen Riding Little Peppy Pistol - McCammon

above: SHE'S BRAND NEW
A Nancy Hoggan Saddle - J2 Brown - Picabo

SPLICING NEEDED
Old Fence - Moore

HAY BALES
Driggs

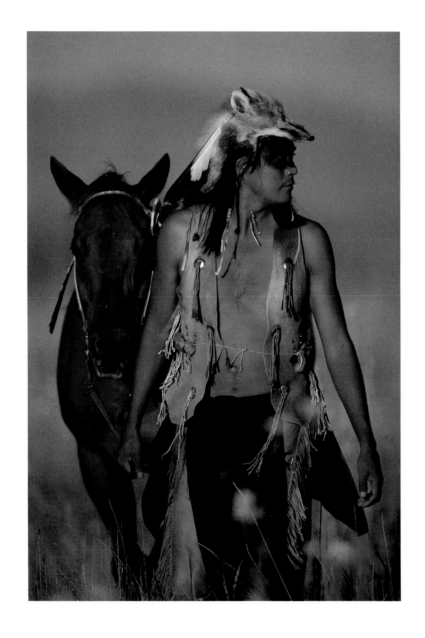

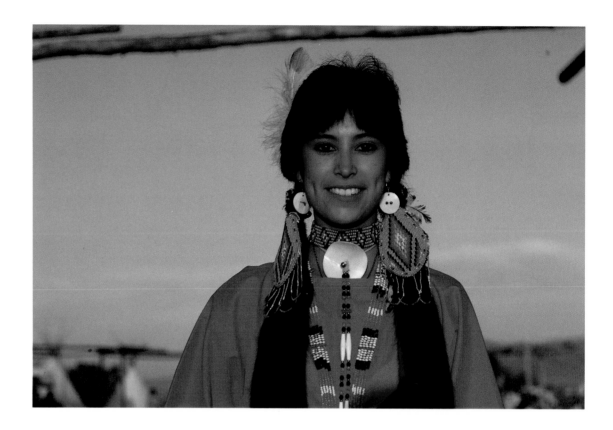

EDDY McCRAY MARGARITE PEREZ

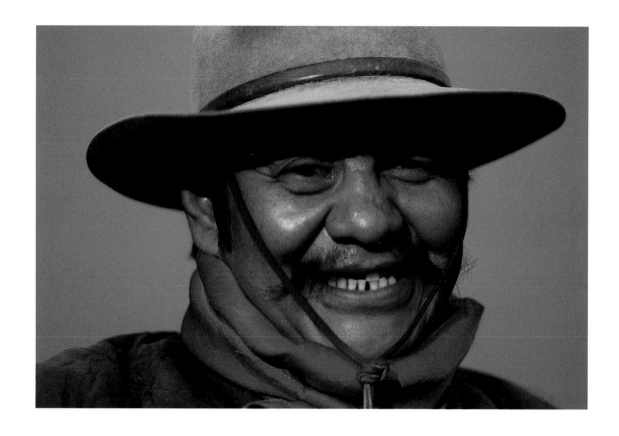

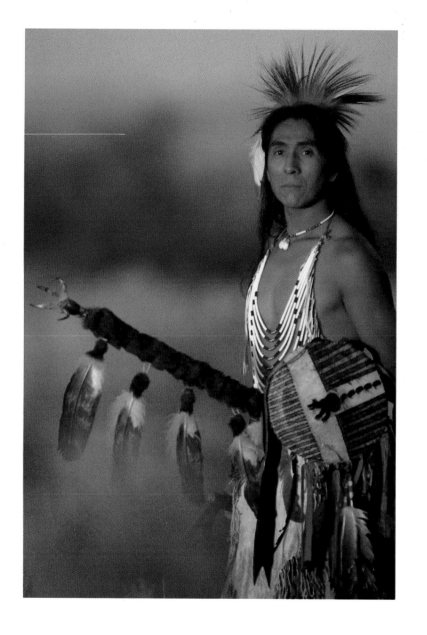

ERICKSON HOOPER

LEO TETON

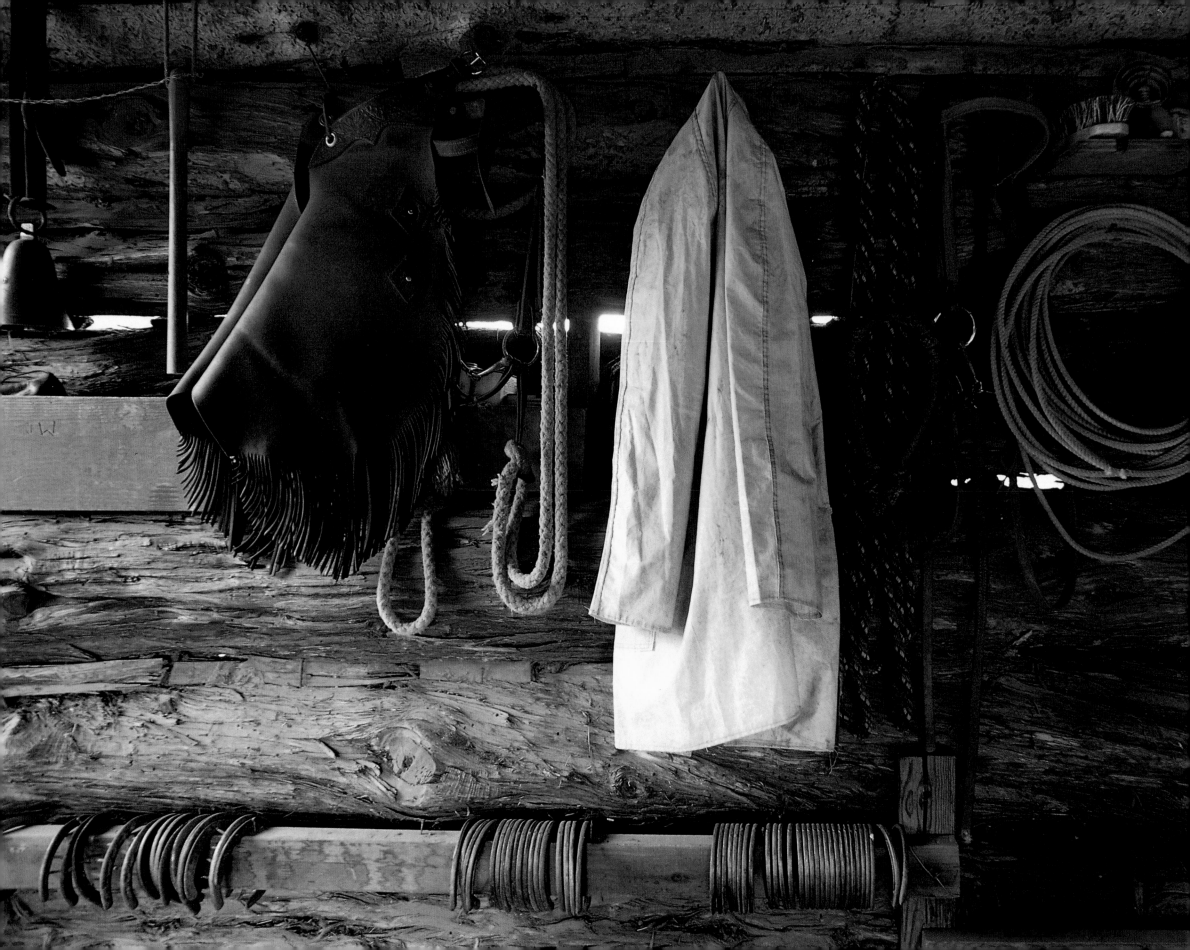

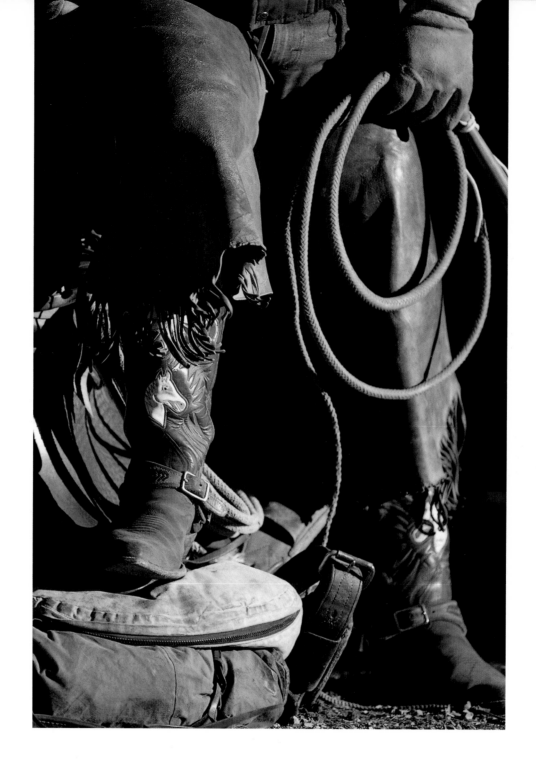

left: RAYMOND'S TACK ROOM
The Avery Ranch - Bruneau

above: JAY'S BOOTS
Jay Hoggan - Medicine Lodge

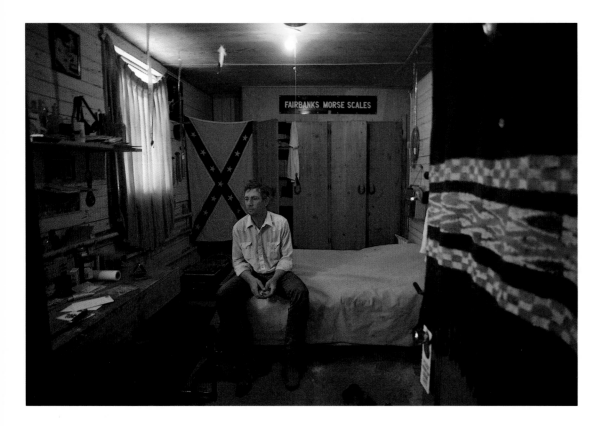

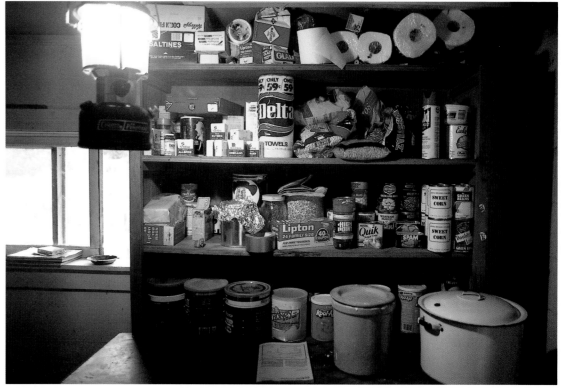

COWBOY CONDO
Bunkhouse · Winecup Ranch · Idaho/Nevada Border

COWBOY CUPBOARD
Bunkhouse · Bonnie Ranch · Bruneau Desert

COWBOY LIBRARY
Bar 13 Ranch · Mackay

COWBOY CANDY
Bar Horseshoe Ranch · Barton Flat

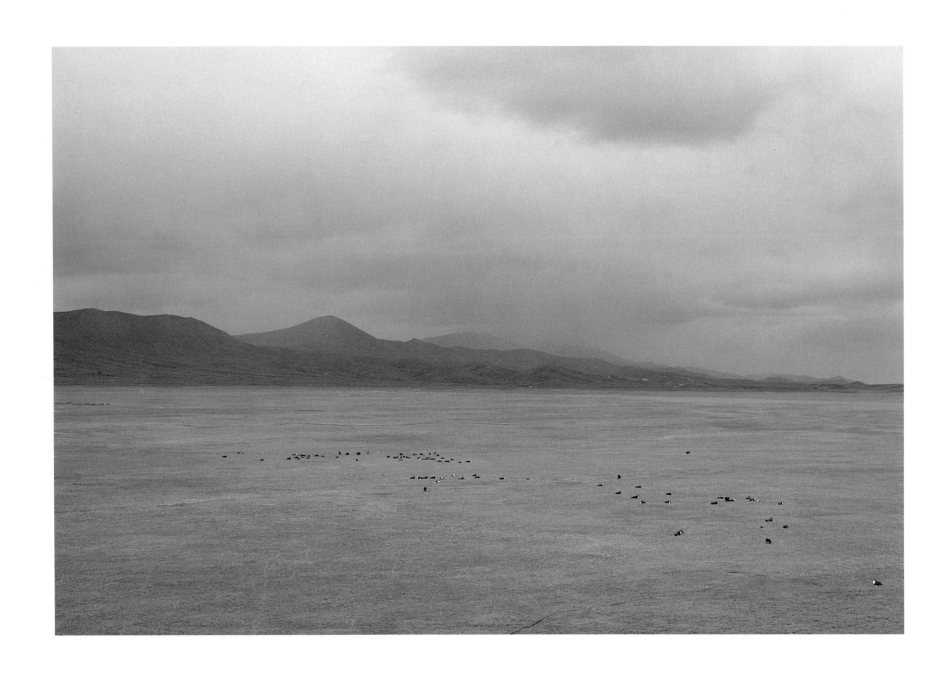

SUMMER RAIN
Camas Prairie - Hill City

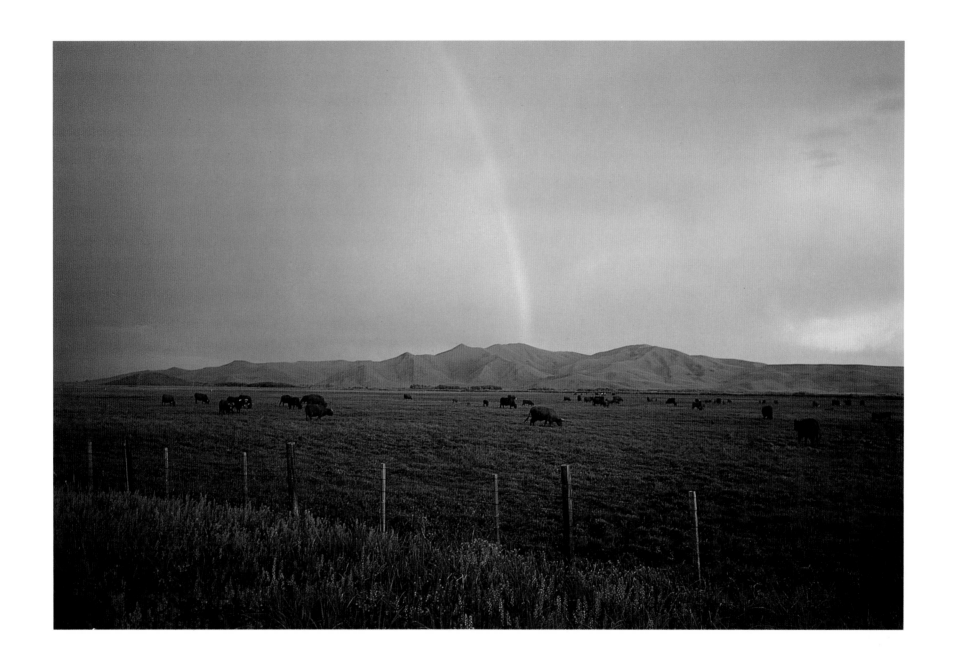

RAINBOW MOUNTAIN
Robert Gardner Ranch - Picabo

next page: FLYING MANES
Cody Jayo - Bruneau

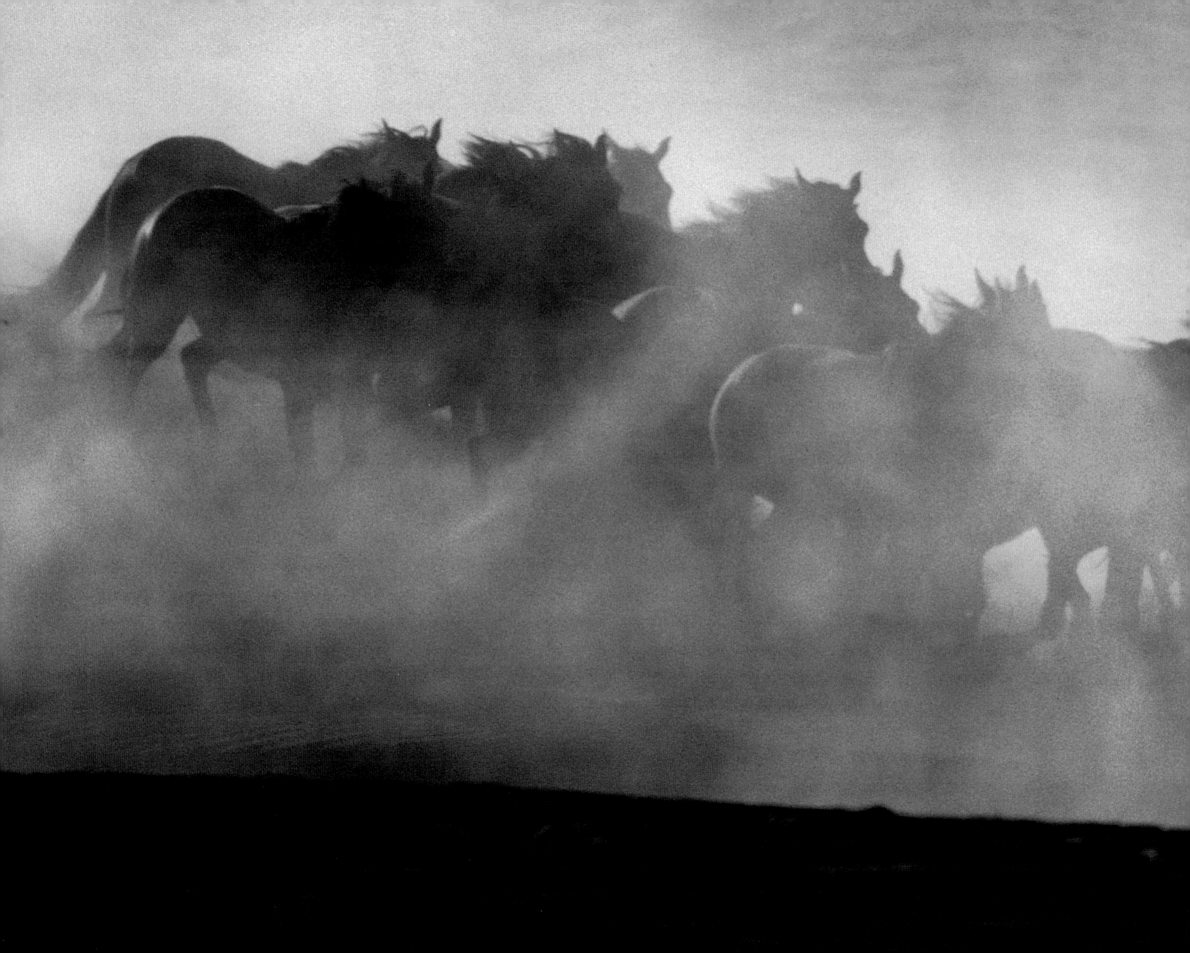

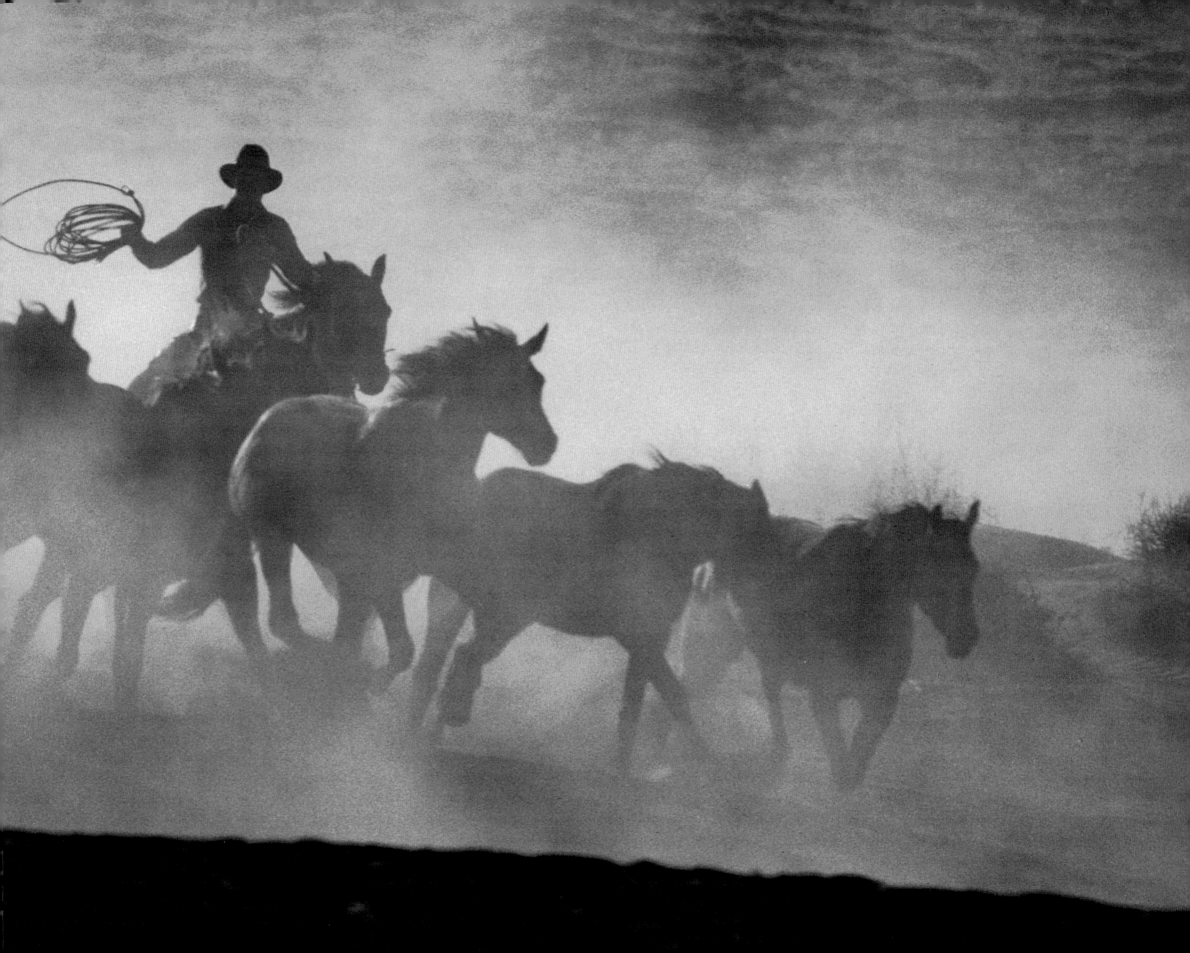

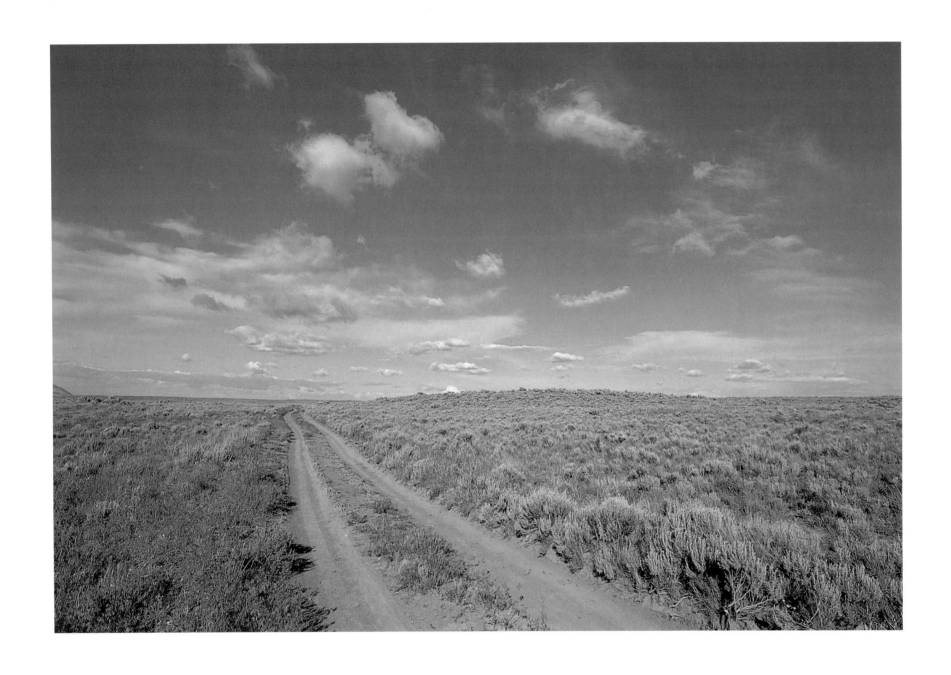

MINIDOKA BOULEVARD
Cox's Well Allotment - Big Desert Unit

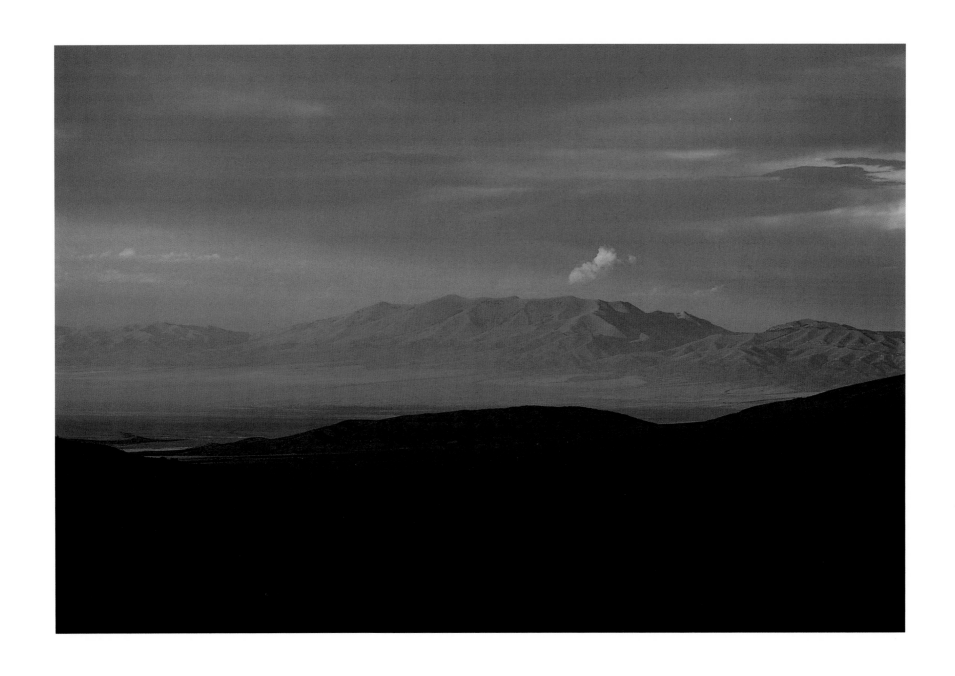

WIND ACROSS THE VALLEY
Raft River

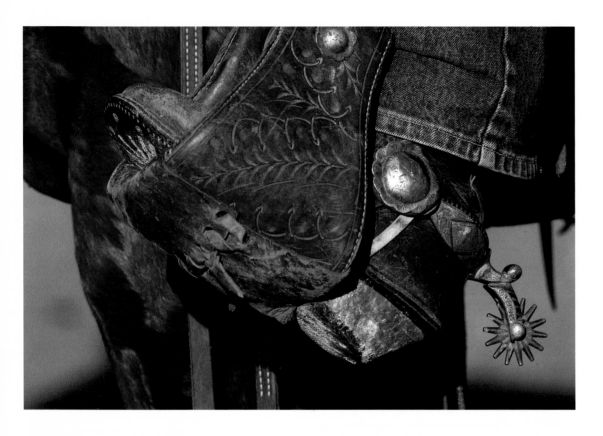

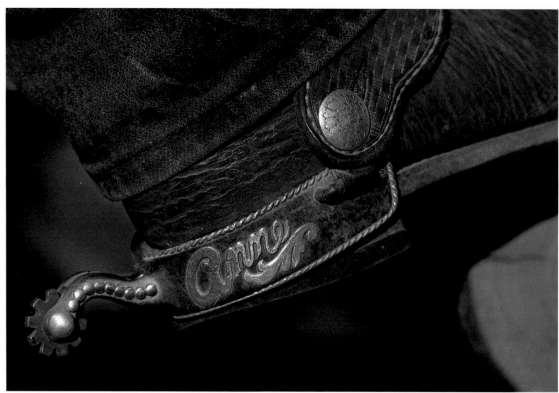

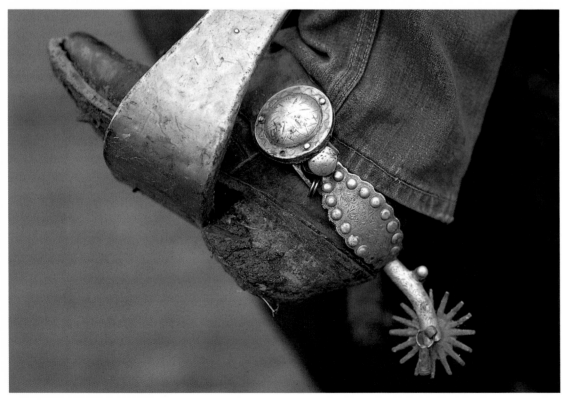

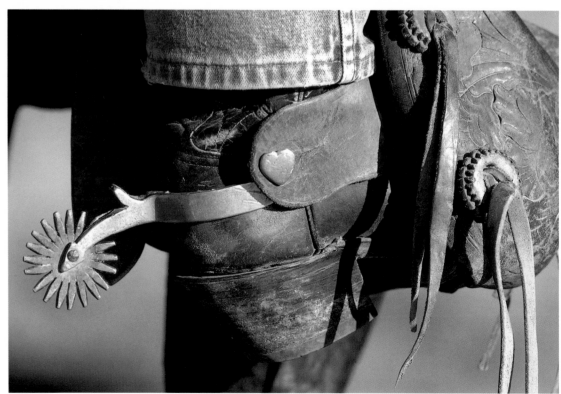

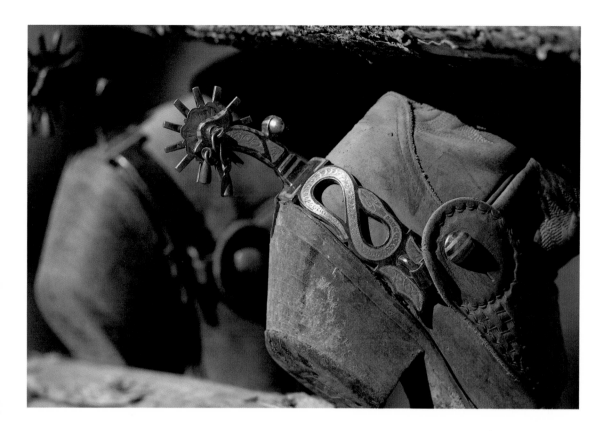

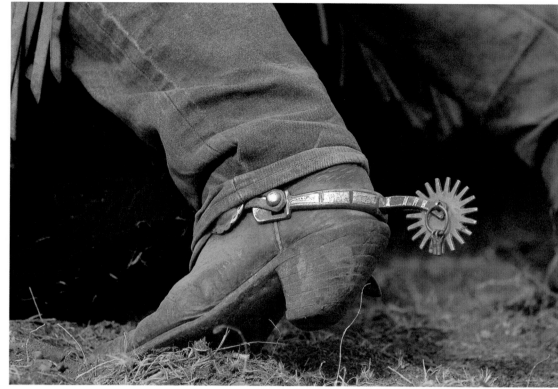

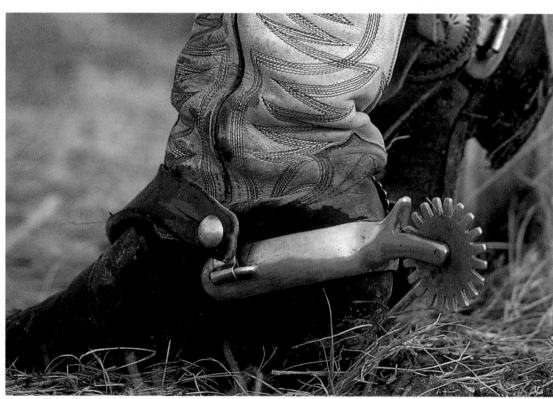

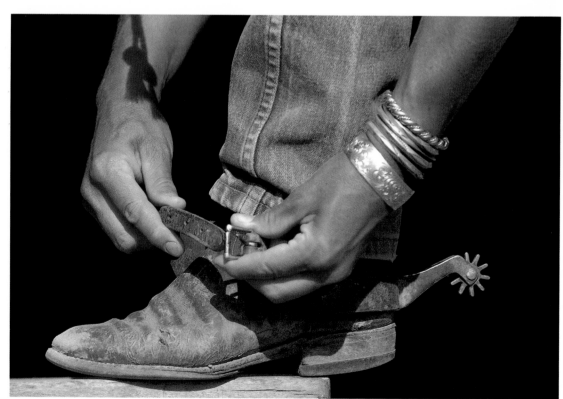

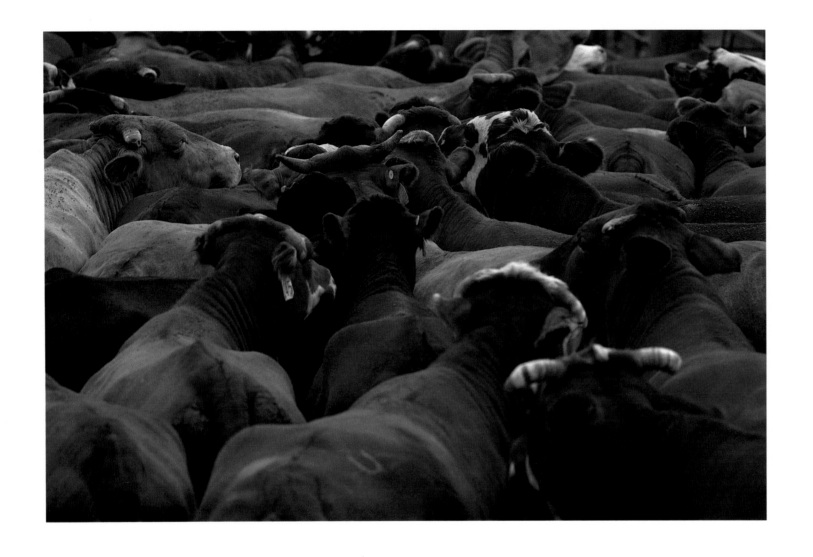

above: WAITING FOR THEIR BABIES

right: SETTIN' THE TRAP
Dave Christensen - Christensen Ranch - McCammon

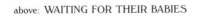

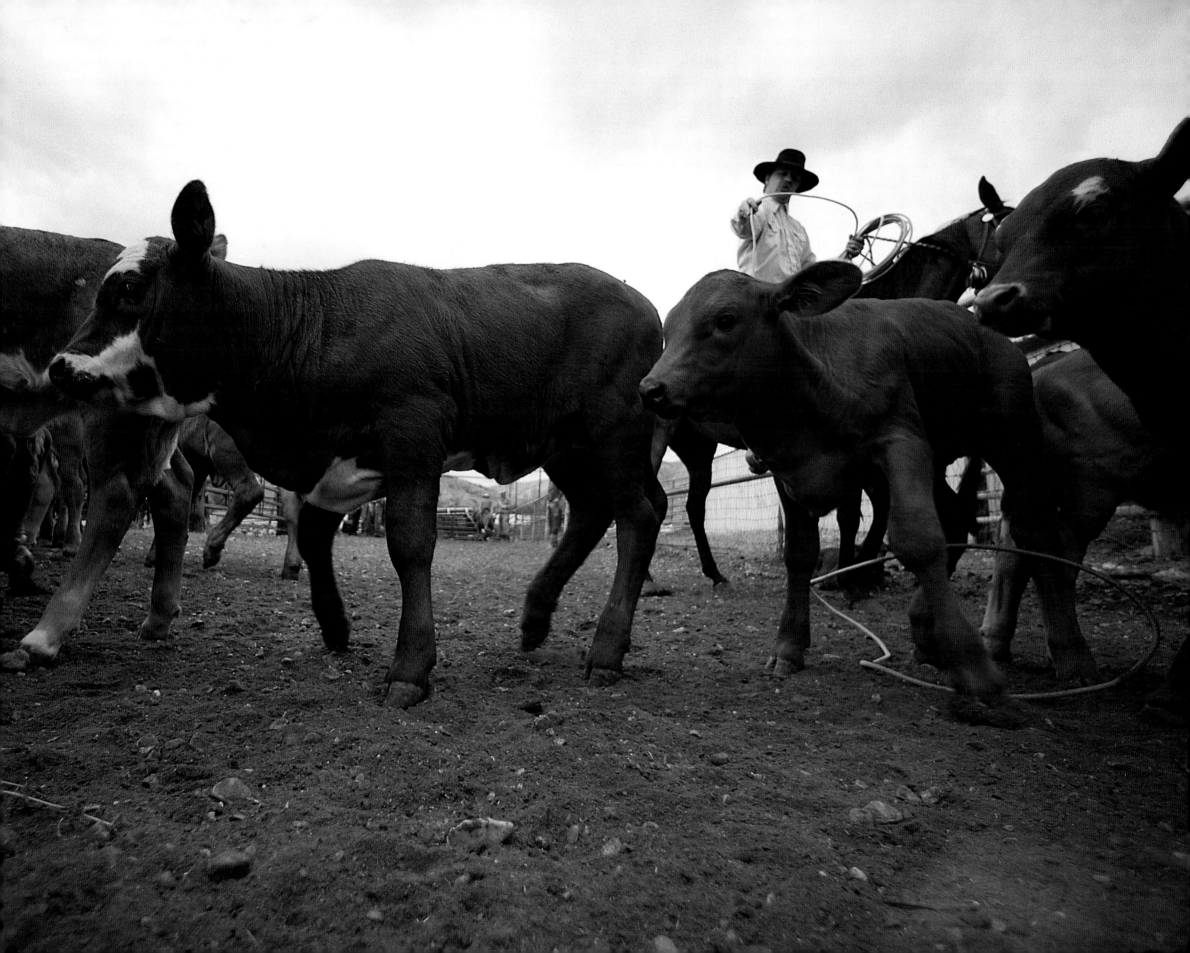

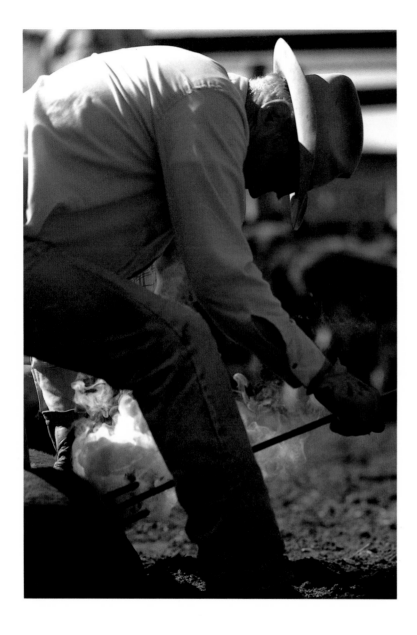

BRANDING SMOKE
Harold Drussel - Picabo

RED HOT IRON

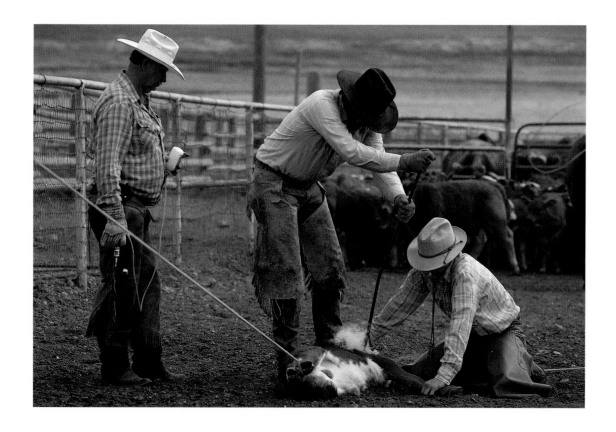

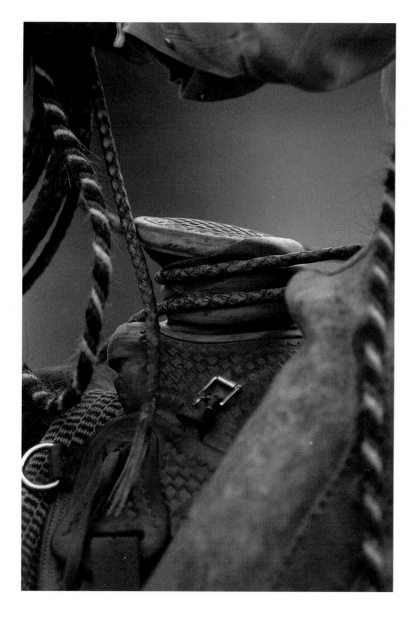

BRANDING
Ray Quire, Kirk and Cody Christensen - McCammon

DALLIED UP TIGHT
Clear Creek Ranch - McCammon

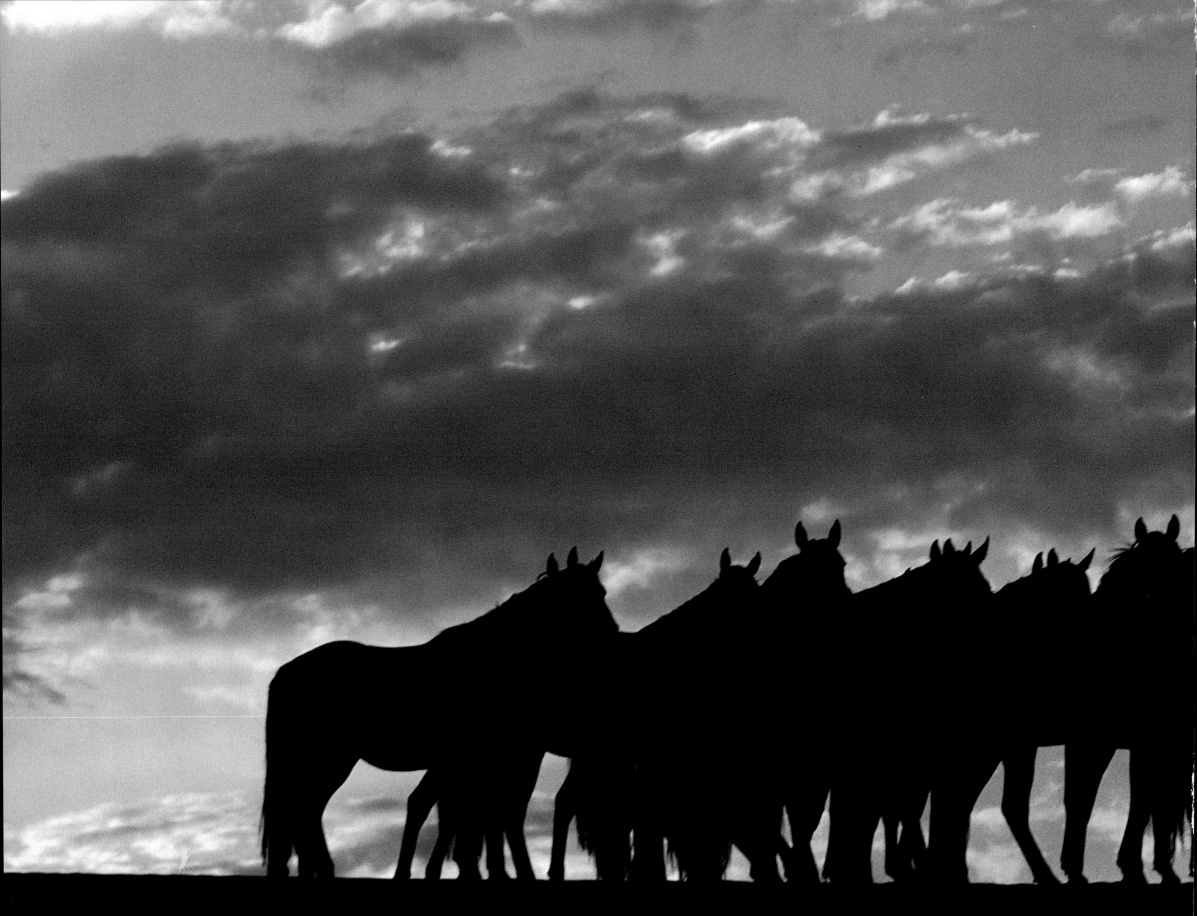

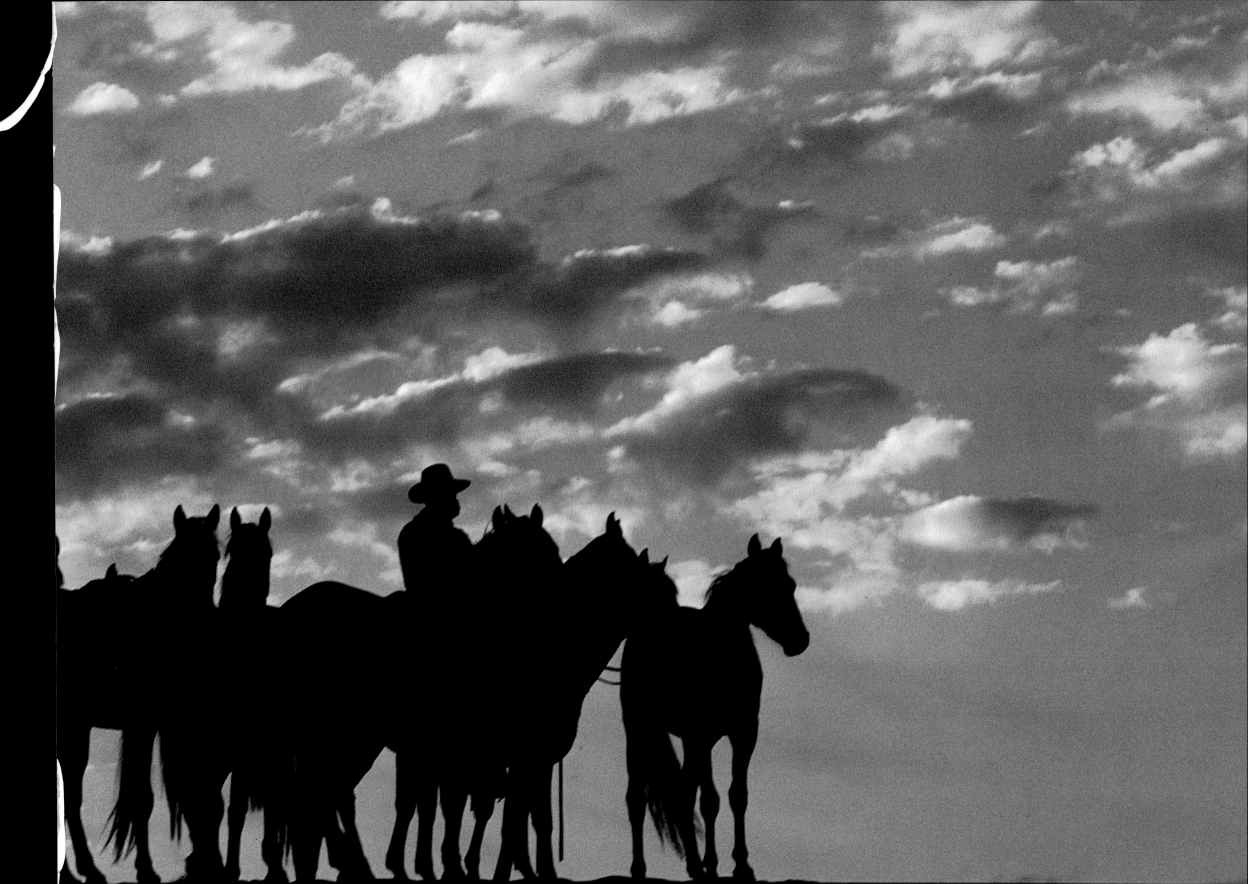

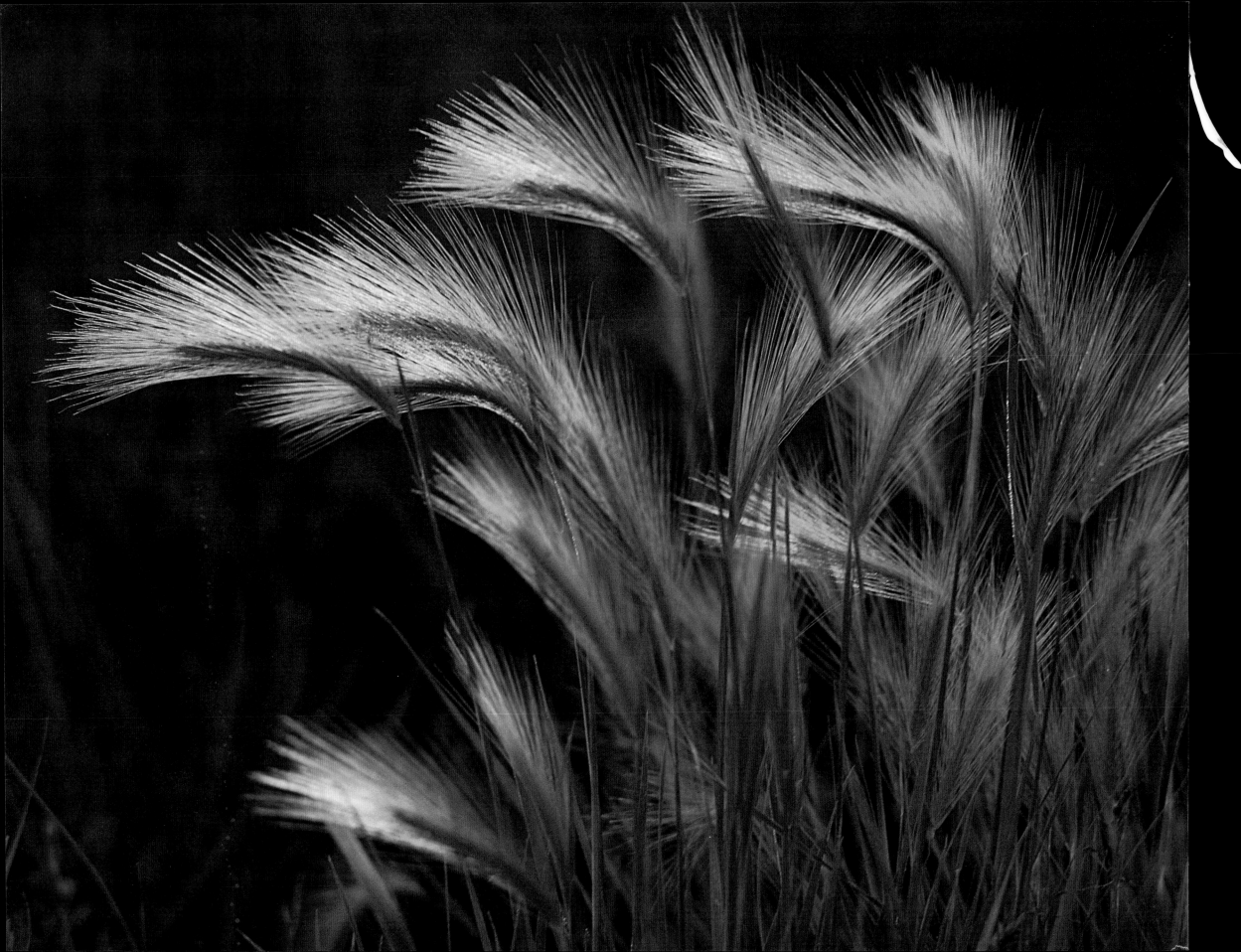

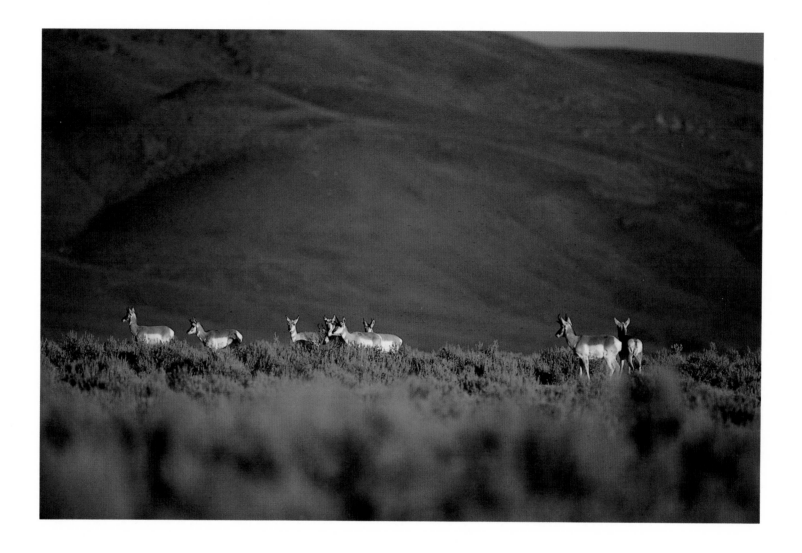

previous page: EVENING CALM
Dennis Jayo - Bruneau

left: MEADOW FOXTAIL
Picabo

above: WATCHING HIS BAND
Pronghorns - Little Lost River Valley

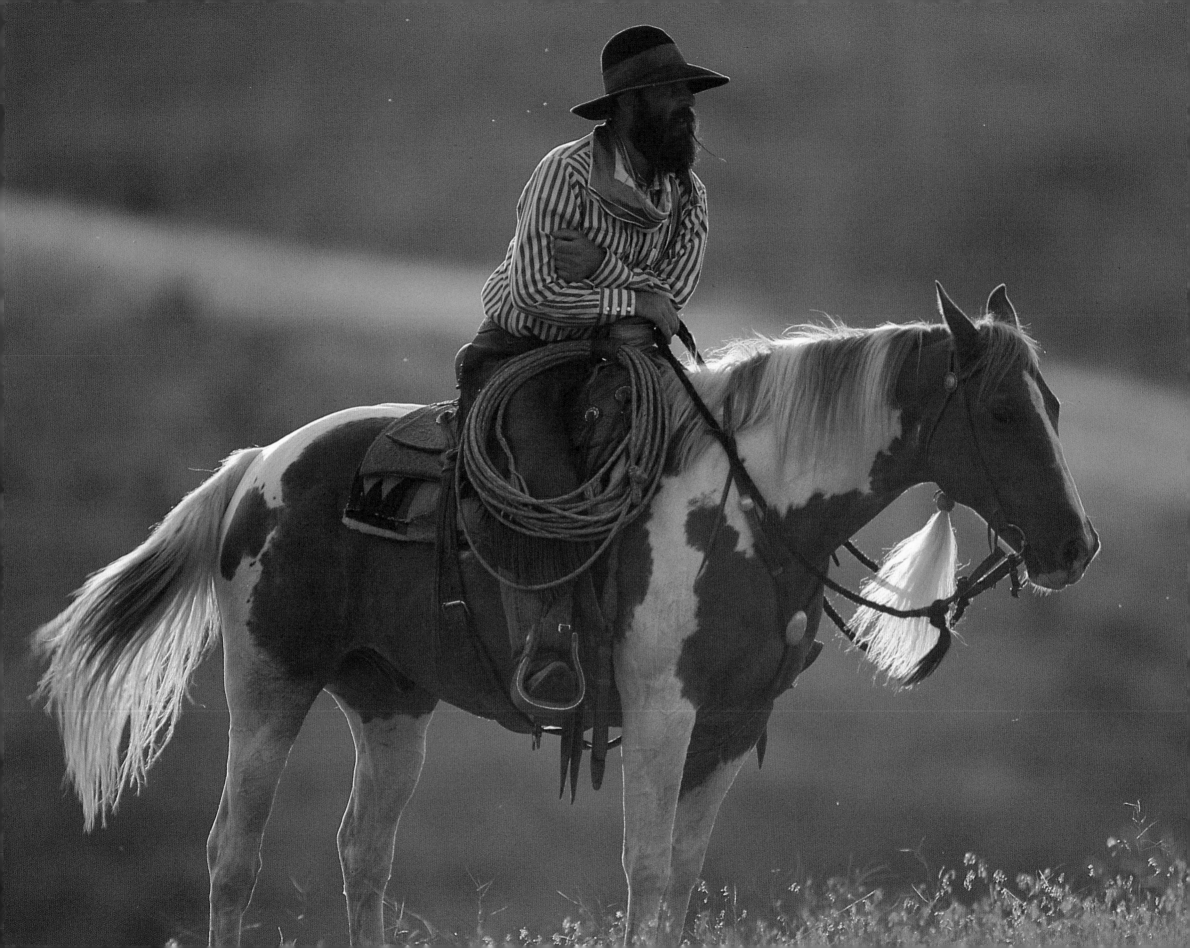

F A L L

Fall signals many changes: Horses begin to hair up, green gives way to yellow and orange, days shorten, clothes change from cotton to flannel, ice forms on water's edge, snow begins to dust the high mountains and the cattle begin to trail home. These changes signal the time for roundup, when cattle are brought home to the valley ranches from high mountain ranges. This is every cowboy's glory, and cow camps are filled with excitement. All the horses, packs of dogs, camp tents and trailers give the roundup camp a kind of carnival atmosphere. The days start way before the first light. The horses are caught and saddled and then they're off to gather the herd. This is usually the time when legends are made and stories become folklore of how the ol' bay horse bucked that cold early morning and how ol' Charlie rode out the storm and stayed aboard. By noon the day's work is done and the afternoon is spent shoeing horses, fixing tack, playing rope games and having the daily horse races. This produces heavy betting and much bragging, especially by the winners!

Cattle are sorted according to owners' brands and each outfit takes their cattle home to the ranch to be worked and sorted for sale. The calves, now weighing 400 to 500 pounds, are weaned from their mothers and sold to an order buyer or through an auction company and then shipped on trucks. This can be a bittersweet event. Sweet in that the calves are sold and the check has been deposited, but bitter in the fact that the banker will get most of the money.

Hunting in the fall is a big part of a cowboy's life. Horses, mules, mountain camps and bedrolls—everyday items of function for cowboys—are to most people things of a seasonal nature only to be used occasionally. Hunting, then, is almost second nature and cowboys take to it in a simple relaxed manner. Cowboys love to be up at 4:00 a.m., packing the string by a lantern's light and then hittin' the trail by feel until that first gray light begins to break the night's blackness. To be out there just experiencing life by being in tune with nature is where the cowboy feels he belongs. It's his vacation, his rest, his rejuvenation.

Fall is a relaxed and reflective time. The cycle is about to come to a conclusion with the sale and shipping of the calves. The awkward and confused colts are now agile and savvy horses that are a joy to ride. Everyday now, there seems to be work with the cattle, be it culling, weaning, sorting or doctoring. Horses, men and cows again make that strange chemistry that bonds all three together. The cold, clear, pre-dawn air is visible from white plumes of hot breath, the shiny silver reflections of frosty grass. Hunched shoulders and humpbacked horses convey images of fall. Bright yellow and orange leaves glimmer with the gentle afternoon breeze and the brilliant red and pink hues of evening alpenglow on high mountain ridges exhilarate the spirit of living high and wide, proud and free!

REFLECTIONS
Raymond Jayo - Payette

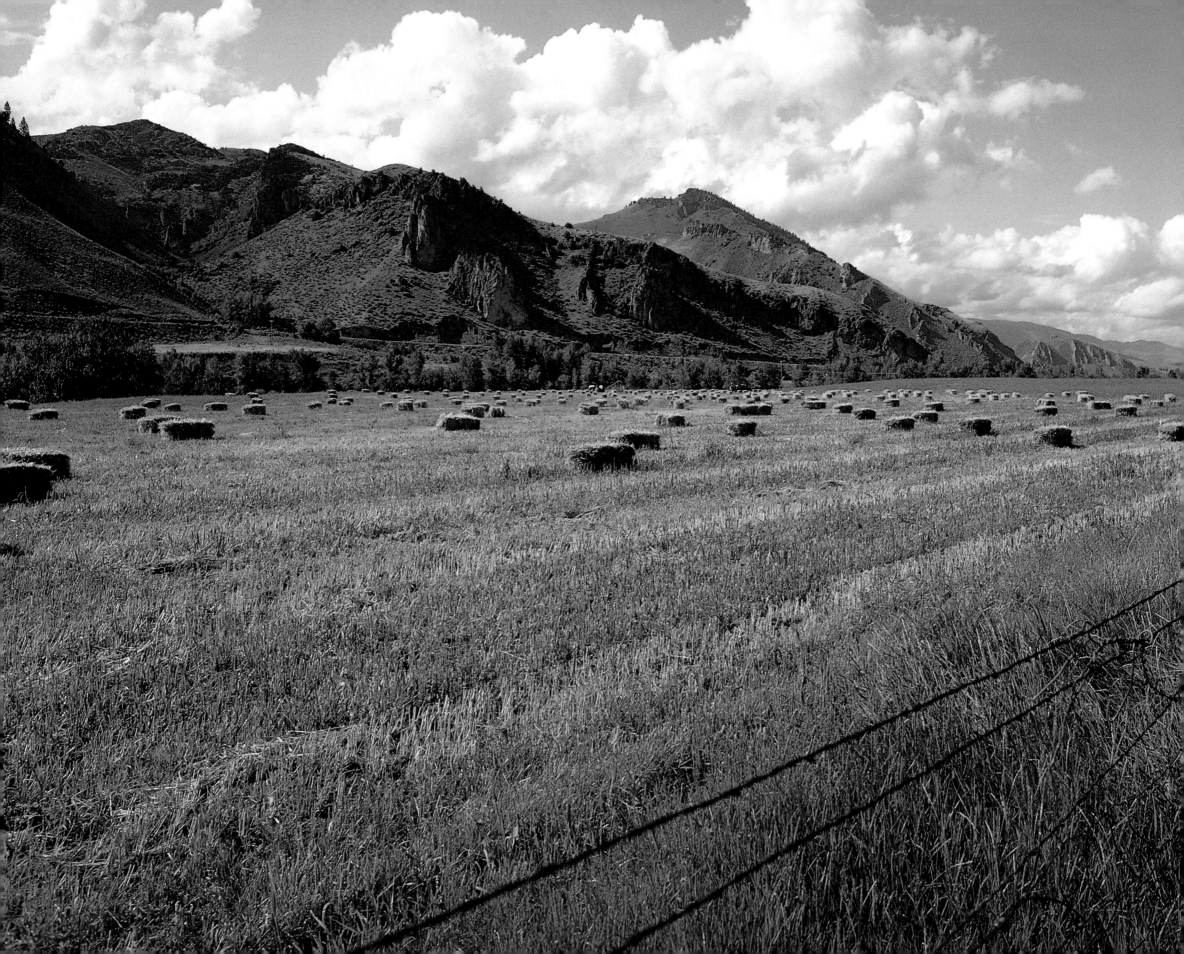

left: HAY BALES
10 Mile Creek - Salmon

above: BARLEY
Monteview

115

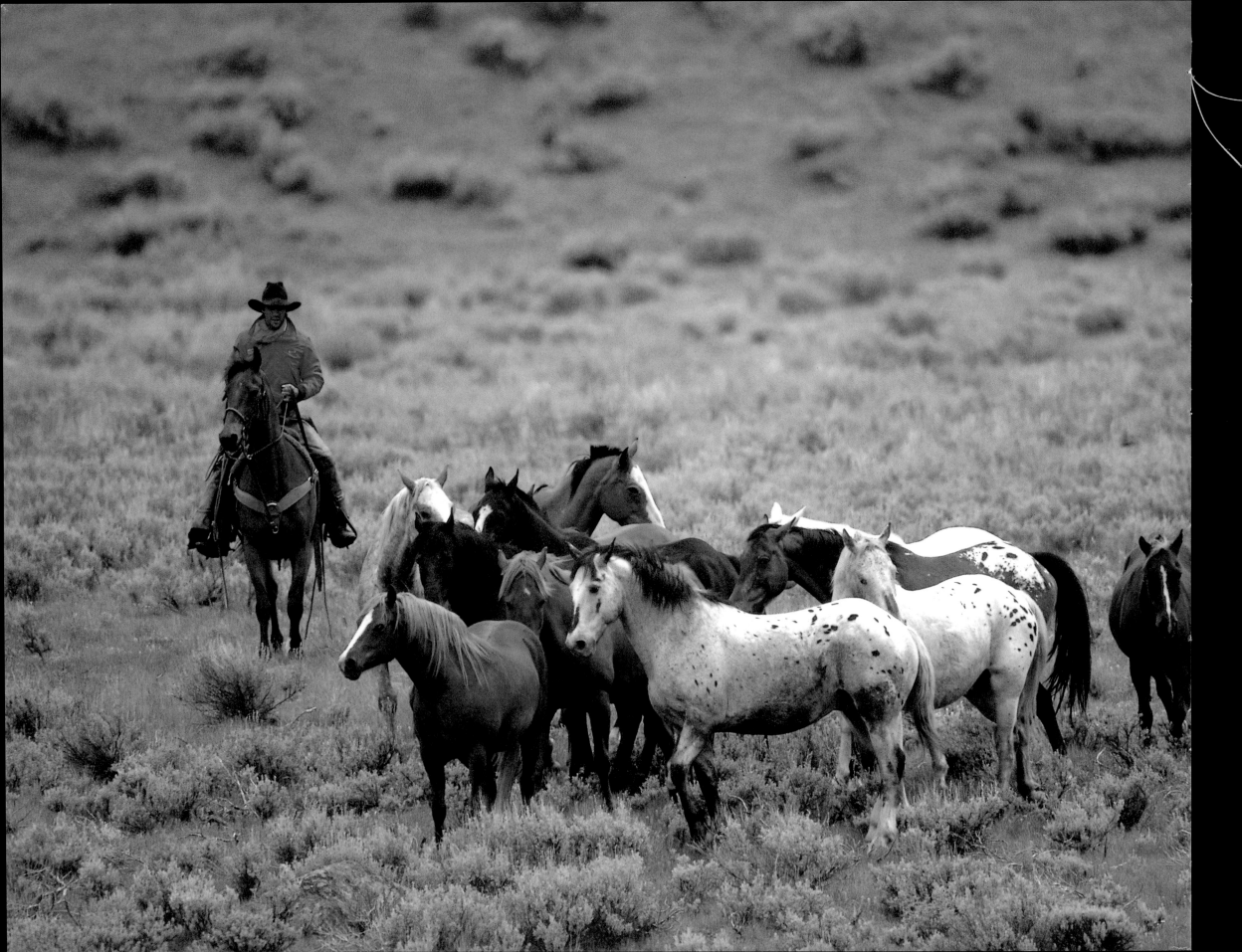

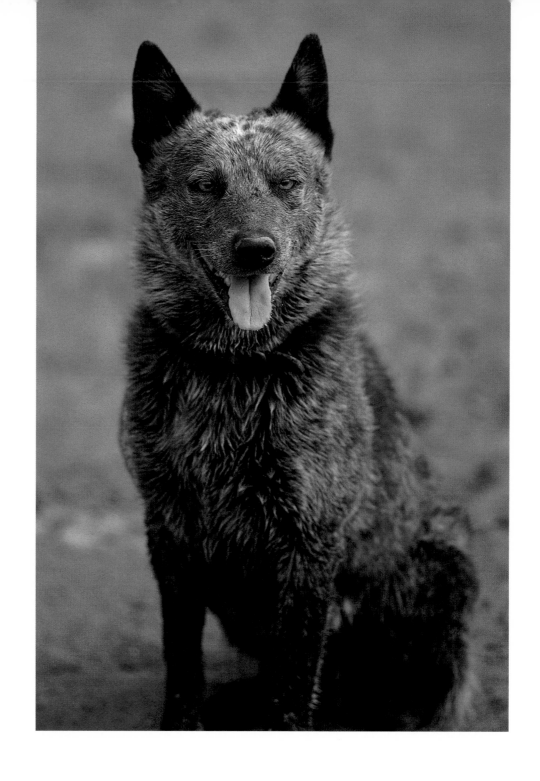

left: GETTING THE PACK STRING IN
Mike Seal - Busterback Ranch - Stanley

above: COWBOY'S HELPER
Stinger - Raymond's Dog

117

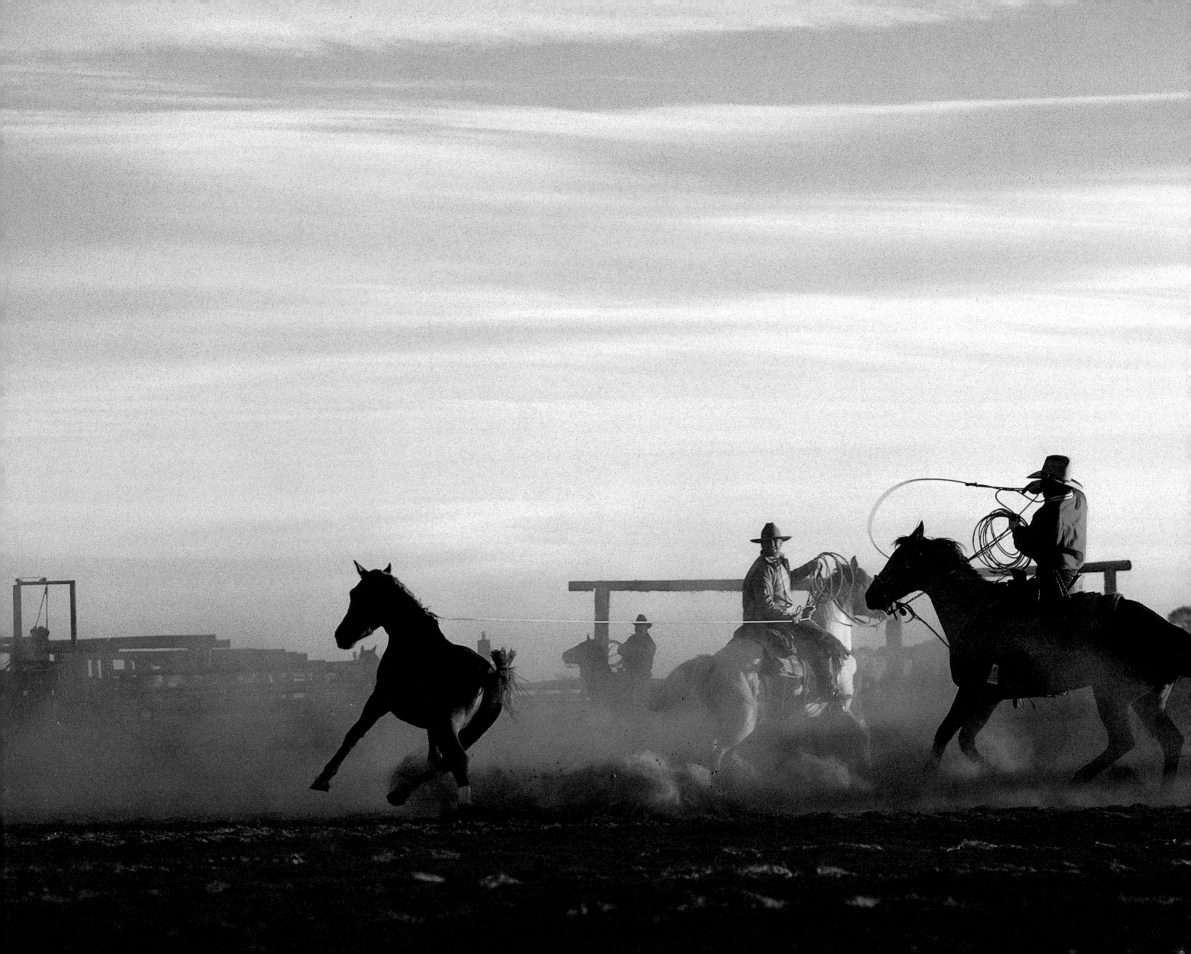

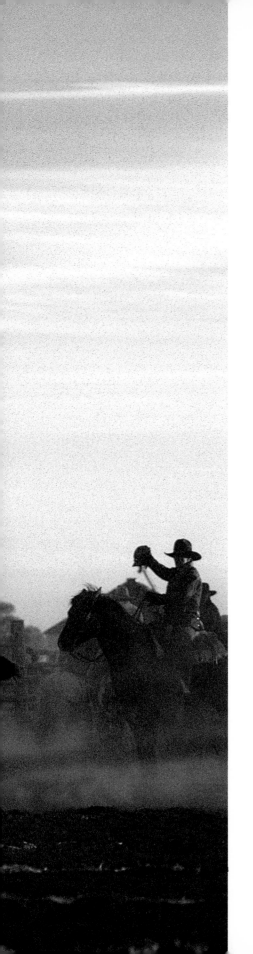

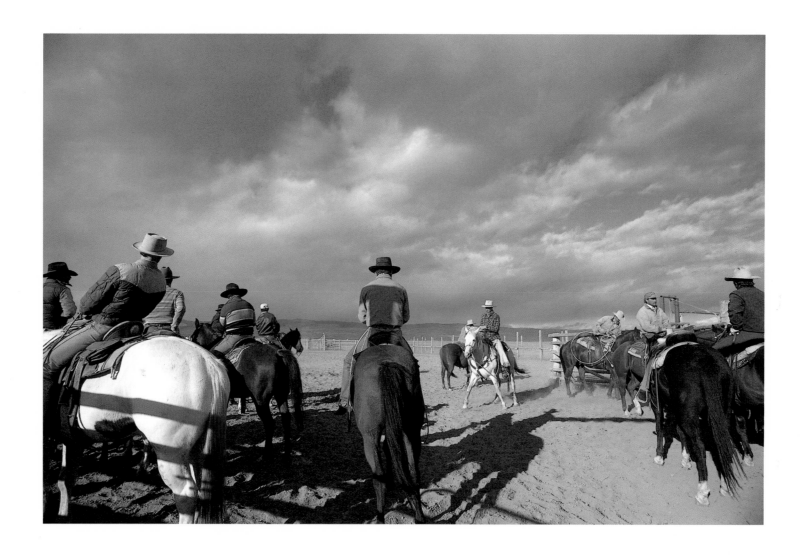

left: COMIN' AROUND
Bob Marriott and Chris King Horse Roping - Medicine Lodge

above: ON DECK
Horse Roping - McGarry Ranch - Medicine Lodge

119

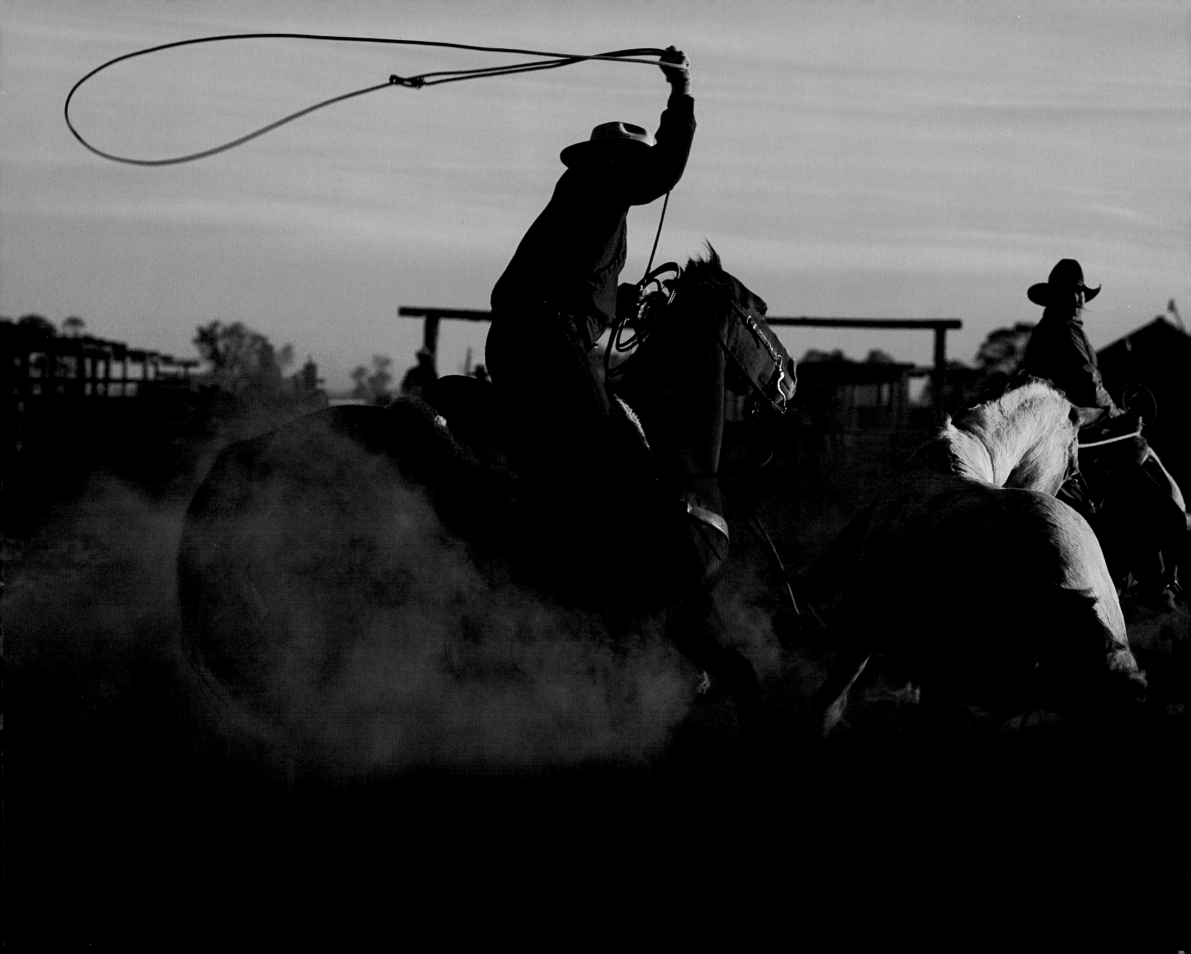

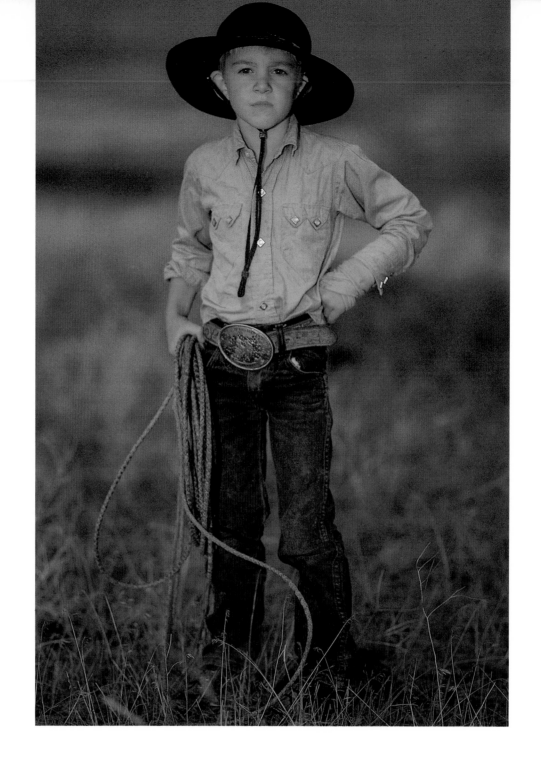

left: HORSE ROPING
Bret Reeder and Joe Maeher · McGarry Ranch · Medicine Lodge

above: LITTLE HORSE ROPER
Levi Jayo · Payette

121

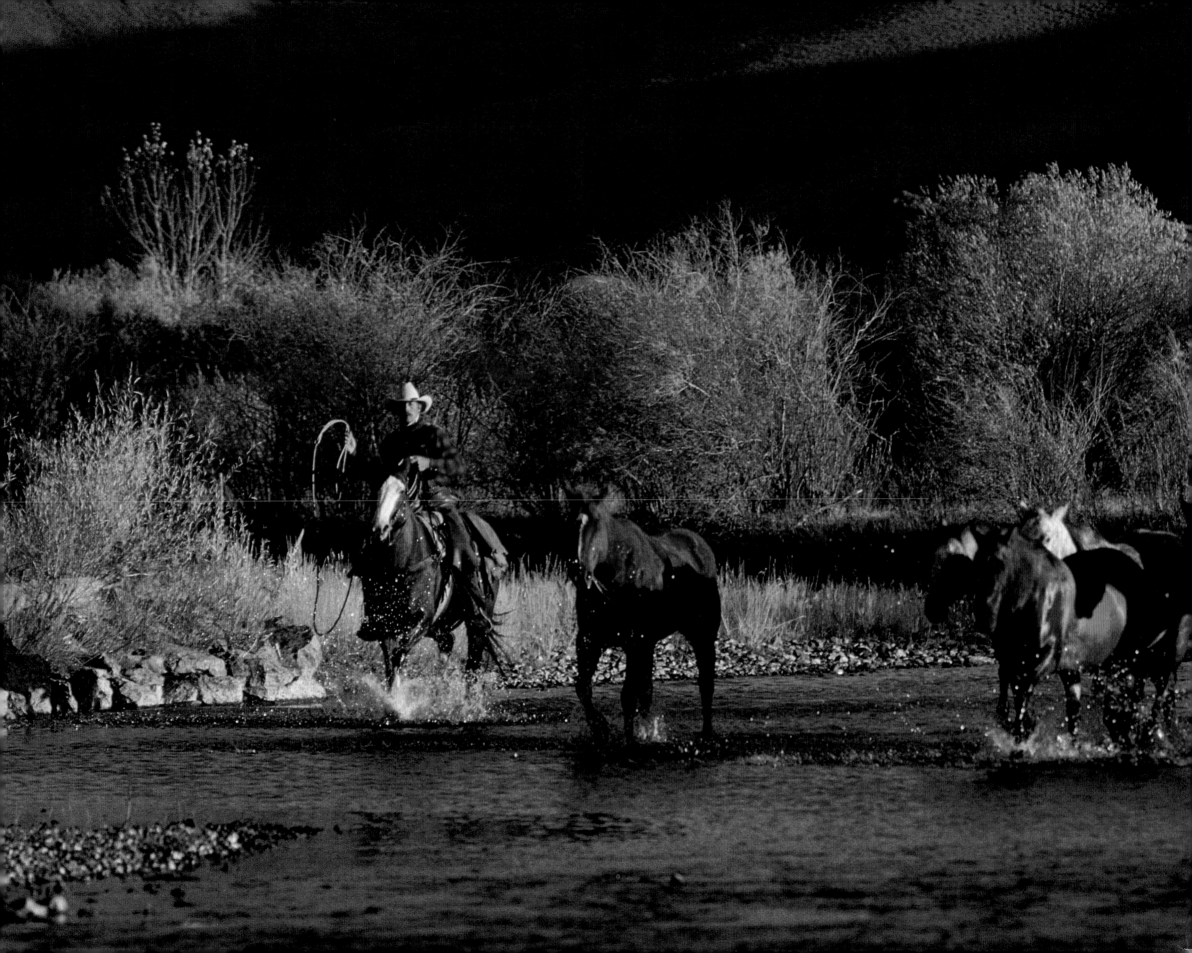

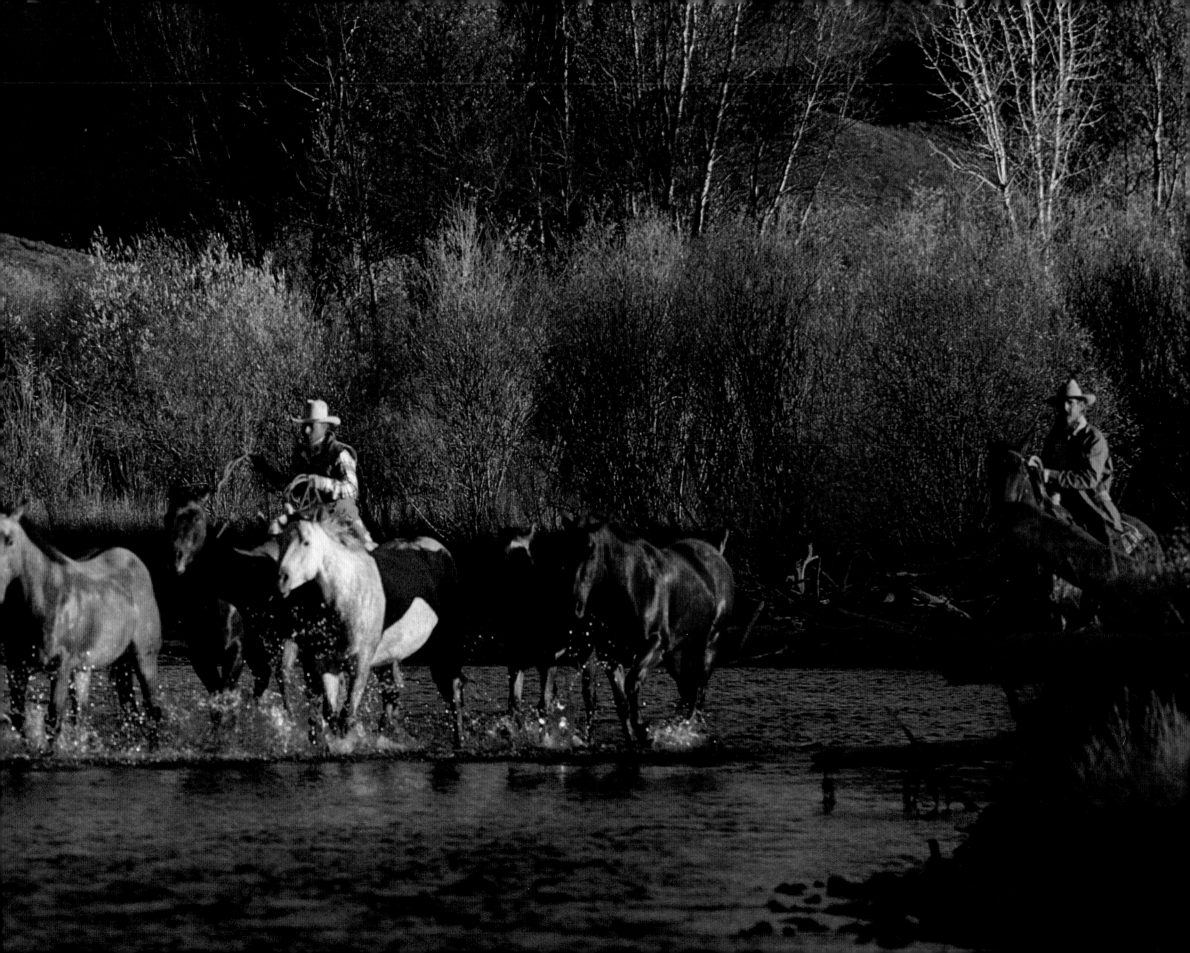

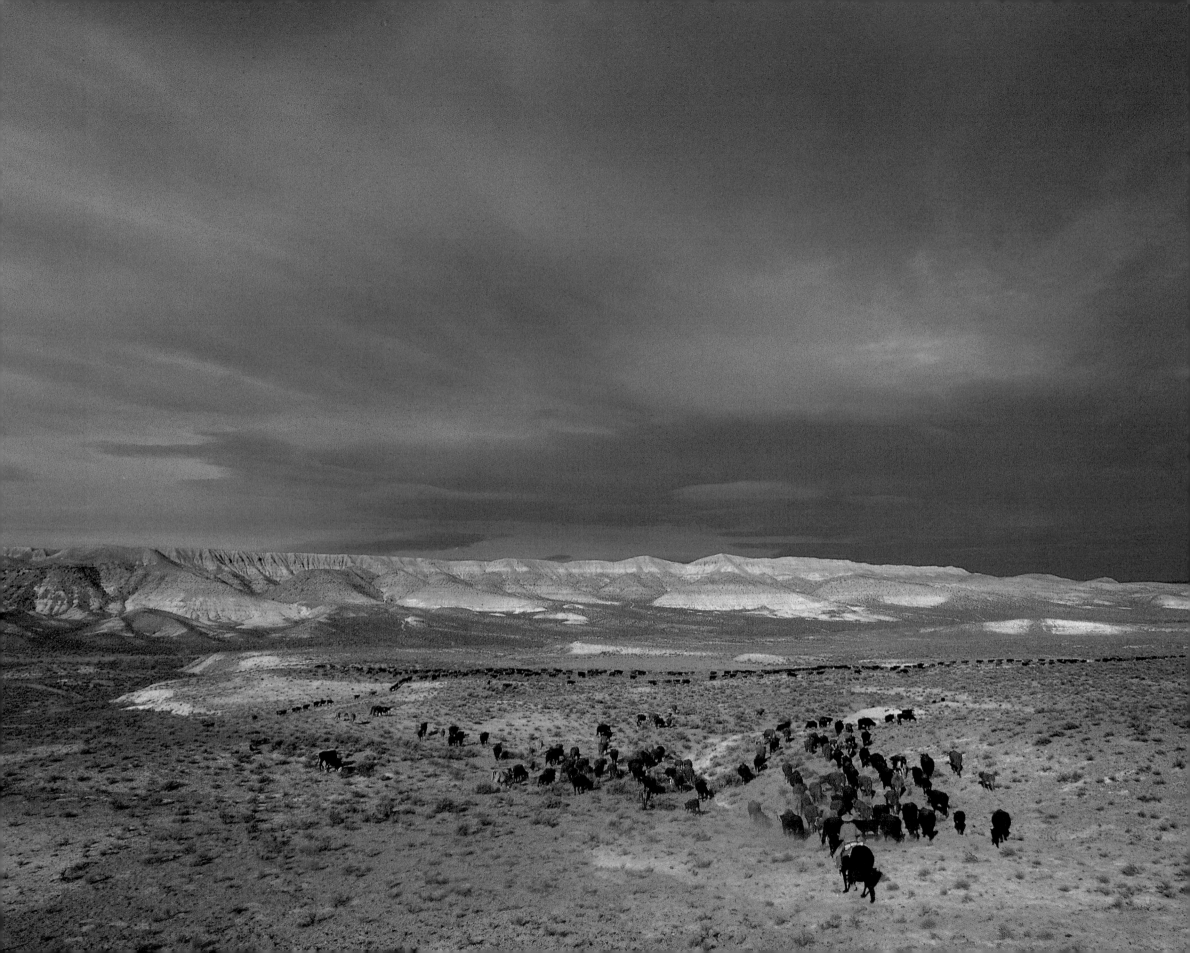

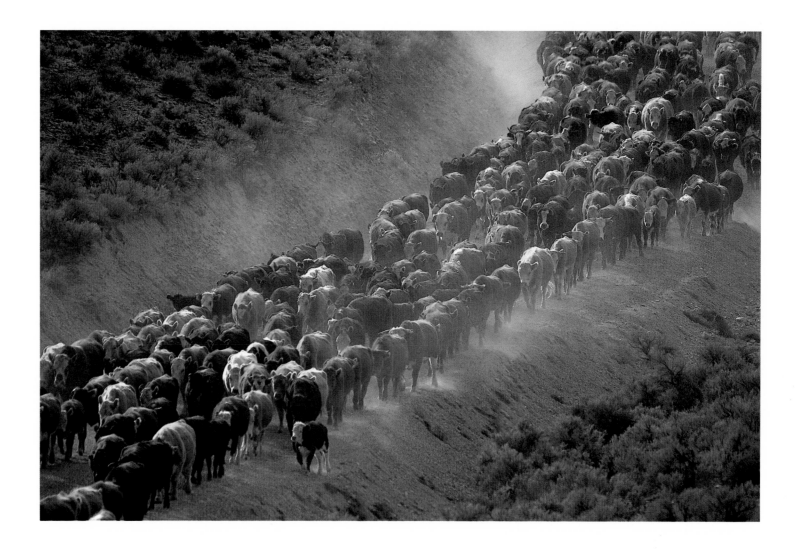

previous page: CROSSIN' THE BIG LOST RIVER
Jack Goddard, Ross Goddard and Monte Funkhauser
Bar 13 Ranch - Mackay

left: FILING INTO THE BASIN
Triangle Ranch - Oreana

above: HEAVY TRAFFIC
Triangle Ranch - Oreana

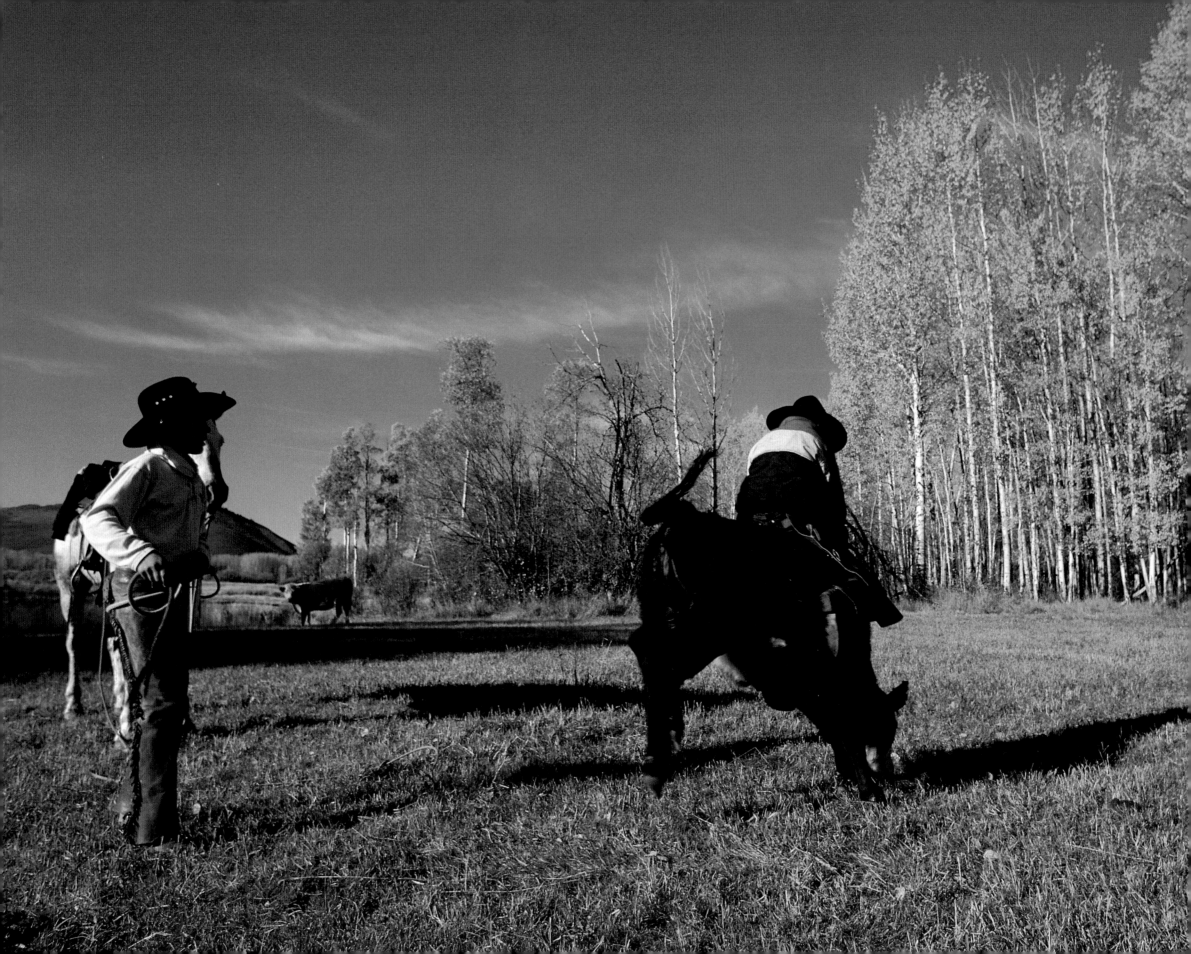

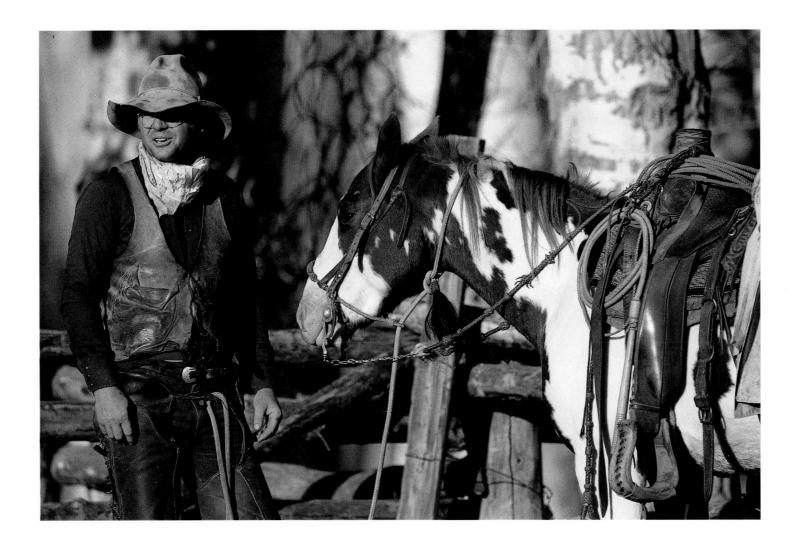

left: BETCHA CAN'T
Shawn Hatch and Leavin' Cheyenne Hatch
Rafter 11 Ranch - Chilly

above: DON'T PULL BACK
Les Hatch - Chilly

127

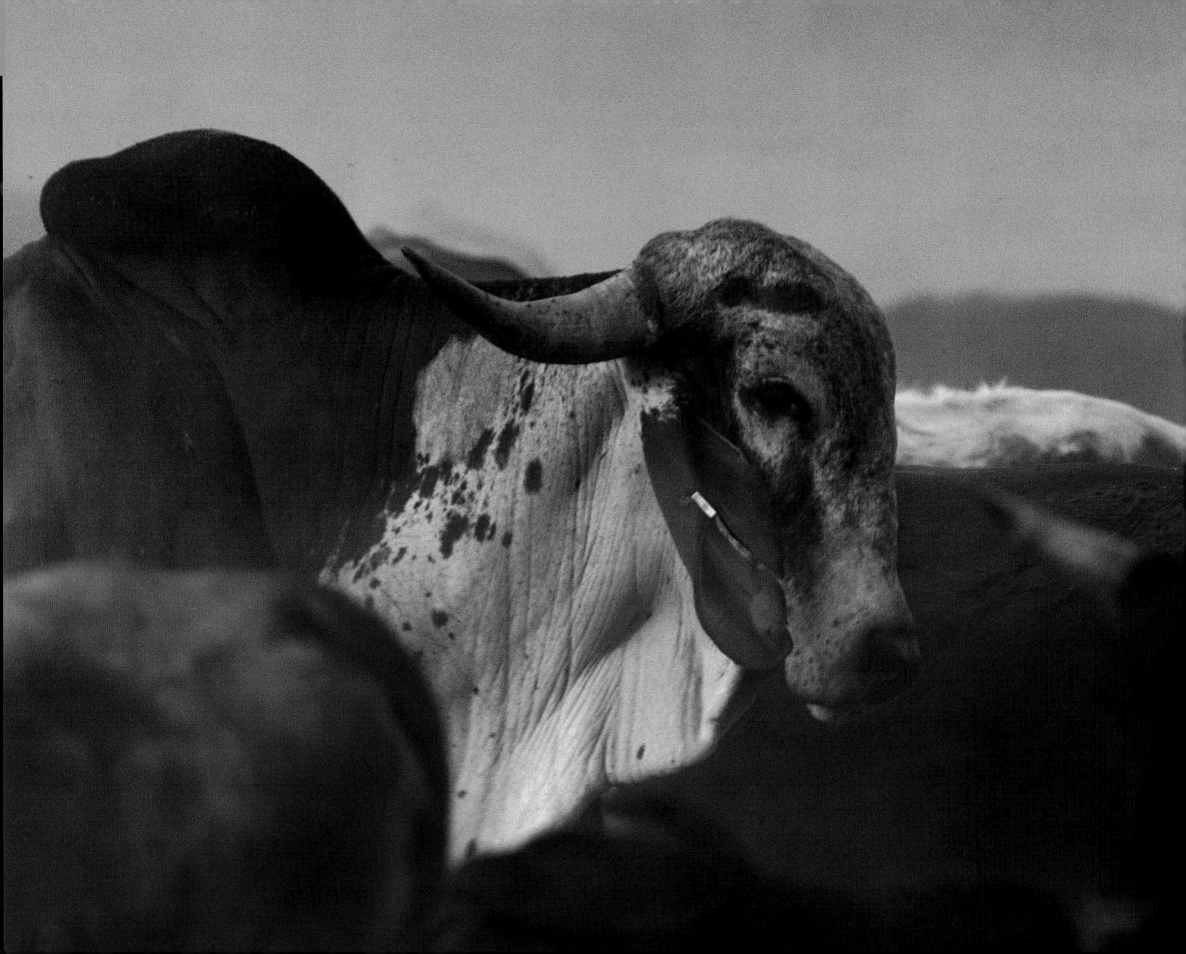

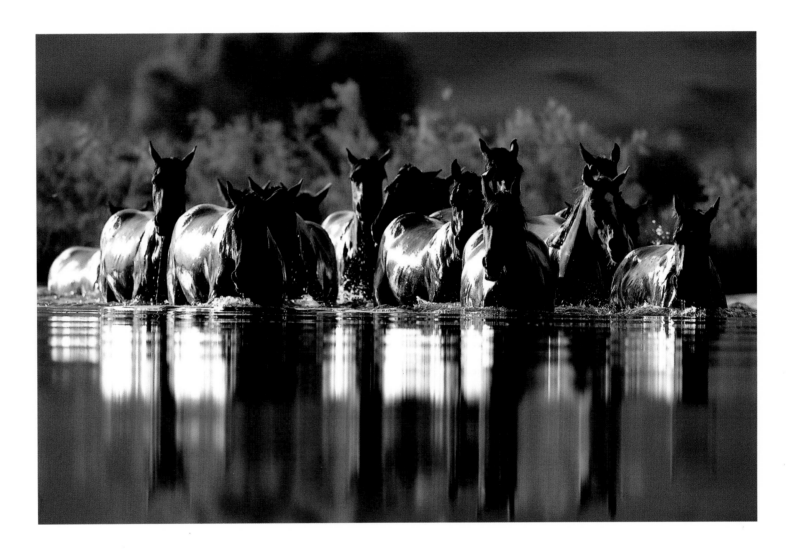

left: MERLIN'S BULL
Rupp Ranch - Snake River Breaks

above: COOL REFLECTIONS
Horses - Bruneau

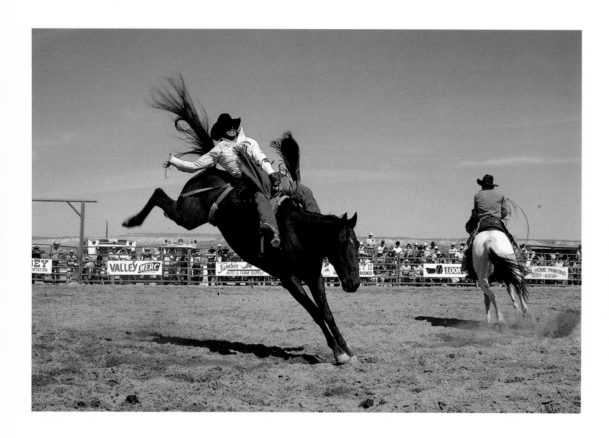

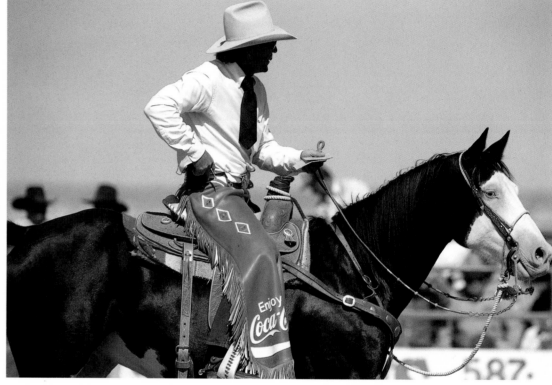

BAREBACK RIDER
Bruneau Rodeo

RODEO ANNOUNCER
Lonnie Hatch - Bruneau Rodeo

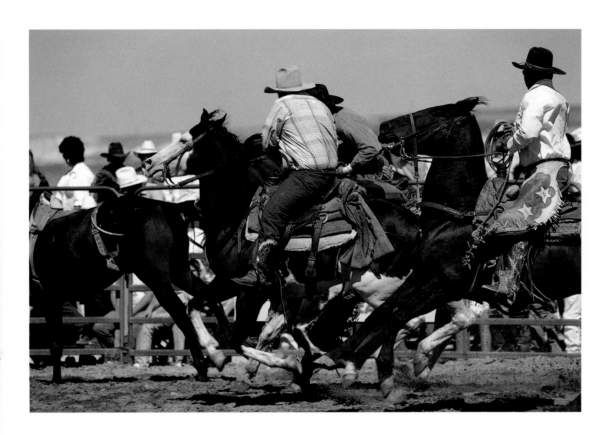

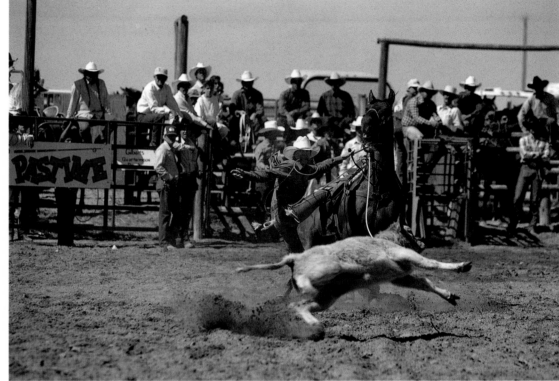

PICK-UP MEN
Bruneau Rodeo

CALF ROPER
Bruneau Rodeo

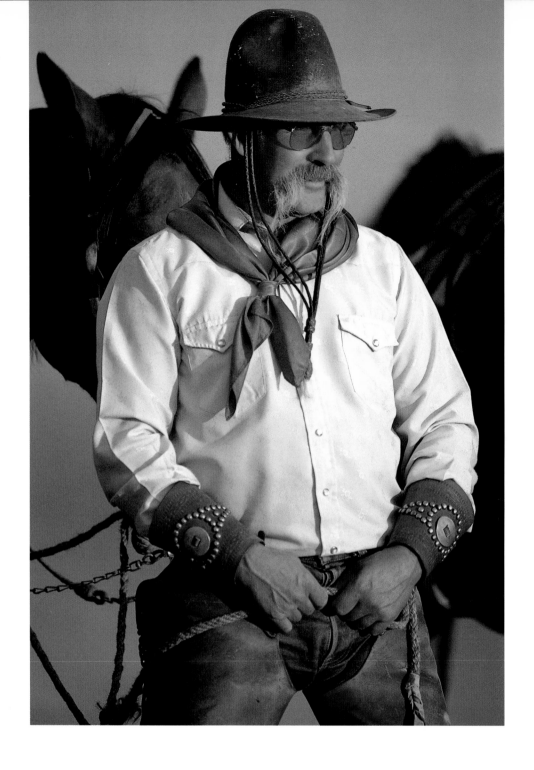

above: BLUE SCARF AND CUFFS
Merlin Rupp - Snake River Breaks

right: PICKIN' ONE OUT
Merlin Rupp - Snake River Breaks

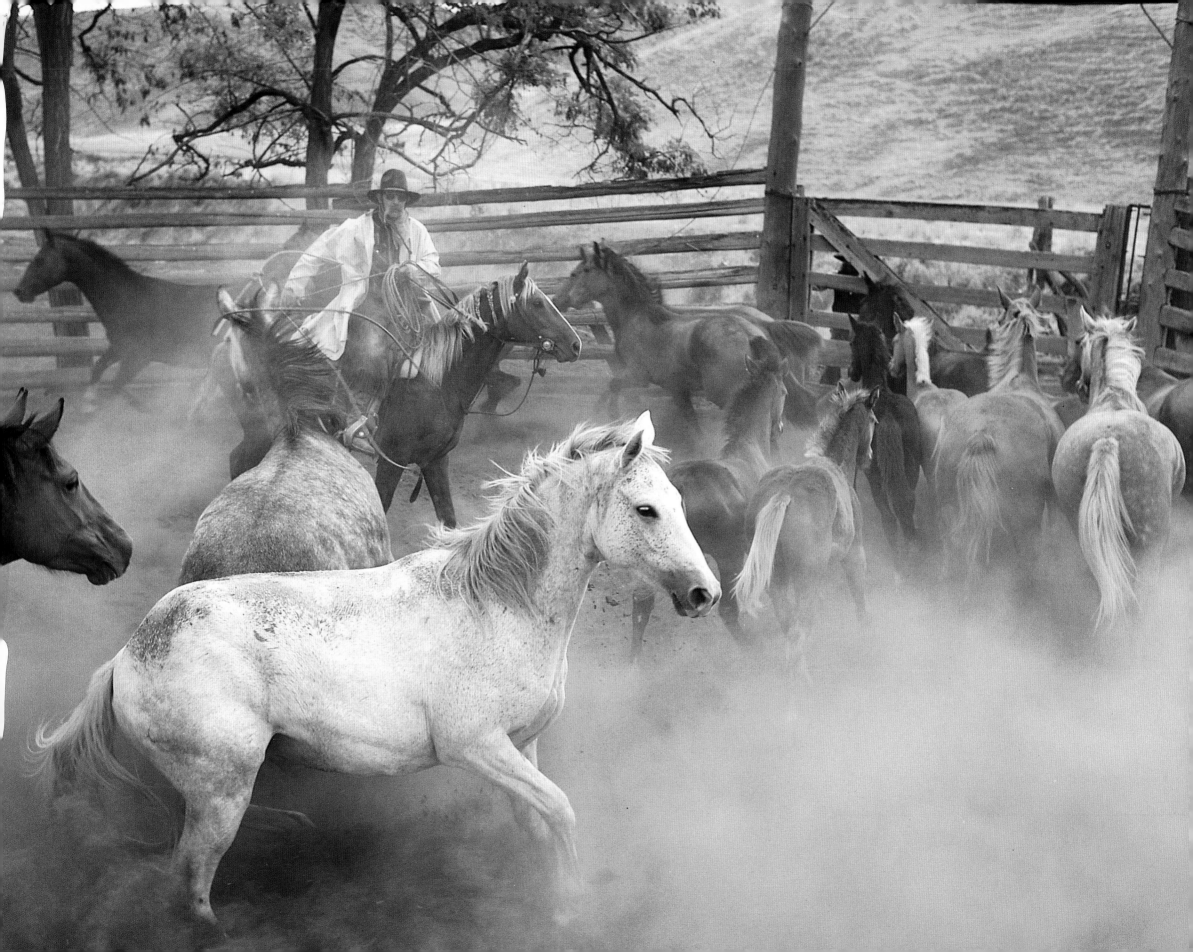

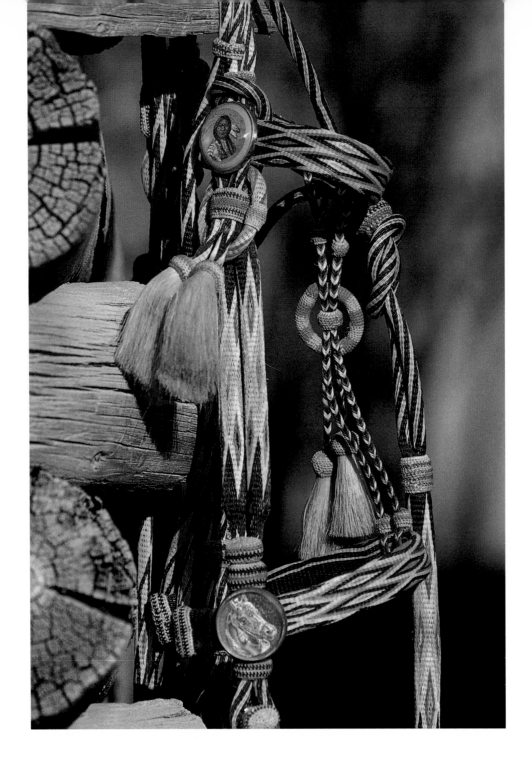

above: HORSE HAIR BRAIDED HEADSTALL
Made By Walla Walla Prison Inmate - Turn Of The Century

right: MADE 'ER BACK
Cows - Rafter 11 Ranch - Chilly

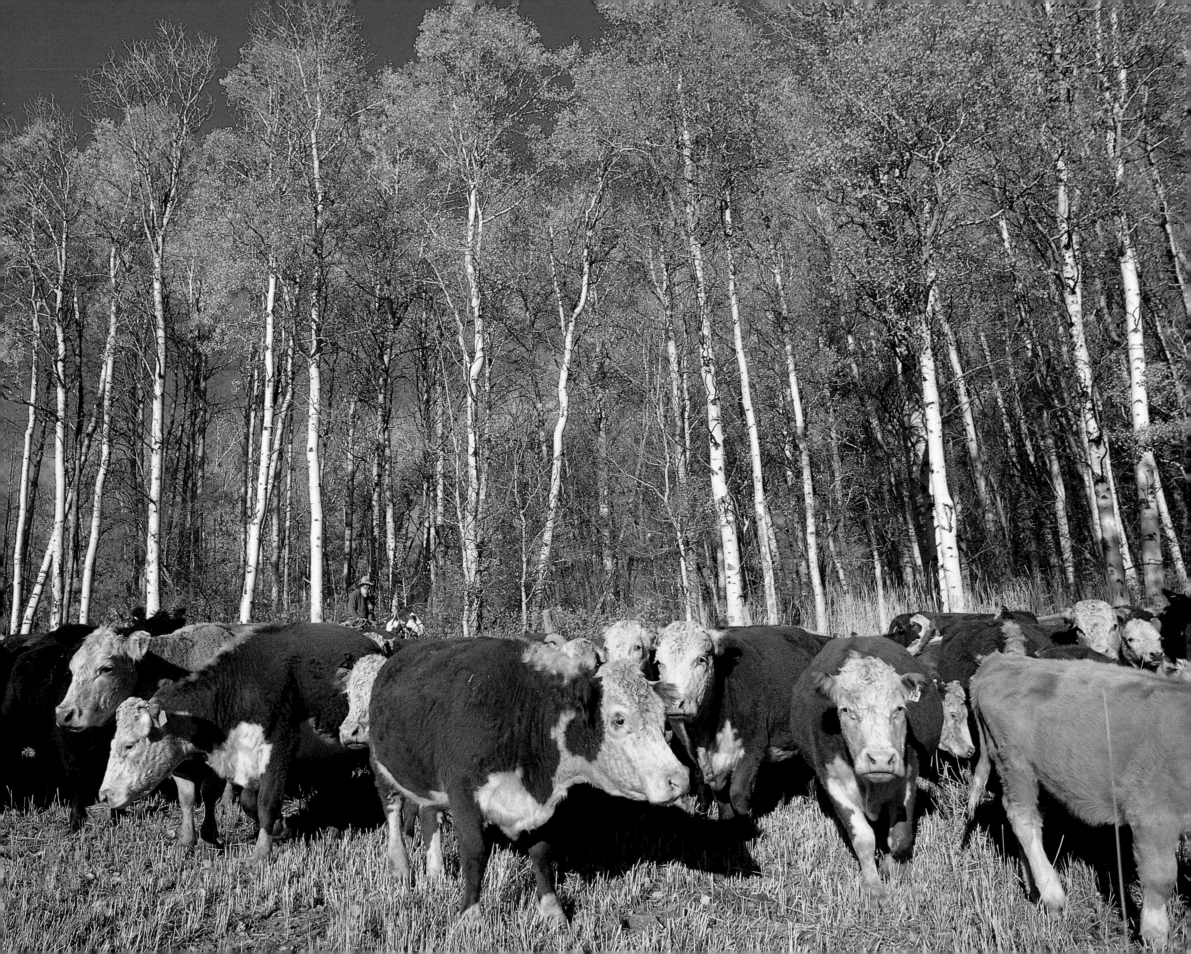

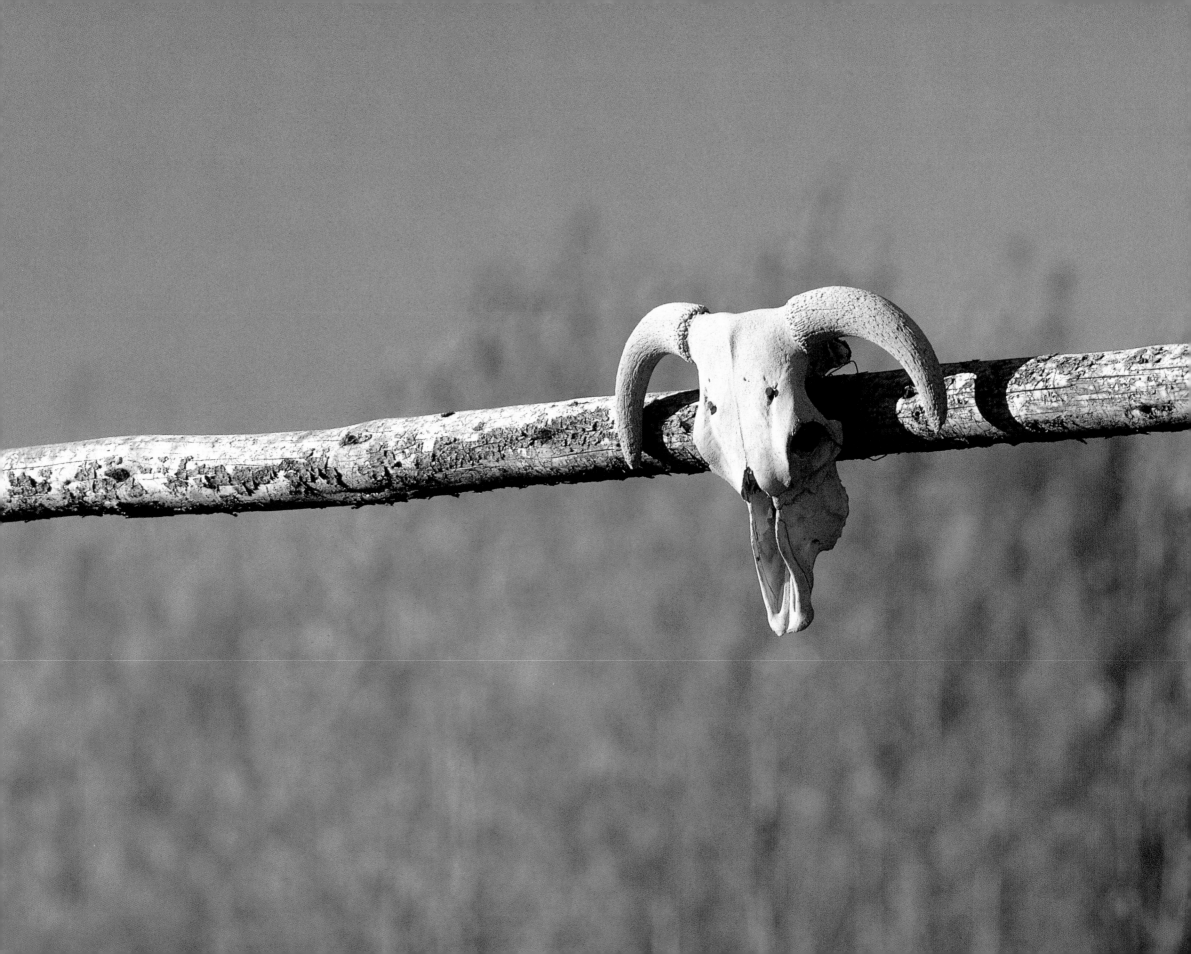

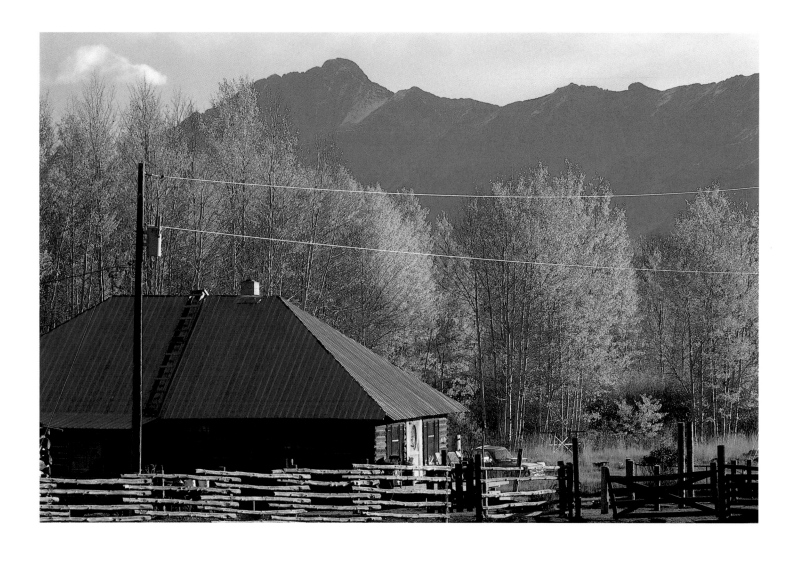

left: BULL SKULL
Rafter 11 Ranch - Chilly

above: OVAL WINDOW
Rafter 11 Ranch - Chilly

137

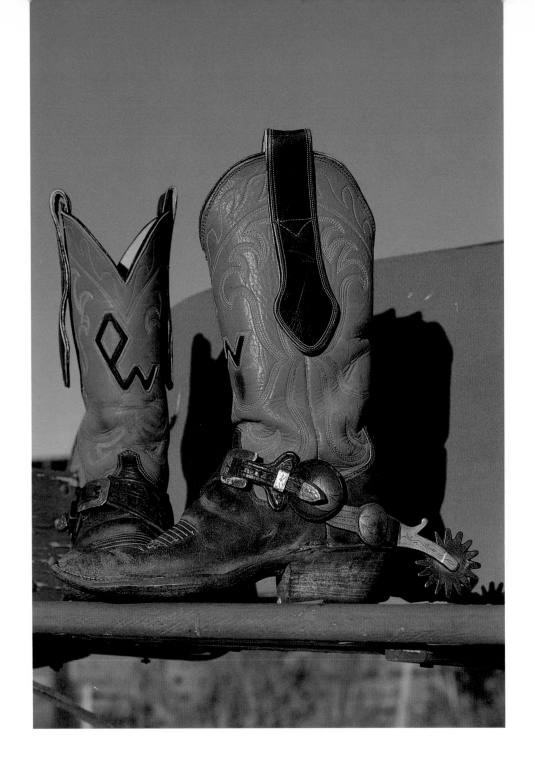

above: HANDMADE BOOTS
By Bev Gilger - Medicine Lodge

right: GRAZING ON THE RIDGE
Merlin Rupp - Snake River Breaks

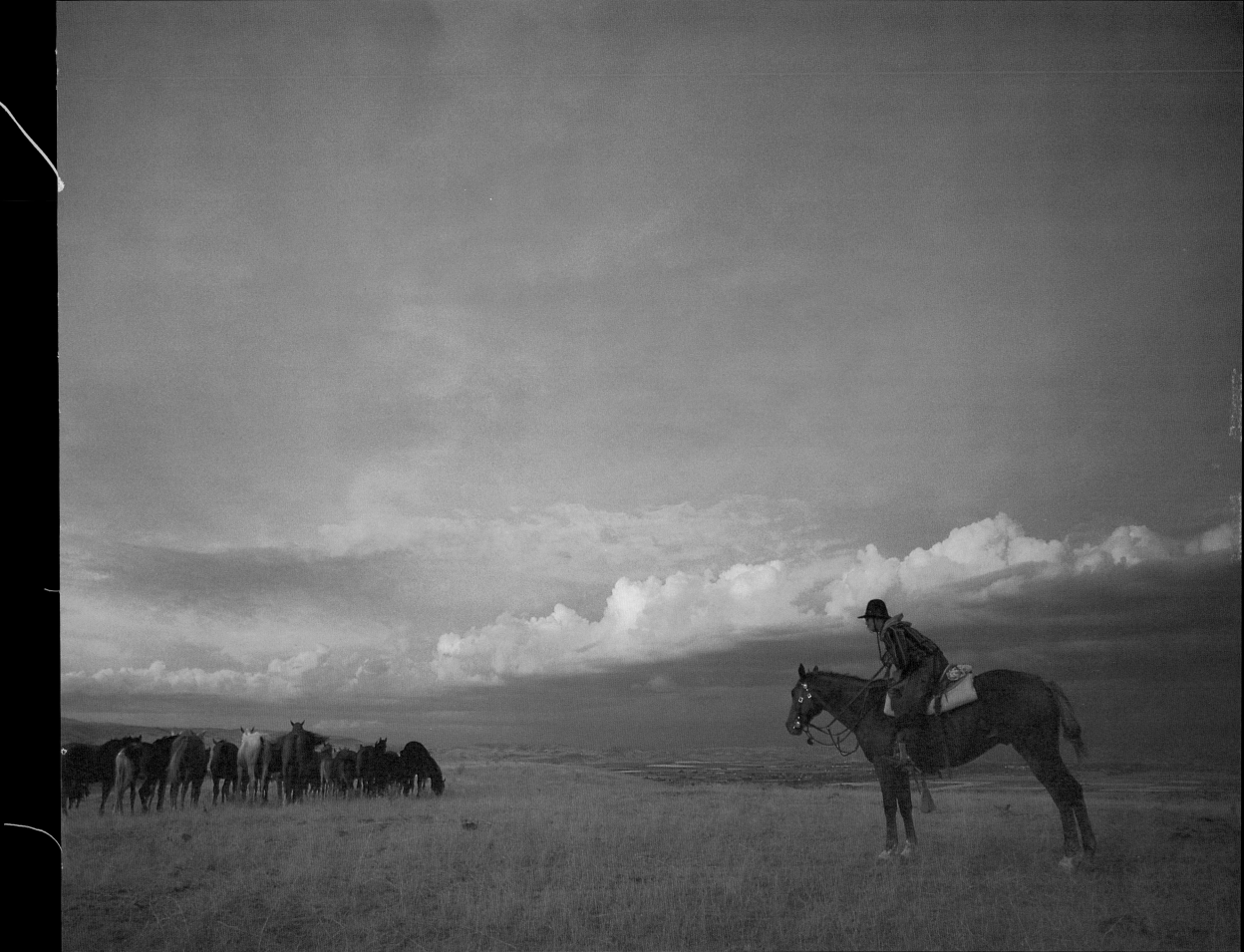

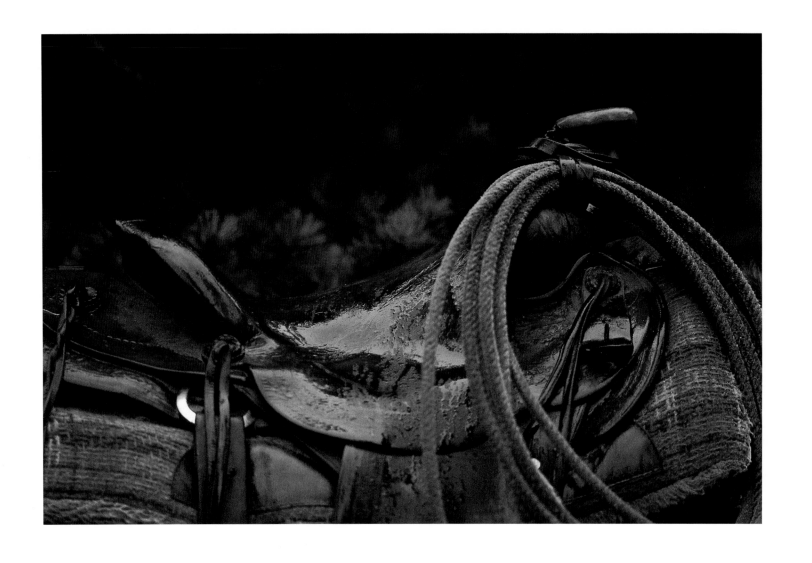

above: RAY'S SADDLE

right: HANDLE BAR MUSTACHE
Keith Hill - Hill Hereford Ranch - Mackay

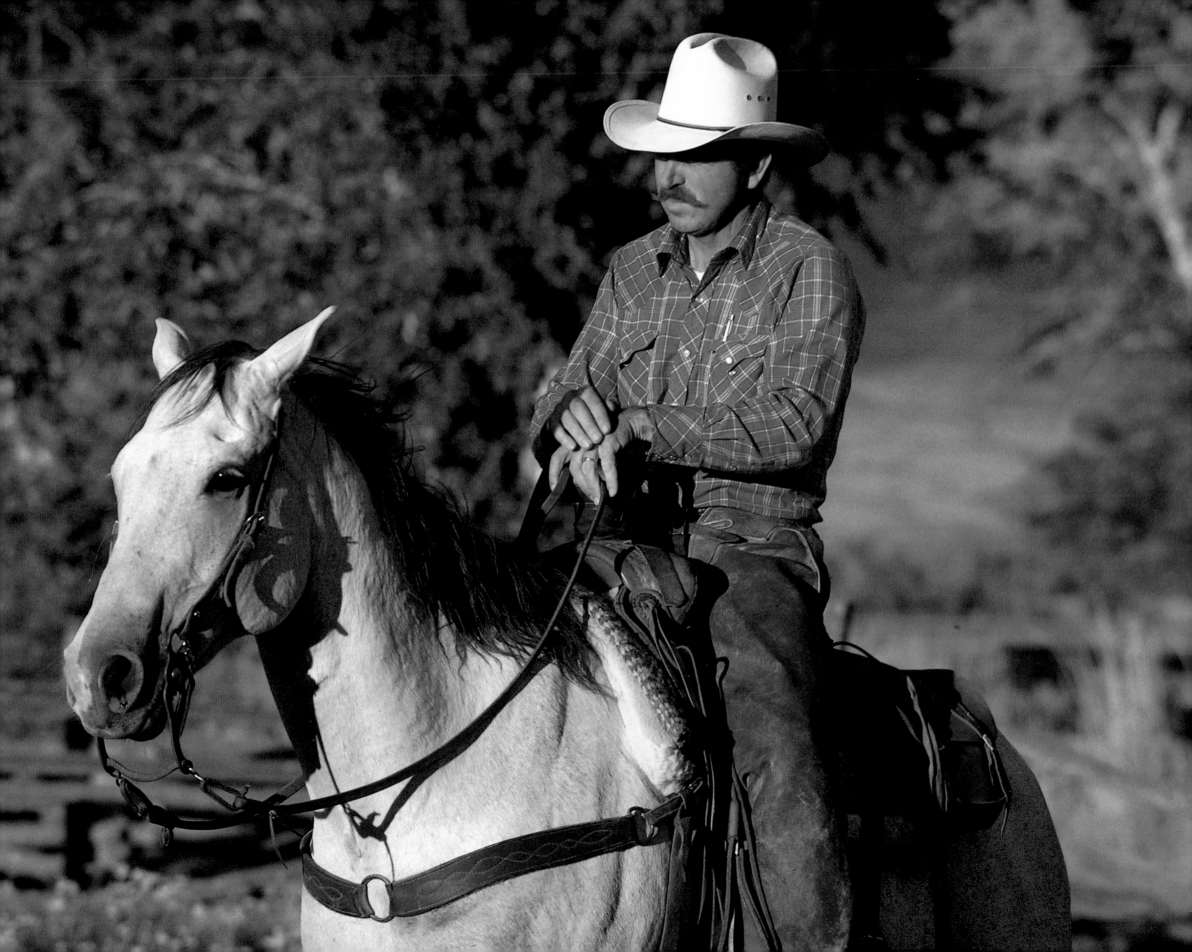

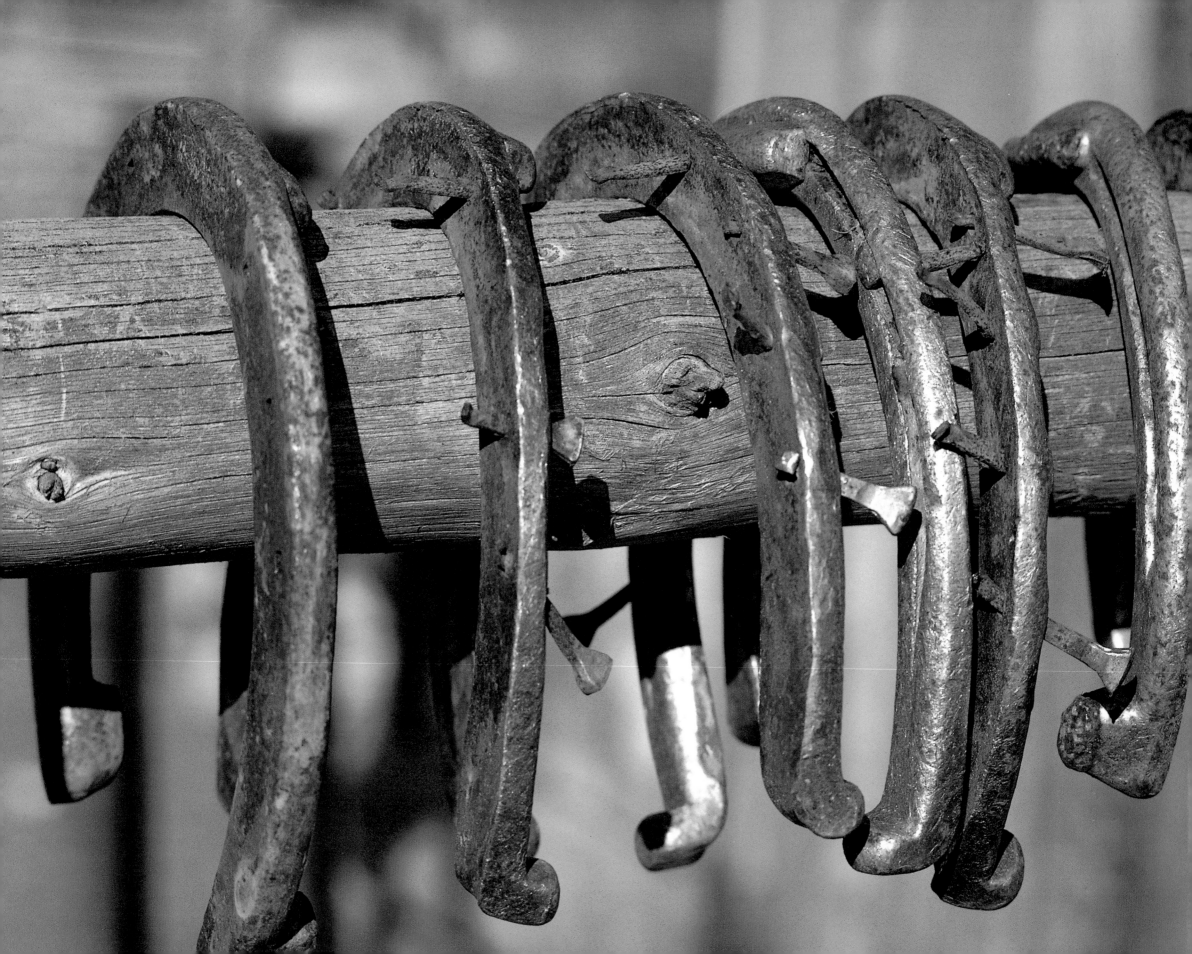

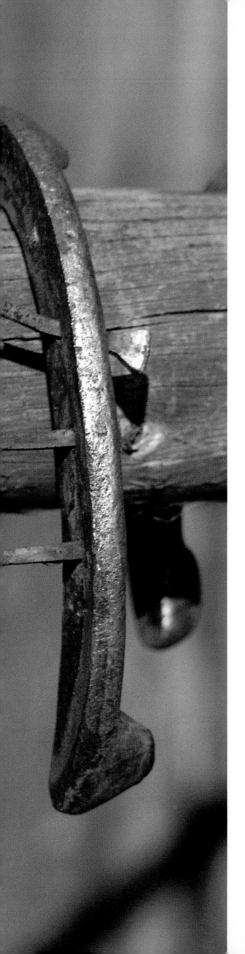

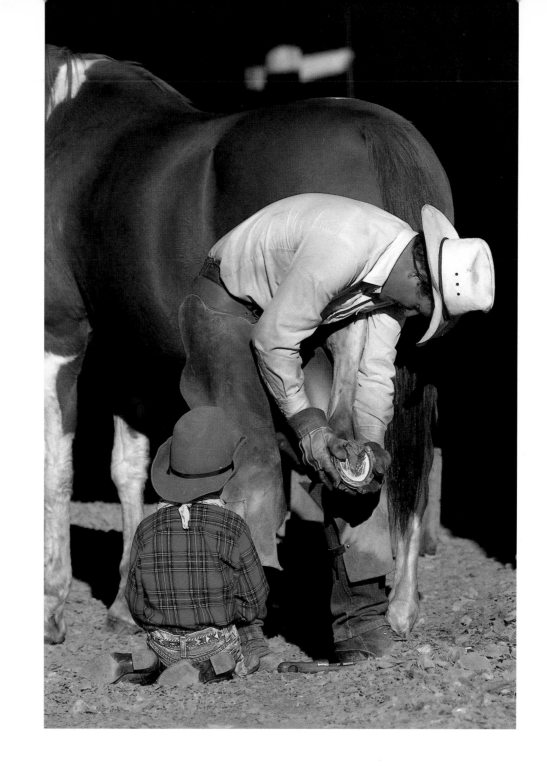

left: RUST ON HORSESHOES

above: FARRIER'S APPRENTICE
Calvin Amy and Drew Stoecklein - Bar Horseshoe Ranch - Barton Flat

143

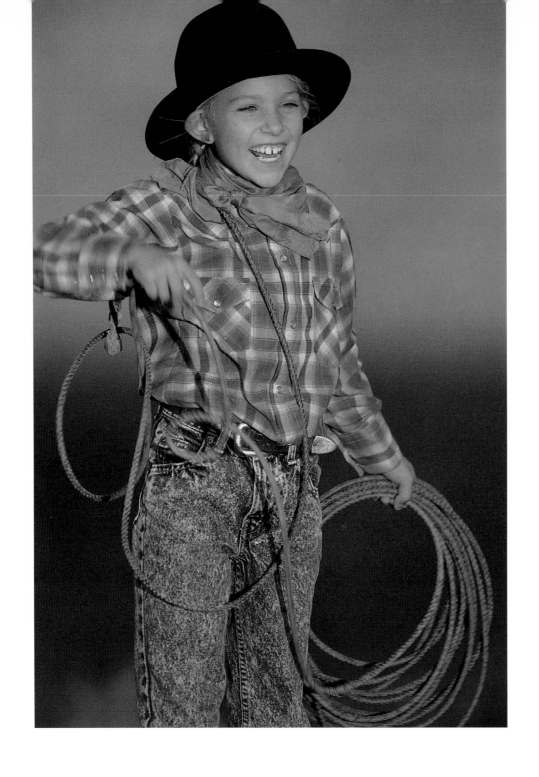

above: LITTLE DARLIN'
Dally Jayo - Payette

right: SADDLE POCKETS AND CONCHO

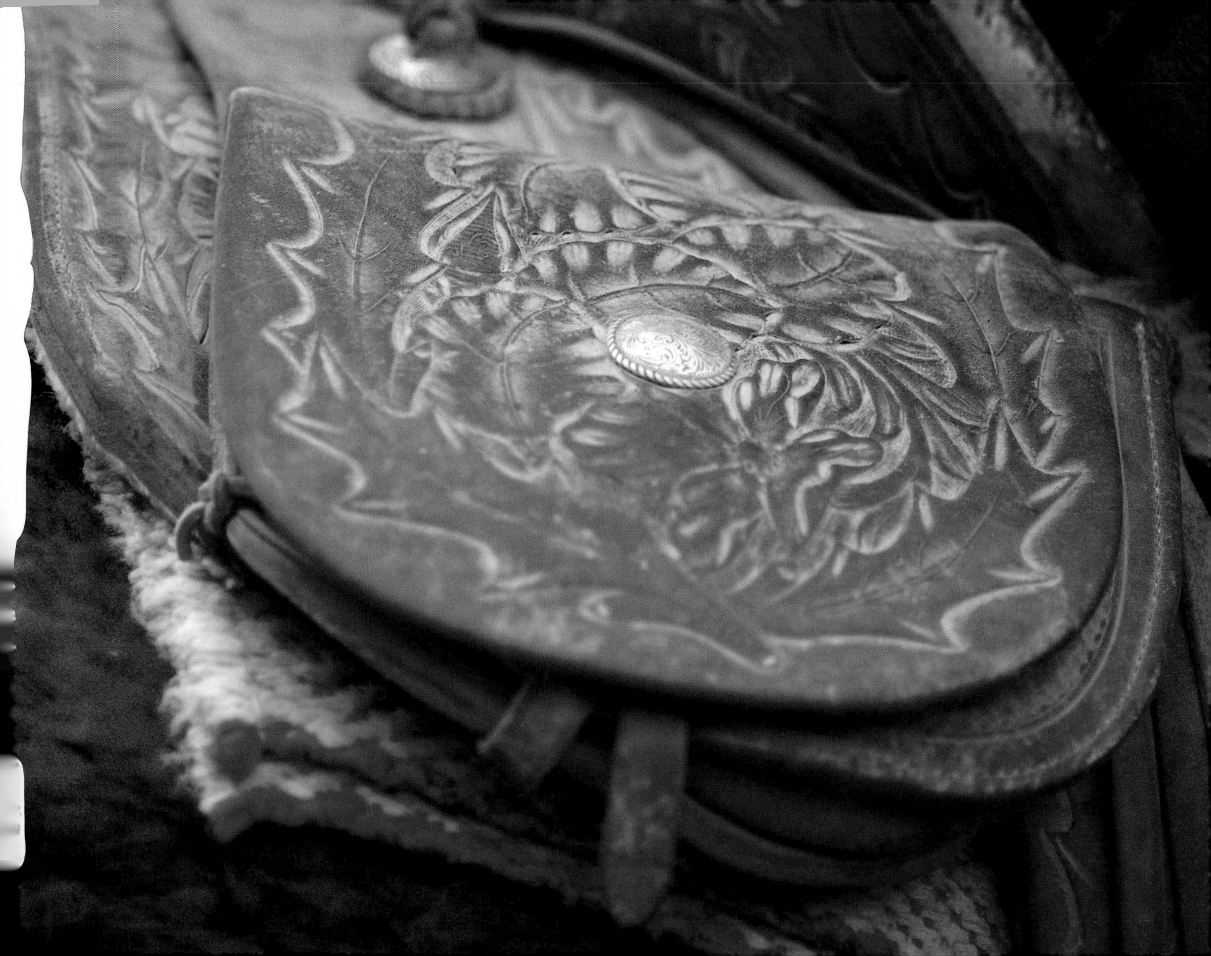

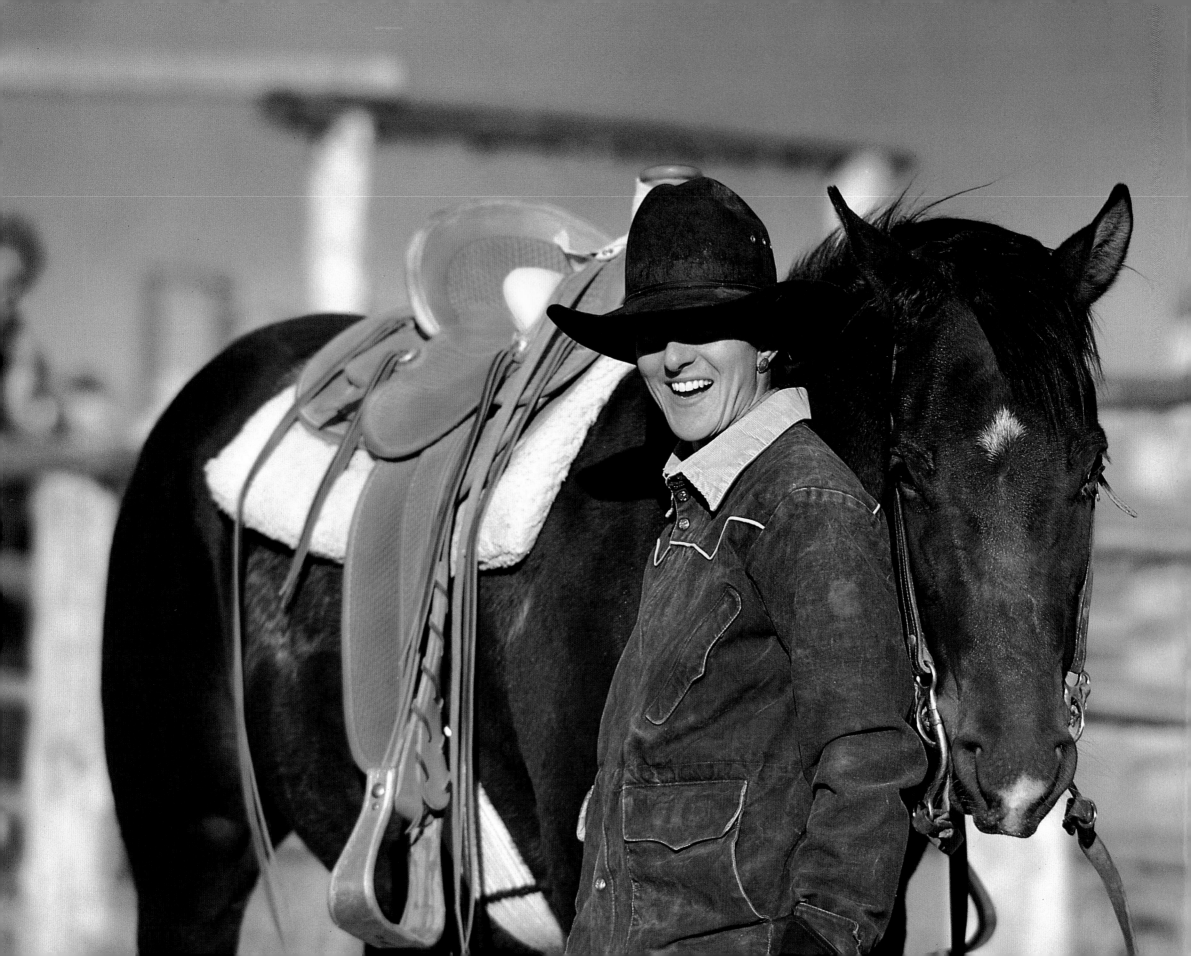

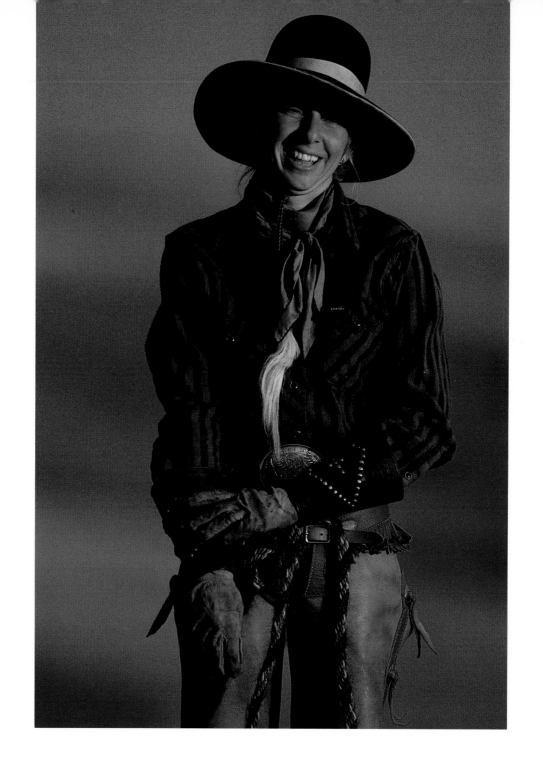

left: NANCY'S SMILE
Nancy Hoggan - Medicine Lodge

above: JACKIE'S SMILE
Jackie Jayo - Payette

147

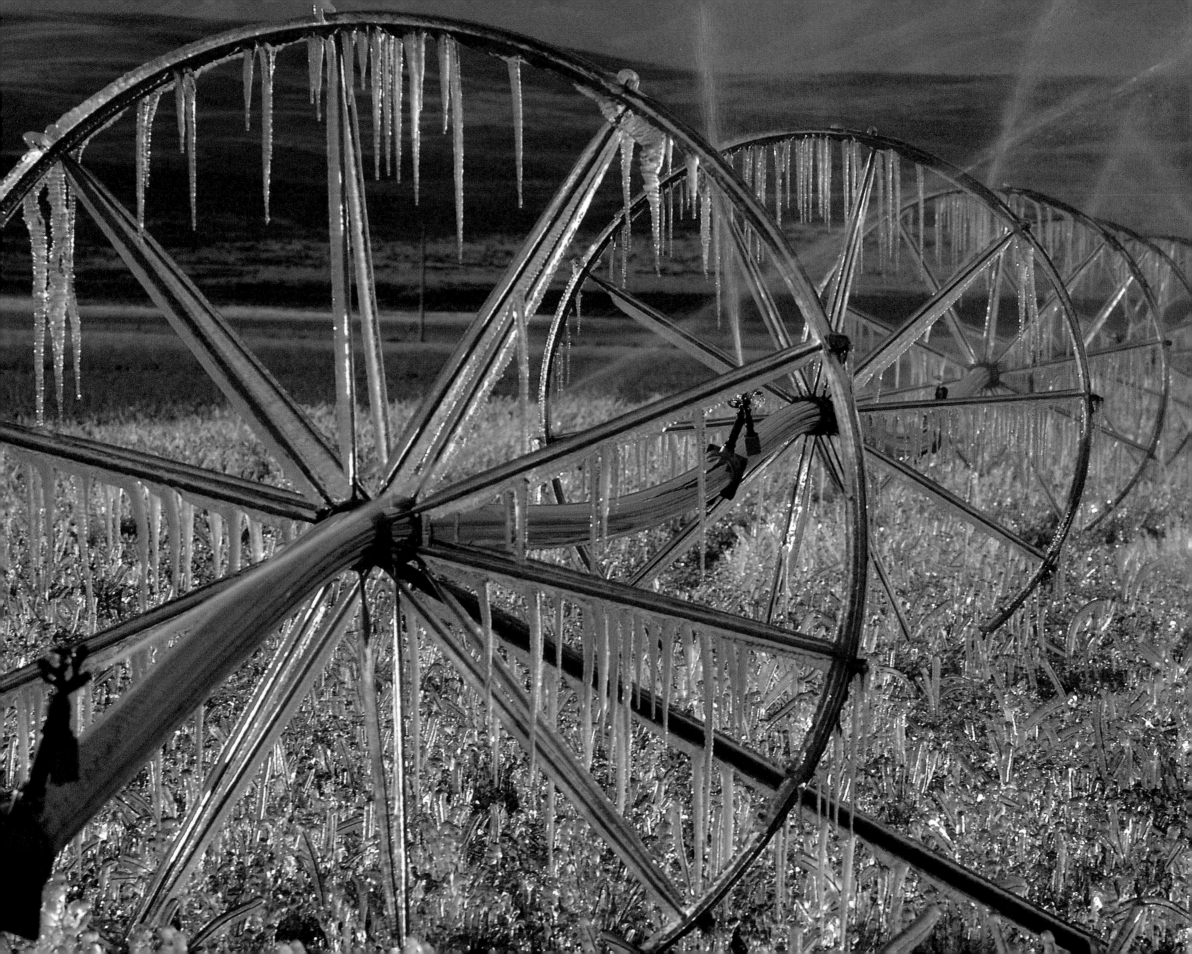

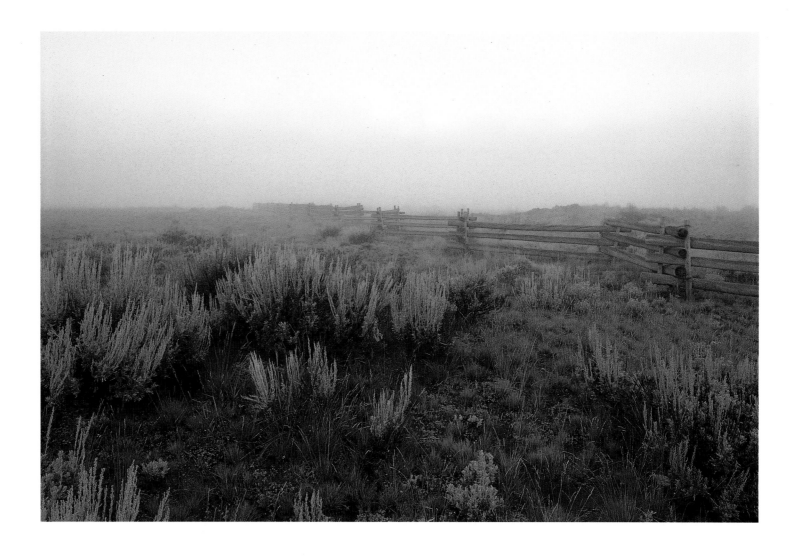

left: CRYSTAL CLEAR MORNING
Wheel Lines - Pahsimeroi Valley

above: SAGEBRUSH AND RAILS
Piva Ranch - Stanley

149

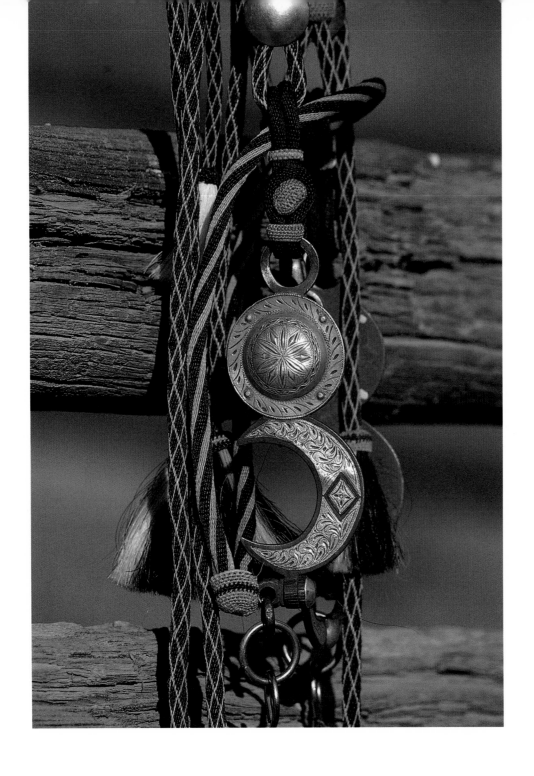

above: GS GARCIA HALF BREED BIT
Made About 1910

right: MARTIN BLACK
Winecup Ranch - Idaho/Nevada Border

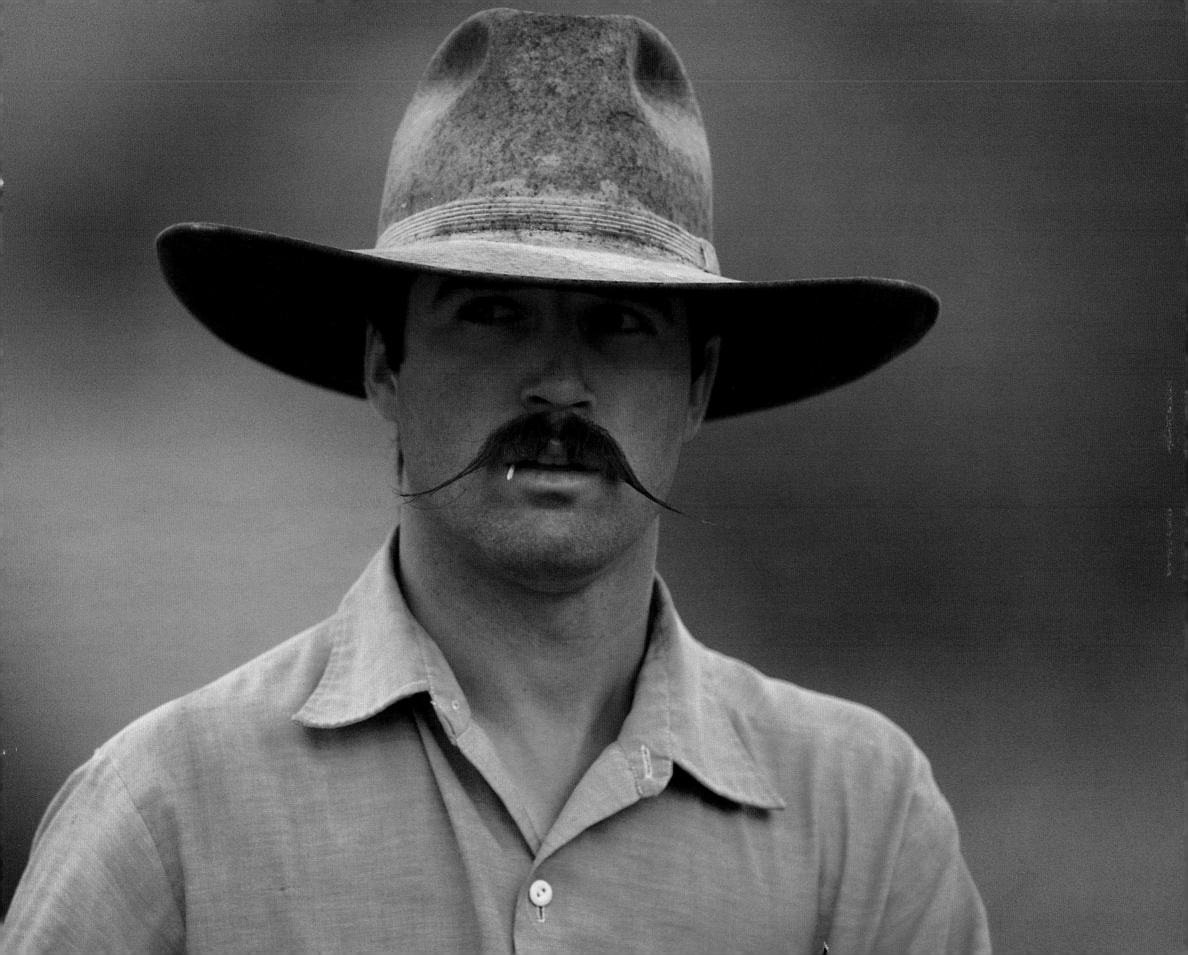

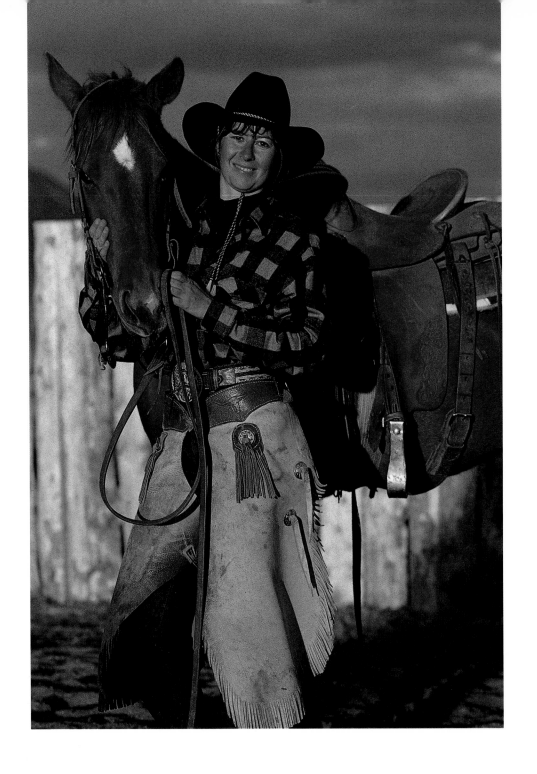

above: PROUD AS PUNCH
Sally Johnson - Chilly

right: COWGIRL BEAUTY
Lorna Steiner - Triangle Ranch - Oreana

next page: GHOST RIDERS
Monte Funkhauser and Bill Rousey

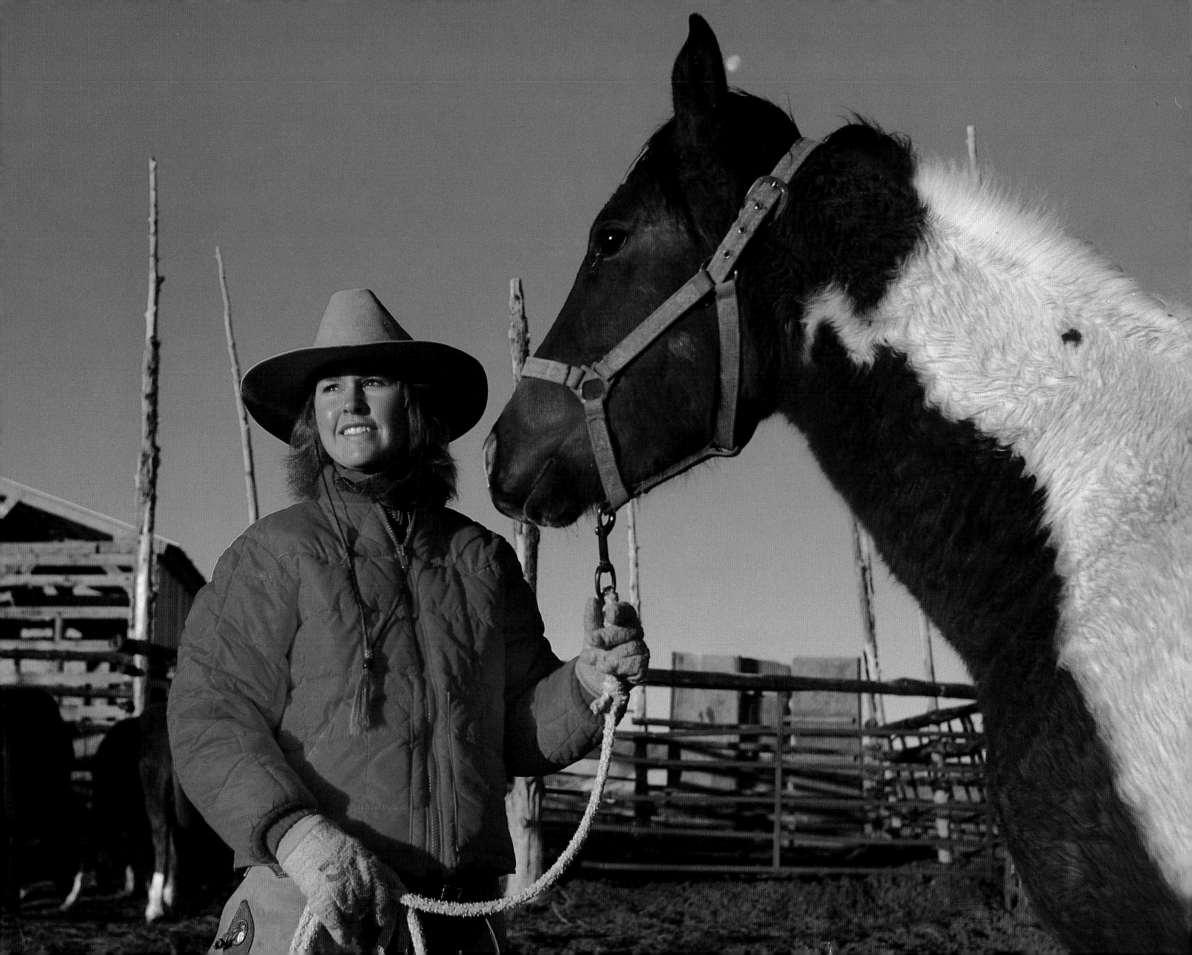

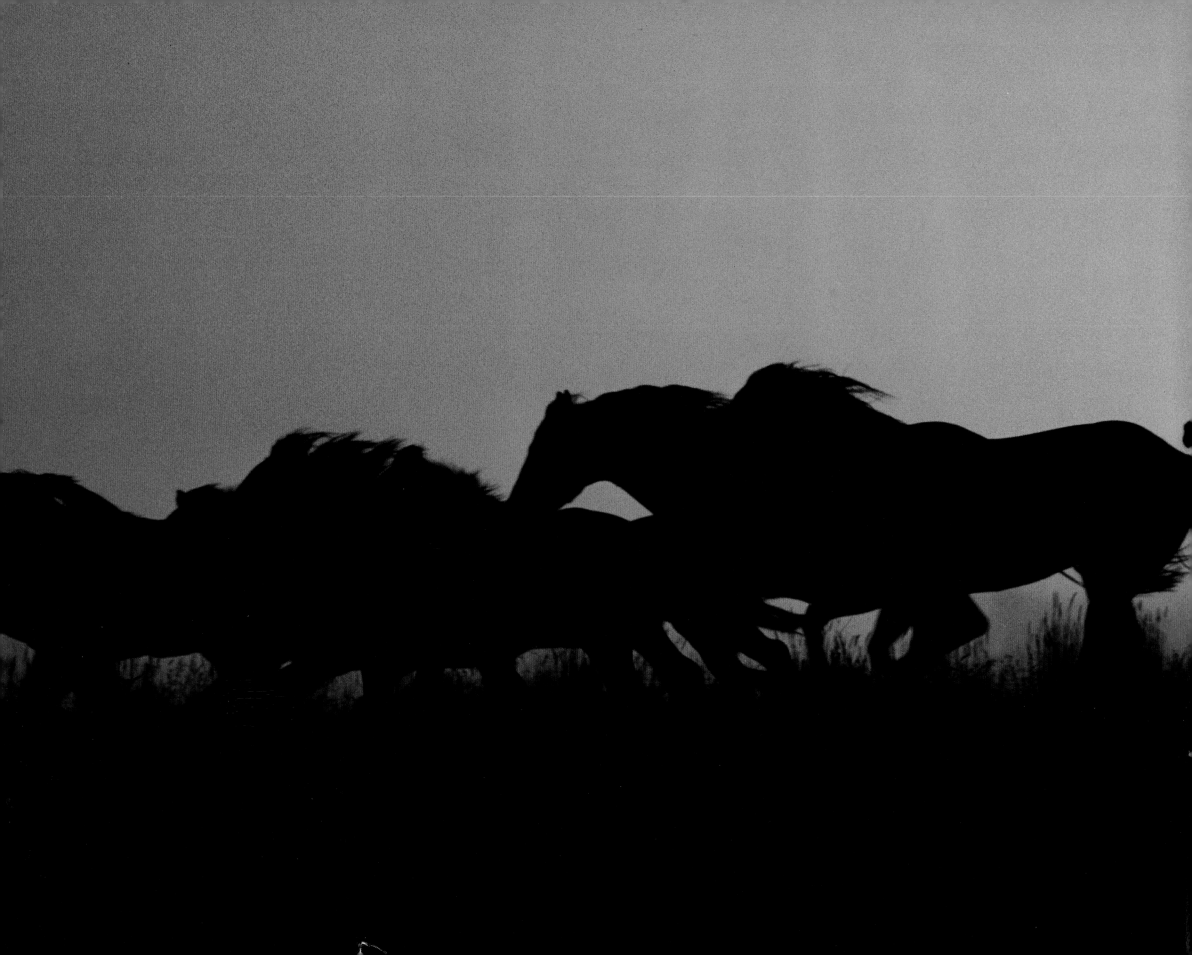

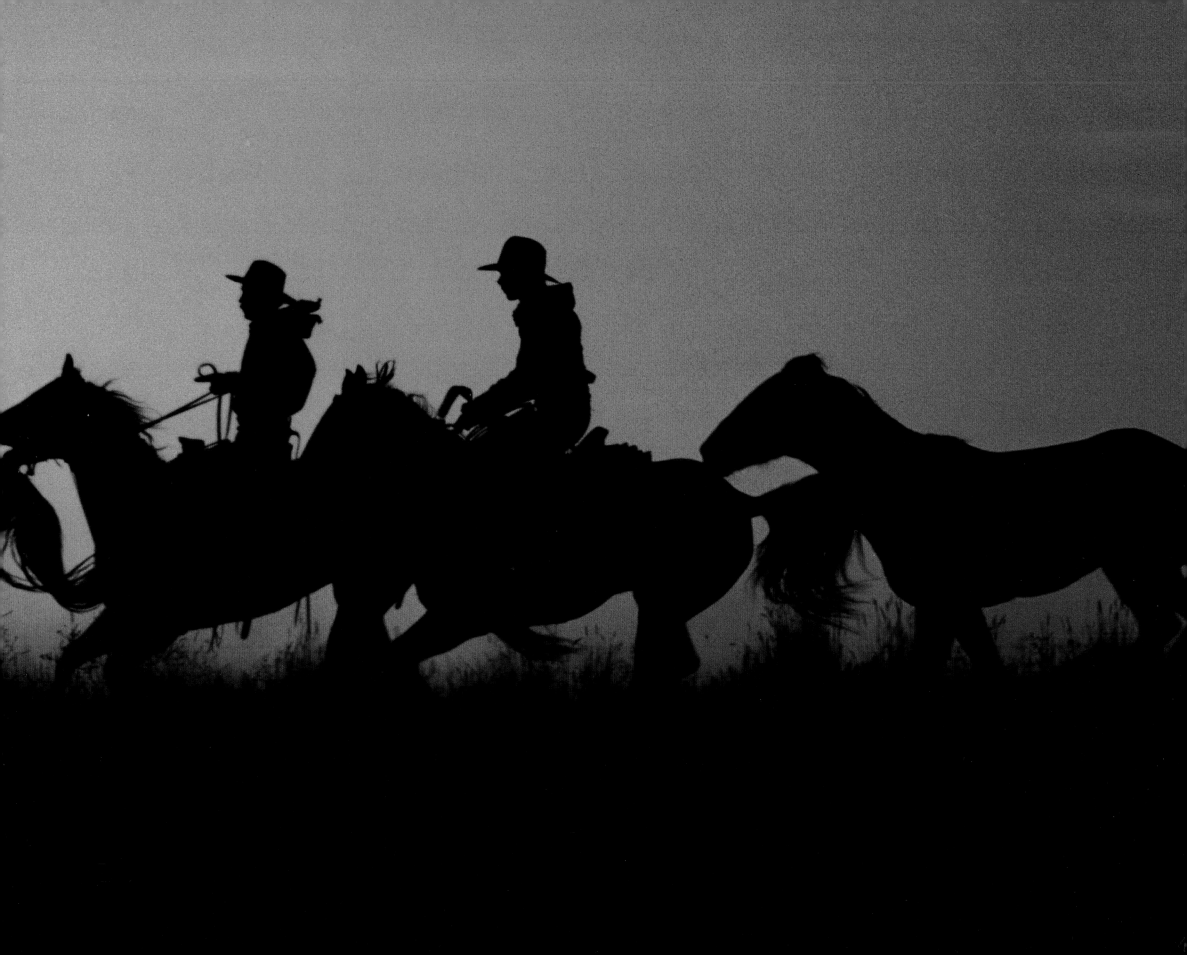

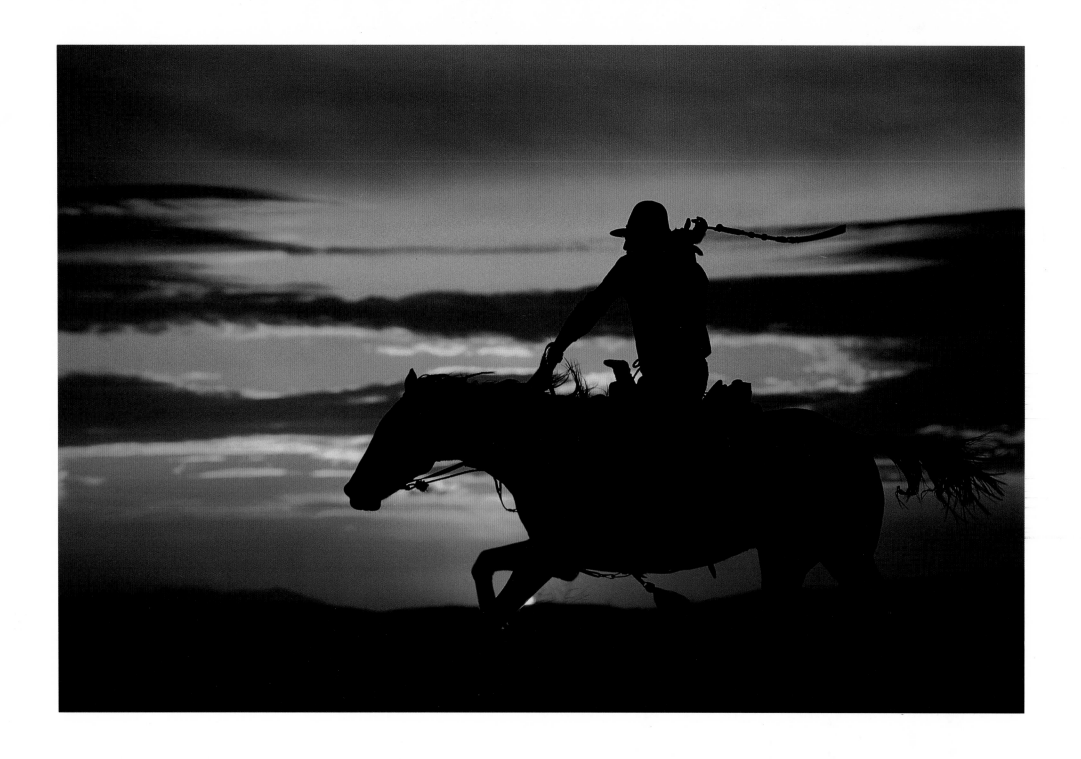

QUIRT AND FLY TASSEL

Merlin Rupp - Snake River Breaks